GOLDA MEIR

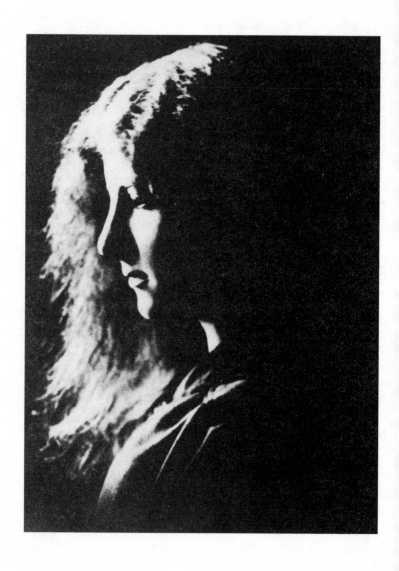

Golda Meir

Israel's Matriarch

DEBORAH E. LIPSTADT

Yale

UNIVERSITY

PRESS

New Haven and London

Yale University Press books may be purchased in quantity for educational, business, or promotional use. For information, please e-mail sales.press@yale.edu (U.S. office) or sales@yaleup.co.uk (U.K. office).

Set in Janson Oldstyle type by Integrated Publishing Solutions.
Printed in the United States of America.

Library of Congress Control Number: 2022947865
ISBN 978-0-300-25351-1 (hardcover : alk. paper)

A catalogue record for this book is available from the British Library.

This paper meets the requirements of ANSI/NISO Z39.48-1992 (Permanence of Paper).

10 9 8 7 6 5 4 3 2 1

Frontispiece: A 1918 portrait of Golda Meir taken at a meeting of the American Jewish Congress in Philadelphia. (Archives, University of Wisconsin–Milwaukee Libraries)

For Isabel, Alex, Theo, Wendy, and Rose
You exude great joy and give us hope for the future

CONTENTS

CONTENTS

GOLDA MEIR

Introduction

IN WRITING THIS BIOGRAPHY, I faced developing a serious case of historical whiplash. I read a myriad of works—scholarly studies, popular books, memoirs, autobiographies, biographies, plays, and essays—that address the life and career of Israel's fourth prime minister, Golda Meir.[1] The portraits they drew of her and her accomplishments differed markedly. Some of these works vilified and reviled her. Others valorized and revered her. When studying a person's life—particularly a life lived so publicly— one expects to find differing evaluations. But these ranged from the venomous to the hagiographic. At times I felt as if I was viewing a *Rashomon* rendition of her life. (*Rashomon* is a Japanese thriller that tells the same story in wildly different and often contradictory ways.)

I experienced the same whiplash in personal encounters. At one point I found myself in Israel as one among a small gathering of some highly accomplished Israeli women. For amusement

we were speculating on a short list of "great" Jewish women, including scholars, humanitarians, artists, and politicians. Before we could even commence, one of the women stated, with an emphasis not unknown in that part of the world, *"Just don't include Golda.* Too many of my family and friends died because of her." There were murmurs of concurrence around the table. These bright, well-educated, and thoughtful women, all of whom had been in university or the army during the Yom Kippur War, were utterly convinced that, but for her obstinance and inability to shed her "They will hate us forever" perspective on Israel's status in the Middle East, some of those who had fallen in the war would still be alive.

Shortly thereafter an American friend shared a family anecdote. "Both of my grandmothers belonged to the women's Labor Zionist organization, Pioneer Women (PW). They were part of the Hannah Szenes group (or *gruppa*, as they would call it). Initially the women all called each other ' Chavera ——,' using the person's last name. Even my two grandmothers would, even after their children married, call each other 'Chavera Chazan' and 'Chavera Libman,' using the Yiddish pronunciation Cha-*vay*-reh. Then, as they got older, they dropped the Chavera and just called each other by their last names. Golda came to install my grandmother Chazan as president of the local PW chapter in the early 1950s. When they asked her how to properly address her, she said, 'Just call me Goldie,' which they did. It endeared her to them and, they believed, them to her *forever.*" I heard variations of this story multiple times, evidence of how Golda made these women and countless others (men too) feel, in the words of the American Jewish fundraising slogan of the late twentieth century, "We are One." In the eyes of millions of American Jews, she could do no wrong. For close to five decades, for better and for worse, she shaped how American Jews saw and understood Israel and its place in the world.

If the laudatory works depict a woman who built a nation,

sent men into battle, negotiated treaties, spoke truth to power, and still found time to make homemade chicken soup, her critics depict a Golda who is domineering, uneducated, unimaginative, incapable of conceptual thinking, and unable to break out of her preconceived perceptions about many things, particularly the peace process. She was, they contend, at her very best an apparatchik who, absent her own ideas, loyally executed what was demanded of her.

Who, then, was the real Golda Meir?

Her long career encapsulates a microhistory of the Jewish state. She was part of the small cadre of people who helped craft a state and lead it as it transformed itself from a wobbly enterprise to a regional military power. She was one of only two women to sign Israel's Declaration of Independence. A member of David Ben-Gurion's close circle of political allies, she held three pivotal positions in the Jewish state—as labor minister (1949–56), foreign minister (1956–66), and Israel's fourth prime minister (1969–74). She was the first and, as of now, the only woman to hold that position.

During her career, the endless flow of laudatory press reviews detailed every aspect of her life—entertaining dignitaries, her high-profile White House visits, and spectacular receptions by Jews worldwide. She had a papal audience, a first for any Israeli prime minister. She helped realize the initial liberation of Soviet Jewry. Plainspoken and with few airs, she was repeatedly ranked as the world's most admired woman. During her years as labor minister, she laid the foundation of Israel's social welfare system, facilitated the immigration of hundreds of thousands of people, and created a social safety net system that persists seven decades later. There is no resident of Israel whose life is not made more secure because of the innovations she put in place.

Yet she, who thought of herself as the consummate socialist, would face accusations of racism from segments of Israel's

non-Ashkenazi Jewish population. All this would happen against the background of a proliferation of terrorist attacks, both in Israel and outside it, including the tragedies of a massacre at Lod airport, the shooting down of an Israel-bound airliner, numerous border incursions, and the murders at the Munich Olympics.

Three years into her tenure as prime minister came the disastrous Yom Kippur War (1973). Though she was officially cleared of responsibility for the war-related failures, many Israelis held her—and still hold her—responsible for Israel's initial devastating losses. In 1974, ill, tired of the demands of public life, and feeling responsible for the war, she retired. She subsequently told journalists that after that experience she was no longer the same person.

In addition to shaping Israeli society, she, possibly more than any other Israeli with the exception of David Ben-Gurion, built and cemented the Jewish state's relationship with the American Jewish community. American Jews were in awe of the brawny, tanned, and swarthy sabras, the "new" Jews, the kibbutzniks and fighter pilots. But it was Golda Meir who captured their hearts and their purses for the Zionist enterprise. Those American Jews were thrilled to open the July 1957 issue of the iconic American women's magazine *Good Housekeeping* to find a full-page photograph of a middle-aged woman, her hair pulled back in an efficient style, wearing a small flowered apron and poised above a sink washing dishes. She was identified as Foreign Minister Golda Meir of Israel. The article, in which Golda described how she planned meals, entertained guests, and cleaned, even while conducting the country's foreign affairs, telegraphed the message that here was a no-nonsense woman who could negotiate with other countries, host officials from abroad, and still tend to her domestic tasks. Moreover, she did this with "no sleep-in help."[2] A 1950s Superwoman. This was part of the mythic Golda, and it was a myth she helped cultivate.

Something she did not have to cultivate was her quick wit. She knew how to use a quip to cut down the most powerful people, particularly those whom she perceived as thinking of themselves as better than she. When Henry Kissinger told her that he thought of himself as an American first, secretary of state second, and a Jew third, she is reported to have responded, "We in Israel read from right to left." Shortly after Nixon appointed Kissinger as secretary of state, the president turned to Golda and, referring to the Cambridge-educated Abba Eban, said, "Just think, we now both have Jewish foreign ministers." Golda responded, "Yes, but mine speaks English."[3]

Then there is, of course, Golda Meir the woman. She was, in fact, only the third woman to serve as a head of state in the twentieth century and the first to do so without benefiting from the "appendage privilege." She did not come into office, as had been the case in other countries, because a father, brother, or husband had previously held that position. Well before Margaret Thatcher gained the moniker Iron Lady, Golda was sending soldiers into battle. She sent them to battle but also demanded to be awakened, even in the middle of the night, when one of them was killed. "I should get a good night's sleep and they fall in battle?" she mused to a journalist.[4] Meir consistently ranked among the most admired women in the world in polls conducted by the Gallup organization in the 1970s.[5] In 1977, despite having left office three years earlier, she was still second on the list. Yet her relationship with Israel's feminists was at best testy and more often downright hostile. They felt great enmity toward her, and this has shaped the way some feminists view her entire career.

Though many people perceived of her as the quintessential Jewish mother, things were not as they seemed. Her relationship with her children was often strained. They longed to be with her, but she was consumed with the Zionist enterprise, often attending late-night meetings and traveling on long trips. She

regularly left them in the care of others and, long before it was fashionable, arranged for a "nanny" to live with them. Nor were things as they might have appeared in terms of her intimate relations. She had a series of avid relationships with a number of the leaders of the Yishuv, the Jewish community in pre-state Palestine. Some of them occurred simultaneously.

I mention these aspects of her private life—Golda as a mother and Golda as a lover—because I know they are important parts of her story. Yet even as I do, I wonder: if her name had been David Meir, would these issues have been considered relevant? Are her appearance, role as a mother, and intimate relationships integral parts of the story only *because* she is a woman? Or, conversely, are they important because they seem to stand in contradiction to the public image she projected? When I told an older female friend who is well read in this area that I was writing this biography, she responded, "Oh, she was a great leader." Then, after just a momentary pause, she added, "But she wasn't a good wife or mother." I asked her if she knew what kind of husbands and fathers other Israeli luminaries (all male) were. She did not. And yet that—knowing about her relationships, but not about the men's—is also part of her story.

Finally, though I write as an American, I have studied and lived in Israel, including during her tenure as prime minister. I grew up in the era when she was often in the United States. People clamored to see her. American Jews spoke—and continue to speak—of her with a respect akin to reverence. For many among them, she could do no wrong. To suggest to them that she might have seriously failed at key moments in her political career is akin to heresy, if not historical revisionism. Conversely, there is a generation—if not more than one—of Israelis, like the women who would not even consider including her as a great Jewish woman, for whom the right she did has been all but obliterated by what they perceive as her wrongs. To suggest to them that their evaluation may not be entirely fair or com-

plete is dismissed as equally heretical. I understand both the reverence and the sharp critique. I have sought the balance between these two extreme views of Israel's fourth prime minister in order to write a study of an exceptionally accomplished woman who was not without her serious flaws.

1

Laying the Foundation: From Russian Jew-Hatred to American Opportunity

GOLDA MABOVITCH WAS BORN in 1898 in Kiev. Her early life was difficult. Her parents had lost five children at birth or shortly thereafter. Three children survived. Sheyna, the eldest, would have a profound impact on Golda's life. Clara was the youngest. Whenever Golda Meir reminisced about her Russian childhood, she repeated a familiar mantra of terrible hardships: poverty, cold, fear, hunger, and Jew-hatred. Often there was not enough food in the house even for an evening meal. Sheyna occasionally fainted in school because of hunger. When Golda was a young child and Clara an infant, her mother gave them porridge—a luxury. Her sister finished her bowl first and a "shocked" Golda watched her mother take some of her porridge for the infant. That moment of deprivation remained a vivid memory for her.

But she experienced more than poverty and hunger. When she was four, she learned about Cossacks, men who came "gal-

loping" [into Kiev] brandishing knives and huge sticks, screaming 'Christ killers.'" They had but one goal: "to do terrible things to me and to my family." Even children engaged in these attacks. Once, when Golda and another Jewish child were standing together, a non-Jewish child approached from behind, knocked their heads together, and proclaimed, "This is what we'll do with the Jews . . . and be through with them."[1]

Traumatized children often carry that trauma with them into adulthood. And so it was with Golda. In 1973, when she was seventy-five years old, she was the first Israeli prime minister to be welcomed at the Vatican. She was quite nervous. The visit began with the pope berating her for Israel's treatment of Arabs. Her nervousness evaporated, replaced with barely disguised contempt. As she so often did, she began with the personal. "Your holiness, do you know what my own very earliest memory is? It is waiting for a pogrom in Kiev." Then, having established her bona fides, she moved from the personal to the larger context of Jewish history as she lectured the leader of over a billion Catholics: "My people know all about real 'harshness' and . . . learned all about real mercy when we were being led to the gas chambers."[2]

The pogroms the Jews so feared never came. But the threatening prospect of them shaped Golda's evolving worldview. She was left with both a conviction that non-Jews could do terrible things to Jews and with memories of the Jews' "impotence." Golda recalled standing on the stairs of her home, holding hands with a little Jewish girl whose family lived in the same house as they watched their fathers tried to secure the home by barricading the entrance with wooden boards. Decades later she vividly described her fears: "Oh, that sound of the hammer pounding nails into the wooden planks! Oh, the sound of horses' hoofs when the Cossacks are advancing along our street!" She understood that her father's efforts were puny in the face of these marauders. "I remember how angry I was that all my father

could do to protect me was to nail a few planks together while we waited for the hooligans to come."[3] Had the attack actually come, the boards would have been ludicrously ineffectual. The lesson she repeatedly claimed to have gleaned from that moment was that if one wanted to survive, one had to personally take effective action. Whether she learned that lesson that night or long afterward is immaterial. She imprinted that memory on her consciousness. It framed her worldview. Being stronger than those who might want to do you harm became the leitmotif of her career, particularly as prime minister.

But that was not all she claimed to have learned from her years in Russia. Her life was threatened not because of anything she had done but simply "because I was Jewish." Being Jewish was the explanation not just for the violence they feared but also for her family's hunger and poverty. She was repeatedly told that her father, a carpenter, was always being cheated, despite having done exceptional work, because he was a Jew, and that as a Jew he had no recourse. Given these life lessons, it is not surprising that for her Zionism represented an antidote to a hostile, Jew-hating world. Even her conception of what it meant to be a Jew fit into this construct. While still a youngster, she told her mother that what made the Jews unique was "not that God chose the Jews, but that the Jews were the first people that chose God, the first people to have done something truly revolutionary."[4] And she too would be revolutionary. This was Golda Meir's Russian legacy. If you wanted a better future, one free from poverty, fear, and Jew-hatred, you must act. You could not depend on others to protect you. You had to be a revolutionary. That lesson would be the cornerstone of her life.

When Golda was five, her father, unable to earn a living in Russia, left to work in America. Golda, her mother, and her two sisters moved to Pinsk, her mother's hometown. They expected her father to return after he'd made his fortune. But the *goldene medina* did not produce the easy money—or even the steady

job—that his dreams had promised. Golda's mother, tired of waiting for her husband to return and fearful of remaining in Russia, where the political situation was deteriorating and the ever-present antisemitism intensifying, left for America with her three daughters. A woman of action, she arranged for smugglers to sneak them across the border to Galicia, where they waited for a few days in an unheated shack. A train then took them to Vienna and on to Antwerp, from where they sailed to Quebec City. They took another train through Chicago to their final destination, Milwaukee. During the Atlantic crossing, the family spent fourteen days in a stuffy cabin with four other people. They slept on bunks without sheets and ate "food that was ladled out to us as if we were cattle."[5] Despite these difficulties, Golda and the other children in steerage regaled one another with fantasies of the unimaginable riches awaiting them in the *goldene medina*.

Her father had been sent to Milwaukee by the Hebrew Immigrant Aid Society (HIAS), the Jewish agency that resettled immigrants. The agency's objective was to disperse Jewish immigrants in as many different cities as possible—that is, not in New York. Upon arrival the family discovered that Golda's father, despite having been in America for three years, could not afford an apartment for his family. Instead they joined him—temporarily and uncomfortably—in the room he rented from a family of eastern European Jews who had recently arrived. Eventually they found a two-room apartment, albeit one without electricity or bathroom, in the "poorer" section of town.

Despite these hardships, Golda was thrilled by the sights and sounds of her surroundings. Soon after arriving, she attended a Labor Day parade. She was captivated by the popcorn, balloons, brass bands, floats, and crowds and impressed by the fact that her father, now in the carpenters' union, was marching in the parade. This event stood out for Golda because although it was not a Jewish celebration, Jews were full participants. Her

father marched with the other carpenters. For Golda this exemplified her new American "way of life." But there was also the matter of the mounted police, who reminded both Golda and her little sister Clara of the Cossacks. The terrified younger girl, convinced that an attack on Jews was in the offing, screamed, "Mommy, the Cossacks are coming!" and had to be taken home. Golda's reaction was the stark opposite. She took note that in America the mounted police did not "trample" marchers underfoot. They protected them.[6]

Not long after arriving in Milwaukee, Golda officially became an activist. When she was twelve, the Milwaukee School Board, which generally distributed used textbooks to poor students, adopted new books. There were no used ones to distribute to indigent students. Determined to rectify the situation, Golda organized a fundraising campaign to buy books for needy students. Together with her friend Regina Hamburger, whom she had met in the second grade at Public School 4, she recruited a group of young girls. Under her tutelage they planned a public meeting, distributed invitations, and convinced the owner of a hall to rent it to a group of schoolchildren who promised to pay the fee after the event. According to the *Milwaukee Journal*, dozens came and contributed a "considerable amount of money." The paper described the organizers as a "score of little children who give their play time and scant pennies to charity, a charity organized on their own initiative." The article was accompanied by a photo of the group. Tellingly, the caption identified only one of them. "President Goldie Mabovitz [*sic*] is in top row, fourth from right."[7] Even then, her close friends recognized her special qualities. A classmate who walked to school with her every day recalled that she was "fearless . . . a firebrand with strong convictions."[8]

At the event, she was to deliver the main speech. Her mother begged her to write it out. She refused, preferring to just say

what was in "my heart." In a letter to Sheyna, she reported, "I said a speech from my head." For the next sixty years, this remained her practice. With the exception of major policy addresses before the UN and the Knesset, she spoke extemporaneously.[9] But this entire event gave evidence of more than her speaking ability. She had identified a problem, devised a plan of attack, ignored those who thought the plan foolhardy, carefully recruited supporters, and set about resolving the issue. This would become her lifelong modus operandi.

Throughout her life, Golda's supporters and detractors all agreed on her steely resolve. When Golda was still a young child, her mother, lamenting her stubbornness, declared, "There's a dybbuk in her."[10] That dybbuk did not come ex nihilo. She inherited that "will of iron" from her forebears, including those whom she never knew but whose stories were part of family lore. Her paternal grandfather, who came from a highly religious family, had been "kidnapped" as a child to serve in the czar's army. Golda was raised on the story that during his thirteen years of service, despite threats and punishment, he maintained his religious practices, never eating non-kosher food and subsisting on uncooked vegetables and bread. It is immaterial to debate the literal truth of this story; what counts is that it was etched into Golda's consciousness. She also recalled how, upon returning home, he so feared having sinned that he repented by sleeping on a hard bench in the cold synagogue with a stone for a pillow. "Little wonder," Golda observed, barely masking her contempt for such fanaticism after years of deprivation, "that he died young."[11]

But it was the women in her life who truly shaped her. Her strong-willed mother, breaking with the prevailing convention of relying on a matchmaker, fell in love with Golda's father, informing her own father that she planned to marry him even though he was penniless. Golda doubted whether her mother's siblings could have overcome their father's objections to this

serious breach of protocol. "But Mother managed." The couple had another resolute ally: Bobbe Golda, the great-grandmother for whom Golda was named. She insisted that what counted was that the groom was "a mensch." The match went forward. Golda thought of her mother as "energetic, shrewd . . . enterprising."[12] She arrived in Milwaukee determined never to let her family endure the abject poverty they had experienced in Russia. Within a week of landing in a country whose language she could not speak and with whose customs she did not know, she opened a small grocery store—without either the capital or the knowledge to manage a commercial enterprise.

Golda may have inherited her resolve or stubbornness from these forebears, but it was her sister Sheyna, nine years her senior, who made her not just a Zionist but a fervent adherent of Labor Zionism, the amalgam of Jewish nationalism and socialism. For much of Golda's life, Sheyna was her muse and the person whose opinion was most important to her. "For me she was a shining example, my dearest friend, and my mentor." When Golda's family decided not to send her to school because education was not a requisite for girls, Sheyna became her "chief" teacher.[13] While still in Pinsk, fourteen-year-old Sheyna convened a weekly gathering of young Jews to discuss how to resolve the challenges they faced. On Saturday mornings, while their mothers were in synagogue, the group would meet either in her home or that of Chaya Lichtenstein, whose brother would become Israel's first president, Chaim Weizmann.[14]

The teenagers engaged in vigorous debates to which the six-year-old Golda listened from her perch atop the coal stove. The Bundists wanted a revolution in Russia and promoted the notion of national-cultural autonomy in areas where Jews lived. The Labor Zionists, embracing the notion of Jewish peoplehood, called for Jewish national independence built on the foundation of a socialist society. Listening, Golda claimed she learned that "it isn't enough to believe in something: you have to have

the stamina to meet obstacles and overcome them, to struggle." Sheyna may have thought of her Saturday morning gatherings as a debating society, but the czarist police considered them a revolutionary effort. Golda remembered it as her "first lesson in illegal activities."[15] Their mother, concurring with the police, quickly recognized that it was no longer safe or practical to await their father's return. She took her three daughters and left. Thus ended the Russian chapter of Golda's life. Despite its brevity, it left its stamp on her.

Life in Milwaukee was an adventure. The fact that she retained no recollection of learning English is indicative of how quickly and smoothly she took to the language. Fifty years after she attended the school, she returned for a visit as prime minister. In addition to being welcomed with Hebrew and Yiddish songs by the student body, which was now predominantly African American, she was given a copy of her transcript. Her scores of 95 in reading, 90 in spelling, 95 in arithmetic, 85 in music, and what she described as "a mysterious 90" in something called manual arts, of which she had no recollection, are testimony to her success. In their comments on her report card, her teachers described her as "talkative."[16]

But attendance at school had competition: her mother's grocery store. It quickly became the bane of young Golda's existence. In the early morning, when her mother went out to buy supplies someone had to tend to the store. Sheyna, the committed socialist, refused to work in the capitalist enterprise. Golda had to stand behind the counter every morning until her mother, unfazed that Golda's groceries duties compelled her to be late to school or to miss classes altogether, returned. The eight-year-old Golda, as she later recalled, cried all the way to school. When Golda protested, her mother dismissed her complaints as inconsequential. When the truant officer came to the store to reprimand her mother, she would listen attentively, despite barely comprehending what was being said. Her mother's

entrepreneurial efforts did not ease the family's finances. In 1908 Golda wrote to Sheyna, who had contracted tuberculosis and moved to Denver for treatment, "Pa does not work yet and in the store, it is not very busy."[17]

Despite this unhappy situation, Golda remembered her time in Milwaukee as "good years." She completed elementary school at fourteen and was named class valedictorian. Convinced that her future was "bright and clear," she planned to continue to high school and a teaching career. She wanted to "open up the whole world for children."[18] Her parents thought otherwise. Believing that education was no asset for a woman in her search for a husband, they proposed that Golda work full-time in the store until she found a match. When she objected, they offered a compromise: secretarial school, which, they argued, was better than teaching since a teacher had to resign once she married. A secretary could continue working. Neither Golda's tears nor her entreaties changed her parents' mind. Golda believed her father might have supported her efforts, but at this point life had defeated him and he could not challenge his wife.

So, showing the independence of spirit that would mark so much of her life, she started high school. Her mother, demonstrating her own strong will, tried to arrange her marriage to a man more than twice her age. At that point, Sheyna and her future husband, Shamai, stepped in and, despite their limited resources, urged Golda to come to Denver where she could study and control her future. Sheyna reassured her: "Goldie, . . . you are too young to work; you have good chances to become something."[19] Golda grabbed this lifeline and, with Regina's help, escaped. On the appointed night, she lowered her bundle of clothing out the window to the waiting Regina and then snuck out of the house. Using the small savings she had accumulated, she bought a train ticket for Denver, a distance of one thousand miles and a ride of over twenty-four hours. She was fourteen years old. Her "escape" caused an upheaval and, Regina reported,

a rumor circulated that she had eloped with an Italian man. Her parents, anxious to save face, told neighbors she had gone to Denver to help Sheyna. In Denver, with Sheyna and Shamai's encouragement, she continued her education. Then she began to fight with Sheyna, whose personality was as domineering as Golda's. She moved out of her sister's house, found a rented room, and began to live on her own. She was fifteen years old.

But in Denver something other than school began to compete for her attention. Sheyna's home had become a meeting place for young Jews who, akin to the group that met surreptitiously in Pinsk, wanted to debate contemporary issues. She "hung on every word." Soon her convictions about Zionism, socialism, and nationalism began to mature. She became enthralled by the work of one of Labor Zionism's ideologues, A. D. Gordon (1856–1922), and his concept of *kibush haavodah* (conquest of labor). Gordon, who had moved from Russia to Palestine at age fifty, believed Jews could transform both society and their place in it through creative labor. Tilling the soil, planting crops, and reaping harvests were acts of self-liberation. She also encountered the work of Dov Ber Borochov (1881–1917), who believed that the resolution of antisemitism demanded the "normalization" of Jewish life. Jews were an anomalous people who, in contrast to all other national groups, lacked a territory. Once concentrated in Palestine, they could create a Jewish working class and participate in the liberation of the working class worldwide.

But at these gatherings she was mesmerized by more than Zionist ideology. One of the regular attendees was a sign painter, Morris Meyerson. An autodidact, he had an encyclopedic knowledge of matters that were entirely foreign to her, and he became both her mentor and her lover. They spent hours talking about classical music, poetry, art, history, and philosophy. The young girl who grew up in a home that had one book, a *siddur* (prayer book), and whose parents thought education irrelevant,

if not an obstacle, for a girl, now discovered, thanks to Morris, topics that she had heretofore never encountered.[20]

She was not a total tabula rasa concerning higher letters. In Milwaukee she and Regina went to the public library where they would immerse themselves in the classics. They read an array of writers, including Gogol, Chekhov, Dostoyevsky, Hugo, Maupassant, Galsworthy, Wells, Dickens, Twain, Lewis, and Hawthorne. They read classics such as *War and Peace* and *Anna Karenina*. She read so much her mother began to complain that she always had "her nose stuck in a book." While her young-adult reading list was impressive, Morris expanded upon it, recommending Ralph Waldo Emerson, Thomas Carlyle, and Byron's poetry. Soon she was not only more literate, she was in love. She wrote Regina about Morris's "beautiful soul."[21] The two seemed to complement each other's strengths. Their son Menahem later wrote that she was drawn to his "erudition and sensitivity," while he was "overwhelmed by her vivacity, dynamism, and charm." But they also had serious differences. Menahem described his father as an introvert who saw the world as a place of "universal sadness," while his mother was "happy and smiling."[22]

These differences might have been surmountable. People with contrasting worldviews often forge successful relationships. But there was a third party present: Golda's other budding love, Zionism. Morris and Golda had diametrically opposed political ideologies. A universalist, he informed her shortly after they met that he did not "know whether to be glad or sorry that you seem to be so enthusiastic a nationalist. I am altogether passive in this matter, though I give you full credit for your activity." His growing love for Golda did not, at least initially, prompt him to adjust either his interests or his schedule. "The other day I received a notice to attend one of your meetings. . . . But since I do not care particularly as to whether the Jews are going to suffer in Russia or in the Holy Land, I didn't go."[23]

In late 1915, after Golda had been in Denver about a year, her parents, distressed by the separation and reconciled to her desire for education, implored her to return to Milwaukee. She left Denver and Morris, enrolled in a teachers' college affiliated with the University of Wisconsin, and began teaching in the Yiddish Folk Shulen, schools that advocated Labor Zionism. Soon, much to her delight, Morris followed her to Milwaukee. Thrilled, she wrote Regina, "I have the greatest surprise for you. Morris arrived late last night. . . . Regina, can you imagine my happiness. I am the happiest person alive." He continued to expand her cultural horizons. "We read books together," Golda recalled. "He gave me every capacity I have for enjoying . . . poetry, music, philosophy." He included her friends. Her neighbor and good friend Sadie Ottenstein recalled, "Morris opened a whole new life for all of us." When the Metropolitan Opera visited Milwaukee, "it was Morris who got us all seats for a quarter apiece, and then explained the story of the opera to all of us."[24] But the ever-present third party in their relationship remained. Morris wanted a wife, but his bride had another suitor, one with whom he would never be able to compete.

Though her relationship with her parents had improved, there was still tension. Her father grew angry about the speeches on Zionism she was giving at Milwaukee's version of London's Hyde Park Speakers' Corner. He objected not to the Zionism but to the street-corner locale. He angrily told her, "Mabovitch's *tochter* [daughter]? Stand in the street?" This was a *shandeh*, a disgrace of the highest order. He ordered her to stop, threatening that if she did not, he would come and drag her off the platform by her braid. Golda, who had made a commitment to speak, disobeyed. She anticipated that he would appear and make a scene. But he did not show up and the evening proceeded successfully. When she returned home, her mother informed her that her father had indeed come to the venue intending to foil her participation, but was so transfixed by her speech that he

forgot his threat and returned home awestruck. "Ich vais nit fun vanit nemt sich dos zu ihr!" (I don't know where she gets it from). He never objected again. Golda would eventually make speeches at pivotal moments in the Jewish state's history. She spoke before numerous British commissions on Palestine, American presidents, and the United Nations. Yet for Golda none of those compared to that night in Milwaukee where she delivered, she wrote decades later, her "most successful speech."[25]

Her parents' financial situation had improved. Able to rent a nicer apartment, they made their home the destination for Labor Zionist emissaries visiting Milwaukee. Golda listened to Nachman Syrkin and Shmarya Levin, two men who helped lay the groundwork for Labor Zionism. She internalized their opposition to Jews hiring Arabs to work the soil *for* them. She heard about Turkish repression of the emerging Jewish community. Among the repeated visitors to her parents' home was Yitzhak Ben-Zvi, a future president of Israel who, together with David Ben-Gurion, had left Palestine for Egypt when the Turks began to deport people connected to Zionist activities. Shortly thereafter they left Egypt for the United States with the hope of spreading the Zionist message. In Milwaukee Golda participated in Yiddish folk song sessions lead by Ben-Zvi, who would also regale his audiences with stories of the Yishuv.

Her initial meeting with Ben-Gurion did not get off to a happy start. He was scheduled to speak in Milwaukee and to have lunch with her the following day. In a foretaste of the love triangle in which she would be for much of her married life, she opted to skip the lecture and accept Morris's invitation to the Chicago Philharmonic. When she appeared for lunch the next day, organizers told her that someone who failed to come to Ben-Gurion's lecture was unworthy of lunching with him. In the future it would generally be Morris whose priorities would be subordinate to her political ones. The more she met these charismatic figures, the more she became uncomfortable with being

a "parlor Zionist," someone who raised money so that someone else could settle in Palestine. She wanted to be part of things. Ironically, her distaste for parlor Zionism notwithstanding, she, more than any other Zionist leader, would eventually be responsible for creating generations of American parlor Zionists.

While the notion of building a new kind of Jewish society pulled her to Zionism, antisemitism pushed her there. In the aftermath of World War I, there was a series of pogroms in the Ukraine and Poland. They were spearheaded by the "Whites," a loose conglomeration of monarchists, capitalists, and supporters of democratic socialism. (These were responsible, in part, for convincing many Jews to become Bolshevists.) In response Golda organized a protest parade on one of Milwaukee's main streets. Much to her surprise, some local Jewish communal leaders thought protesting "unwise." Now was the time, they told her, to "lie low" and "make no noise." A Jewish owner of a major department store who agreed with this assessment demanded that she come see him. He threatened to leave town if the protest proceeded. Golda, unmoved by the opposition, argued that these protests would earn them the city's respect and sympathy. Golda proved more accurate than these seasoned leaders. The march was attended by scores of people, including many non-Jews. The parade may have been a success, but for Golda it was not enough. She was increasingly convinced that the answer to pogroms was "not parades in Milwaukee . . . making speeches or raising funds." It was time to move to Palestine.[26]

Now she had to convince Morris. They were engaged, but he was still, at best, passive about the notion of a Jewish state. He considered her certainty that creating one would ameliorate Jewish lives "ridiculous." She seemed to be more enamored of Palestine than of her beloved. "I know that you don't feel as strongly about living in Palestine as I do . . . but I beg you to come with me." Emigrating had become a condition of the marriage.[27] His reservations notwithstanding, he eventually acqui-

esced. Golda later acknowledged that he recognized even then that the differences between them were insurmountable. As committed as she was to building a Jewish home in Palestine, he was equally committed to internationalism and pacifism. Yet he was mesmerized by this woman and seems to have believed that love would obliterate these differences. He may have also assumed that after being in the Yishuv, her ardor would wane and she would return to America. Neither happened.

Eventually, political developments helped Morris overcome some of his hesitations. In 1917 the British issued the Balfour Declaration expressing their commitment to a Jewish national home in Palestine. Even Morris was elated, believing that "the exile of the Jews had ended." Equally thrilled, Golda began to travel to other cities to drum up support for Labor Zionism. Soon she was away from Milwaukee more often than she was there. Her itinerary included cities with substantial Jewish populations, such as Philadelphia and New York, and those with far smaller ones, such as Bangor, Maine. The schedule was notable for a young woman traveling on her own. But she was not just a young woman. She was a young bride. During her travels spreading the word about Zionism, she wrote Morris long letters which, she acknowledged, "tended to be more about the meeting I had just addressed, or the one I was about to address, the situation in Palestine, or the movement, than about us or our relationship." Her family began to worry. "Who leaves a new husband and goes on the road?" her father wondered. Sheyna, who now was less the firebrand and more the mother of two children, counseled her to try to be "not what you *ought* to be but what you are."[28] It was striking advice from someone who had risked arrest by the czarist police for holding clandestine gatherings in her mother's home and had enabled Golda to escape to Denver in order to continue her education.

At the end of World War, I, Golda gained a new cause, the

creation of an American Jewish Congress, a democratically elected organization that would represent *all* American Jews. Zionists such as Golda were particularly attracted to it because they believed it would adopt a pro-Zionist platform. They also saw it as a means of challenging the communal hegemony of the current leadership of the American Jewish community, which was generally highly acculturated, wealthy, and fiercely anti-Zionist. Most of these leaders were affiliated with Reform Judaism, which at the time was staunchly anti-Zionist. However, there were exceptions, most notably Rabbi Stephen S. Wise who, despite being a highly respected Reform rabbi, was a leader of the Congress movement. The ranks of Congress supporters were, however, closer to Golda's profile than Wise's. Relying on her growing talents as a public speaker, Golda gave several pro-Congress speeches. Not every Jewish venue was happy to hear her. A resolutely anti-Zionist synagogue refused to allow her contingent to enter, much less to speak. Golda was not to be dissuaded. A friend described the moment:

> The young *havera* [comrade] Golda Mabovitch, who was with us near the synagogue said: "Listen to me. Someone bring me a bench and when they leave the synagogue, we will detain them and speak outside." The plan was accepted. When the Jews left the synagogue *haver* Albert Lewis cried out in his ringing voice: "Attention my friends—we have something to tell you." The crowd remained standing near the door and the synagogue's steps. Golda stood upon the bench and began with the words: "My dear fellow Jews, we are very sorry that we are detaining you at the door of a holy place, but it is not our fault—it is the fault of your leaders— the president and trustees who closed the door to our people. We applied and asked to say a few words to you in the customary and more conventional manner ... but your leaders did not allow our committees that which they allowed others, so we are compelled to act in this way."[29]

Golda attended the Congress, which convened in Philadelphia in December 1918. Thousands of people crowded the opening, with thousands more outside. Golda assured Morris that she did not miss a single session. For her the transcendent moment came with the adoption of the resolution supporting a Jewish national home. After tumultuous cheers, the delegates rose to sing "Hatikvah." In a postcard to Regina, she described it as "the most wonderful thing imaginable." This, Golda declared, was where her "political career actually began." But it was more than just that. One delegate described it as "the beginning of her being famous." Nachman Syrkin, the Labor Zionist ideologue, advised his young daughter, Marie, that "there is a woman in our movement who is a remarkable speaker. I thought you'd like her."[30] That woman was Golda Meyerson.

Convinced that this was the threshold of a new era for Jews, Golda, together with Morris, who had overcome his doubts about moving, decided to leave for the Yishuv, the Jewish settlement in Palestine. They moved to New York's Morningside Heights, where they planned to earn money for the trip and prepare for their passage. The young couple spent their free time in decidedly different ways. Golda went to the offices of Poalei Zion of America (PZA), the American Labor Zionists, and performed any task given her, which often entailed sweeping the floor. Morris visited bookstores, museums, and other cultural sites. Years later their son Menahem zeroed in on these differences. For his father New York was full of expensive things to which he could "aspire." For his mother it was the place "from which she was going to leave for Palestine."[31]

They used this time to sell all their possessions, including their winter clothes because they assumed winter wear would be extraneous in Palestine. (It was not.) The only possessions they took with them, as a concession to Morris, were his record player and record collection. Although leaving behind winter coats was

an unwise decision, taking the record player proved to be a fortuitous one. They then began their farewell rounds. Their first stop was Chicago to bid farewell to Sheyna and her family. Golda, aware that Sheyna disapproved of their decision, went reluctantly. When Sheyna had learned of their plans to emigrate, she admonished Golda: "Goldie, don't you think there is a middle road for idealism, right here on the spot?" Her query made what happened next all the more surprising. As Golda described their plans, Shamai rather nonchalantly asked Sheyna, "Perhaps you'd like to go, too?" Sheyna's response startled everyone present. "Yes, I would." If Shamai would agree to remain behind and earn money, she would go with the two children. This was shortly after Arab riots in Palestine had resulted in wounded and dead Jews. Shamai begged Sheyna to wait for safer times. Her response was unequivocal and not dissimilar to what her younger sister might have said: "Then I must go."[32] Regina's son Meron Medzini, who served as Golda's spokesman when she was prime minister, believed, based on interviews with both Regina and Sheyna, that there was a tinge of sibling rivalry inherent in this decision. My younger sister, whom I schooled in Zionism, is fulfilling the dream and I should remain in Chicago?

Golda was about to go to Palestine. She would be accompanied by a sister and her two young children, none of whom had prepared for the trip, and a husband who was decidedly reluctant about the entire enterprise. Not surprisingly, years later she still felt it necessary to insist that neither Morris nor Sheyna went to Palestine as "my escort." She had not coerced them into going. Rather, they had concluded that "Palestine was where they should be."[33] That may have been true of Sheyna. Morris's decision seemed to have been based less on his love of a place and more on his love for a woman who believed that Palestine was where *she* should be.

Some of Golda's biographers contend that her American

years were a cipher, leaving no ostensible impact on her. They assert that, rather than live in the "real" America, she had inhabited a poverty-ridden ghetto of Yiddish-speaking eastern European Jewish immigrants who interacted primarily with one another.[34] But that misses America's impact on her. She attended school precisely when American civil society was dominated by the "Americanization movement," with its ideal of *e pluribus unum*, or the "melting pot." Her teachers, who were almost certainly non-Jews, taught their immigrant pupils not just reading, writing, and arithmetic but "how to be an American." Instruction included classes on citizenship and elaborate pageants celebrating the remaking of the immigrant into the "American."[35] She learned what she described as an "understanding of the meaning of freedom and awareness of the opportunities offered to the individual in a true democracy." In America, much to her astonishment, officers on horses can protect you, even if you are a Jew. Your father, a Jew, could march with all the other carpenters and laborers to celebrate America. An American-born Jew might not notice anything distinctive about this. An immigrant with her background could not miss it. Late in her life, in an interview with Italian journalist Oriana Fallaci, she acknowledged that America, despite its "many faults [and] many social inequalities," was nonetheless a "great country, a country full of opportunity, of freedom." In that interview she posed what for some people, but not for her, might have been a theoretical question. "Does it seem to you nothing to be able to say what you like, to write what you like, even against the government, the establishment?" She, whose family fled Russia because of the dangers raised by her sister's discussion group, mused, "For America I feel such a gratitude."[36]

Golda also internalized the American version of the Protestant work ethos of the self-made (wo)man, the person who through dint of her own hard work and efforts pulls herself up

by her bootstraps. A person can change her life through hard work and perseverance. She melded this with her Zionism. When she left, the American chapter of Golda's life drew to a close. America was no longer her home. But she took a substantial legacy with her.

2

The Kibbutz Years: A Dream Unfulfilled

ON MAY 23, 1921, the SS *Pocahontas* sailed from New York with a group of twenty-two young Americans, including Golda, Morris, Regina with husband Yossel, and Sheyna with her children. Golda recalled the trip as a "nightmare." The crew had been on strike over unpaid wages and the ship's sorry conditions. Within a short time after leaving New York, the vessel's operating system broke and someone tampered with the passengers' food, making it inedible. Needing repairs, the ship headed to Boston, a voyage that took over a week. (One might have walked faster.) Some of the Zionists, thinking it unwise to continue, disembarked. Sheyna's husband, having heard about the ship, telegrammed her begging her to return. Golda noted that she "of course" refused to do so. Finally they sailed, but their travails persisted. The engine room flooded. Mysterious fires broke out. The chief engineer, with whom some of the sailors had fought, went missing. He was said to have committed suicide, but

when his body was found, it was discovered that his hands had been tied behind his back with a pipe between them. At last, six weeks after leaving New York, the ship limped into Naples.

The group's troubles were not over. Their destination had been Jaffa. Because of the shallow harbor, ships would drop anchor at sea and Arab boatmen would row passengers ashore. However, in the wake of the Arab riots, the boatmen refused to transport Jews. The group scrambled for alternatives, eventually deciding to sail to Alexandria and from there to travel by train to Tel Aviv. Just as they were about to board the new ship, they discovered that their luggage, holding everything they had brought to start their new lives, was missing. Some of the group proposed waiting until their possessions arrived. Golda announced: "You can wait for baggage; I won't." The group boarded the boat without their belongings.

Among the passengers was a cohort of Lithuanian Labor Zionist pioneers. The two groups were of the same age and, more important, shared the same ideological perspective. Nonetheless, relations between them were frosty. The Hebrew-speaking Lithuanians, who had trained at a Zionist agricultural farm, considered the Americans soft, spoiled, and, in the unkindest socialist cut of all, "bourgeois." The Americans seemed to agree. Golda envied the Lithuanians' "dedicated, austere and determined" demeanor. Regina's husband Yossel, feeling "small and unworthy," described the Lithuanians as the "new Jews. . . . Young people with hard muscles, who can sleep on the hard decks, eat hard bread made of bran, and who speak Hebrew with the hard, Sephardic accent. Real Hercules who are ready to build a land on just foundations with their backs. . . . Splendid human material which would be the pride of any people."[1]

To conserve funds the Lithuanians opted to sleep on the open deck. In an attempt to prove their bona fides, Golda told her fellow Americans that they should relinquish the reservations they had for "luxurious" third-class cabins and the hot meals

that accompanied them and join the Lithuanians on deck. As *halutzim* (pioneers), sacrifice was their duty. She seemed undeterred by the fact that Sheyna's two small children were among those who would now endure this open-air arrangement. Their mother was not happy with the results of Golda's exhortations. She wrote Shamai: "I can't bear to stand in line and wait till something [to eat] is handed out. I can't bear to see how Haimke [her son] has to eat out of the same dish with another child." Despairingly, she wondered, "What am I doing to them [her children]? To whom and to what do I lead them?" Despite these sacrifices, some of the Lithuanians apparently remained unimpressed with the Americans. Golda's perception was more rhapsodic. "The stars came out; we sang Hebrew and Yiddish songs together and danced the hora."[2]

Finally, on a scorching July day after a long train ride from Egypt, they arrived in Tel Aviv. In contrast to their rosy imaginations, it was hot, dusty, and dirty. They were part of what became known as the Third Aliyah, the thirty-five thousand Jews who arrived between the years 1919 and 1923. Unlike many of their fellow immigrants, they had come without the organizational or financial support of a social or political group. Consequently they had no one to ask for help with housing or jobs. When the train pulled into the small Tel Aviv station, the only one there was the proprietor of a small hotel who assured them that they would be comfortable at his establishment. Golda, Morris, Regina, Yossel, and Sheyna and family, along with a few other members of their group, decamped on foot to the inviting-looking pension. They quickly discovered that their rooms were infested with bedbugs. Sheyna's attempts to buy fruit at the market for the children was unsuccessful. Everything was covered with flies, and when she did find a few edible items, she discovered there were no paper bags to hold purchases, which was the norm in America. Even Golda found everything primitive and wondered if their Lithuanian shipmates had correctly assessed

them as too soft for this endeavor. To compound matters, they soon encountered American pioneers who, overwhelmed by life in the Yishuv and frightened by the Arab actions, were returning home. She must have worried that Morris would also sour on staying. It did not help that, upon arrival, their good friend Yossel suggested that having reached Zion, now they could return to America. (His suggestion notwithstanding, he remained there for the rest of his life.) She, of course, had no doubts.

In a letter to Shamai, who was in Chicago earning funds to support his family's Zionist endeavor, Golda decried Yossel and his doubts. "Sitting in America and talking about hard work is easier than doing the work." With a certainty of opinion that surprised no one who knew her well, she declared that Zionists who truly wanted their own land must come, must remain, and must "be ready for anything."[3] For her there were no second thoughts, no ideological uncertainties. There were only absolutes. Eventually Morris would also express his wish to return but, like Yossel, he never did.

Matters improved when Golda, Morris, and Sheyna and her children moved into a small, two-room apartment with a few members of their group. And finally, two months after they had arrived in Tel Aviv, their luggage appeared. Their joy was quickly extinguished when they discovered that much had gone missing. Nonetheless, they transformed their trunks into tables, dressers, shelves, beds, and sofas. Morris, the accomplished sign painter, decorated the walls, significantly enhancing their surroundings. His beloved phonograph, which had survived the journey, was given a place of honor. It quickly became a social magnet, drawing visitors and neighbors to enjoy the music and drink tea. For years thereafter people would tell Golda: "I used to come to listen to your phonograph records." Decades later, her grandson met someone who recalled, "Your grandfather lent me stacks of his records."[4]

Soon they discovered pleasant, less dusty—almost green—

parts of the city. Morris found work with a British company and, no longer disheartened, wrote his mother of his joy at being in an all-Jewish city. A relieved Golda was gratified to be in a place where Jews could "live as of right, rather than sufferance." She declared herself "profoundly happy." But Tel Aviv was not their destination. Golda equated Zionist fulfillment with physically building the land in a cooperative venture, that is, joining a kibbutz. Letting others do the dirty work for you was not her kind of Zionism. Golda chose Merhavia, a kibbutz settlement in the Emek (the Jezreel Valley), where the Zionist organization had bought land to create the centerpiece of its agricultural enterprise. She knew that a number of Americans had settled there. This was where, she declared, they could express themselves as "Zionists, as Jews, and as human beings."[5]

Had the group investigated further, they might have discovered that while kibbutzim might be the epitome of Labor Zionist ideology, this one, with its shaky finances and high membership turnover, was a poor choice for realizing that ideal. Nonetheless they submitted their applications, which Golda anticipated would be seamlessly accepted. In the interim, they found temporary jobs. Morris was a bookkeeper at a British firm. Golda was offered a well-paying job as a high school teacher. However, people she encountered in Tel Aviv—one assumes they were fellow socialists—dismissed teaching as "too intellectual an occupation for a would-be pioneer." Fearing that kibbutz members would think she had come to Palestine "to spread American culture" and on the basis of the same reasoning that had led her to sleep on the ship's deck and eat cold meals, Golda declined the job. She chose to give private English lessons instead.[6] Rejecting a teaching position because others might consider it too intellectual seemed like a strange decision for someone who, at age fourteen, had run away from home because her parents did not want her to continue her own education. But being accepted on a kibbutz was what counted.

Apparently she had assessed matters accurately. Their membership application was rejected. Some kibbutz members, whose idealism seemed to have metamorphosed into fanaticism, believed that Golda's choice to teach English in Tel Aviv rather than do physical work indicated that her commitment to Labor Zionism was incomplete and, even worse, that she was "spoiled." In a reflection of the fact that even socialism did not obliterate prejudicial presuppositions, some members did not want an "American girl" who, they assumed, would not do the arduous physical work demanded on the kibbutz. Ironically, if any Meyerson was a questionable candidate, it was not Golda but Morris, who was far less interested in kibbutz life.

Finally, in the autumn of 1921, Merhavia accepted them provisionally. Aware of the members' suspicions, Golda arrived determined to prove that she could be as rugged as any kibbutznik. Attempting to prove her bona fides as she had on the ship, Golda was indefatigable, digging holes in the hard soil for planting saplings, moving rocks, and laboring in the poultry yard. After an arduous day, she often felt too exhausted to go to the dining hall for dinner. Nonetheless she went, fearing that, if she did not it would confirm the members' suspicions about the weakness of that American girl. Eventually the other members noticed her abilities. Soon she was selected to attend agricultural school to study poultry-breeding techniques. Thanks to her innovations, egg production increased markedly and the kibbutz became a model for others.

Eventually they were made full members, an acceptance that may have been facilitated by the prized phonograph. When Golda and Morris briefly visited Tel Aviv, where Sheyna was still living, they took back the record player they had left in Sheyna's possession. In her memoir, Golda mentions the incident in passing. Apparently Sheyna experienced it differently. Stuck at home in a tiny apartment with small children and no husband, listening to music was a great comfort to her. In her

own memoir, written long after the event, she describes losing the machine with an immediacy that reflects her pain: "How could one have the heart to take our single musical instrument from us?"[7] Golda clearly believed it was more important for the kibbutz to have it. It proved so popular that Golda speculated that the members would have preferred to have it rather than its owners or, as she often put it when speaking about peace with Arab nations, "the dowry without the bride." They wanted the dividends peace would bring, but not the reality of Israel.

Throughout her life, Golda remained convinced that the kibbutz was the "ideal form of society . . . no competition, no exploitation. A human being is accepted and judged and participates in the life of the society not according to what kind of work he has, but because he is a human being."[8] As is often the case when a person writes about something or someone they love deeply, blinders obscure the full truth. Golda's idyllic description of the kibbutz may have applied to men, but not to women. From the earliest days of its creation, the kibbutz had patriarchy woven into the fabric of its culture. The women who joined, anticipating that they would be treated as equal to men, found reality to be otherwise. When applying for membership, many women were told that the kibbutzim were not prepared to accept women. Those who were accepted found that the ideology of "equal opportunity for all" did not apply to them. One of the original women members of Merhavia recalled longing to "join the line of the *haverim* who were driving the first Jewish plough through the Emek." Instead she was assigned to work in the kitchen. Between meals, she recalled having to "wash our comrades' clothes."[9] Another woman described the male *halutzim* as believing that these young women's job was to serve them. Rahel Yanait (Ben-Zvi), a much-respected pioneer who helped create a network of farms for training women in agriculture, described how these women workers, who passionately wanted to work the land, "suddenly found themselves thrust

aside and relegated once more to the ancient tradition of the house and the kitchen." The men were building new Jewish identities by "uniting themselves with the land," while the women were *on* the soil but not part *of* it. When kibbutz Kinneret received a contract to construct the road to Tiberias, kibbutz member Rivka Danit wanted to participate. The men told her that "the work was too much for a girl. It wasn't nice for a Jewish girl to be working on the open road." One man contended that a woman building a road constituted "a national crime." When Yehudit Edelman of kibbutz Ein Harod applied to the Yishuv's Workers' Council for a job, she was told that there was "no ladies' work" available. She assured the official that she would do "any kind" of work. His response was unambiguous: "The pioneers don't want girls."[10]

Golda had a different perspective. Presaging her somewhat tense relationship with women who today might be described as feminists, she wondered, "Why is it so much better to work in the barn and feed the cows, rather than in the kitchen and feed your comrades?" One answer to her query should have been obvious. The women thought it was better because the kibbutz thought it was better. Those who worked the soil received professional training and had a higher status among fellow *halutzim*, far higher than those who performed domestic tasks. The contracts kibbutzim signed with the Zionist Organization classified agricultural workers (men) as doing "productive" work and domestic workers (women) as performing "nonproductive" work. On these contracts, men were listed as kibbutz members. Women were omitted. Not surprisingly, there was a pay differential. On kibbutz, Golda earned 6 Egyptian pounds; Morris earned 19.[11] Labor Zionism promised to revolutionize the traditional Jewish occupational structure, but that change clearly did not apply to household duties and childcare, which remained women's work.

In one of her earliest multiple biographies of Golda, Marie

Syrkin, who became one of her closest friends and confidantes, offered a more skeptical perspective on these women's struggle for equality. One can safely assume it came from Golda. These women's belief that women must be equal comrades in all things was unrealistic. They demanded to do physical labor to which they were unaccustomed and totally unsuited. Then, when they failed to measure up to the men, they engaged in "self-flagellation," which left them injured and unfulfilled.[12] Then they blamed the men. The results, Syrkin—and Golda, by proxy—concluded, were disastrous. While the description may have applied to some women, it was also revisionist history.

Golda, determined to differentiate herself from the women who were rankled by kitchen work, insisted that she enjoyed it. She took pride in having improved the quality of the food and the ambience in the Merhavia dining room. She recalled with undisguised glee her most renowned innovation: tablecloths. On Friday nights, kibbutz members would shed their workday clothes. The men would put on pressed shirts and clean slacks and the women would don skirts and blouses. Golda decided the dining hall needed similar dressing up. "My most celebrated 'bourgeois' contribution . . .—about which settlers all over the Emek talked despairingly for months—was the 'tablecloth' (made from a sheet) that I spread on the table for Friday night suppers—with a centerpiece of wild flowers yet! The members of Merhavia sighed, grumbled and warned me that I was giving the kibbutz a bad name."[13] She may have enhanced the ambience, but her depiction of the reactions to the sheets qua tablecloths suggests that, at least in retrospect, she drew even more satisfaction from the commotion they caused.

Fifty years later, after Golda became prime minister and one of the most admired women in the world, there were kibbutz members who still earned her enmity. Notably, all of them were women. In her memoir, she recalled that the kibbutz women would "dress up" on Friday by ironing their clothing. She, how-

ever, chose to iron her work dress every day, thus earning their disdain for this "bourgeois American." They also complained when she altered things in the kitchen. Kibbutz members often had only one utensil, either a fork, spoon, or knife. This made peeling the herring at the midday meal a difficult, if not impossible, task. Golda decided that the women in the kitchen should peel the fish prior to serving it. The "other girls" complained, leading her to admonish them. "What would you have done in your own home? . . . Your own family table? This is your home! They are your family!" Then, after waxing rhapsodic about how completely at home she felt on the kibbutz because these were "my kind of people," she noted that there were "of course" people on the kibbutz with whom she clashed, particularly some of the "veteran women" who regarded themselves as "entitled to lay down the law on how one should or should not behave."[14] It is worth noting that both her ardent fans and staunch critics describe her governing style as prime minister as laying down the law, firmly and definitively. Syrkin interviewed some of the Merhavia woman, who showered "superlatives" on Golda and her influence on the kibbutz. One described a rainy day when they could not work outside. The women sat shelling nuts. While they worked, "Golda sat looking a bit regal, like always, telling us things." Syrkin, Golda's loyal friend and fierce defender, interpreted this as indicative of "a natural dignity of manner which would serve the future ambassador and minister in good stead." Others, especially her critics, of which there was no dearth, might have seen in it a certain imperiousness and sense of knowing "better."[15]

But Golda made her mark and was elected first to the kibbutz's steering committee and then to its executive committee. Within a year of arriving, she became the kibbutz's delegate to the newly formed General Organization of Hebrew Workers in Palestine, otherwise known as the Histadrut. The Histadrut was then a fledgling entity that operated as a national labor or-

ganization, with representatives from all the political parties. David Ben-Gurion, who had assumed its leadership, wanted to transform it into something far greater, a centralized unit that would oversee the building of the Yishuv. Since the Palestinian economy was then incapable of providing jobs for the workers in the Yishuv, much less for potential immigrants, he wanted the Histadrut to fill that void. In order for the Histadrut to be what Ben-Gurion envisioned, its constituent organizations had to be subservient to it, rather than the reverse.

One of the constituent entities was the Women Workers' Council (WWC). It was created by Ada Maimon and a number of other *haluzot* who were dissatisfied with the Labor Zionist institutions' policies toward women. But the WWC had a problem in making its voice heard within the Histadrut. Histadrut representation was assigned and leaders were chosen based on constituent political parties. The WWC, however, was not a political party; its membership cut across party lines. Consequently, its power within the budding organization was limited. Its leaders attended the Histadrut's founding convention as passive observers, without voting or speaking rights. The result of the WWC's ambiguous relationship with the Histadrut was quickly evident. Of eighty-seven people elected to the Histadrut leadership, only four were women. The convention addressed a wide range of issues, but problems facing women were not among them. A frustrated Maimon threatened to form a separate women's association. This was precisely what Ben-Gurion, who was intent on keeping the various affiliated councils, workers' federations, and agricultural associations from operating independently, wanted to avoid. He arranged that two leadership council seats be reserved for WWC representatives.

In September 1922, Golda left the kibbutz for Haifa to participate in the second WWC meeting. The organization already had six hundred members. Maimon, anxious to make this gathering a working meeting, picked thirty-seven women attendees

from throughout the Yishuv, Golda among them. At the end of the meeting, having clearly impressed the other participants, Golda was chosen for its seven-member leadership committee. She had arrived in the Yishuv only one year earlier. After the gathering, Maimon expressed her complete confidence in this "American girl." Rapidly giving concrete expression to that confidence, she arranged for Golda to be a WWC delegate to the second Histadrut convention. (This gathering is remembered for a number of things, among them the arrival of the Nobel laureate Albert Einstein, who was visiting the Yishuv. During his brief stop in Tel Aviv, he came to the cinema where the Histadrut gathering was being held.)

In his speech, Ben-Gurion briefly addressed the issue of the Women's Council. Acknowledging that women within the labor movement had not achieved full equality, he suggested that once this problem was resolved, there would be no need for a separate women's entity. Later in the gathering, Golda's speech also addressed the relationship between the Histadrut and the WWC, the group she represented. She echoed Ben-Gurion. The Histadrut may have failed women, but once this was rectified, an entity such as the WWC would be superfluous. Sociologist Dafna Izraeli divides the WWC's leadership between the "radicals" and the "loyalists."[16] The older, more veteran leaders, such as Maimon, were the radicals who believed that the male leadership of the Histadrut was unconcerned about equal treatment for women, particularly in the field of training, employment, and leadership opportunities. Women's organizations were therefore not stopgap measures but structural imperatives, necessary to keep women's issues on the Histadrut agenda. Discrimination against women was so deeply ingrained in society that permanent mechanisms had to be in place to ensure that women could become a positive creative force. Golda disagreed. She did not deny that women faced particular obstacles, including being denied access to work opportunities, training programs,

and leadership positions, but she believed that those obstacles could be eliminated. Once these issues were resolved, she insisted, special women's institutions would no longer be necessary. While some might be inclined to interpret this as a savvy political move on Golda's part—siding as a "loyalist" with the men who had the power—it may not have been that at all. She had a deep-seated and abiding faith in Labor Zionism. She had upended her life because of it. She was sure that the ideology, rooted in the notion of equality, would ultimately resolve this matter. She did raise an additional issue, one that would personally haunt her: the dilemma of the working mother. Was she harming her children by working? Her maiden speech was a harbinger of two ongoing tensions that would endure for much of her life: her relationship with feminists and the pull between career and family. Neither would ever be resolved.

The impression Golda left on the delegates emanated less from what she said than from how she said it. One the attendees recalled how silent the room became during her speech. Golda's easy sociability and beauty impressed a number of the members. One delegate contrasted her appearance and dress with that of the WWC stalwarts. He praised her dress, with its neckline embroidery, and complained about the shapeless dresses worn by radical women. (There seems to be no record of the men's garb.) The delegates' faith in her and her conciliatory vision was evident when they elected her to one of the two seats allocated to the WWC on the Histadrut council. Maimon was chosen for the other. Golda was already leapfrogging over veterans.

Her prominence continued to grow. A few months later, Merhavia sent her as its representative to a Histadrut gathering at Degania, the oldest kibbutz in Israel. Once again she was interacting with people who would play critical roles in building the state, including future prime ministers Ben-Gurion and Levi Eshkol, presidents Yitzhak Ben-Zvi and Zalman Shazar, and Histadrut leader and theoretician David Remez. These men

would establish both the ideological and substantive foundation of the Jewish state. Golda would learn a tremendous amount from them, and they in turn would boost her profile and her position within the leadership echelon, though she was never considered their equal in stature. She also eventually became the lover of three of them: Shazar, Remez, and Ben-Zvi.

At this meeting all did not go entirely smoothly for Golda. She addressed the gathering in Yiddish rather than Hebrew, in which she was far less proficient. (Her critics would claim, not very kindly but with some justification, that the situation never improved. Abba Eban, a future foreign minister and someone with whom she had a less than harmonious relationship, would contend that she had a Hebrew vocabulary of only five hundred words. But why, he is said to have wondered, did she not use all of them?) Some participants harangued her for relying on the language of exile. Later in life Ben-Gurion acknowledged that he had once shown a similar zealotry against Yiddish, but was now glad that his children had access to it.[17] Proceeding with her speech, Golda raised the same question that she had been asking the women of Merhavia. Why is work in the barn and fields preferable to kitchen work? Golda omitted a crucial caveat in her speech, one that Maimon had included, namely, that domestic tasks were not the exclusive responsibility of women. Women should be free to work in the barns as well as in the kitchens. And men should also be able to make this choice. Forty years later Golda acknowledged that she should have added this point, suggesting that she did not because it was common sense. The problem with this ex post facto explanation is that Golda was already aware of what a sensitive issue this was for many women.

She may have been thriving in the political world of the Yishuv, but at home matters were rather bleak. Golda loved the camaraderie of kibbutz life. Morris abhorred it. He preferred a private and contemplative lifestyle. Initially he had been mes-

merized by the flora and the physical beauty of Merhavia. His letters to his mother had extolled the joy of physical labor and "the wonderful physical feeling of fatigue after a day's work in the open fields."[18] Those sentiments had dissipated. Golda knew how unhappy he had become. "He couldn't stand eating at the communal table. He couldn't stand the climate and the feeling of being part of a community." In contrast, she so loved the communal atmosphere that, after eating and working with her fellow kibbutzniks, she would seek out additional opportunities to be part of the larger whole. She would go to the kitchen in the middle of the night to "chat and eat" with the men on guard duty.[19] The distance between the young couple continued to grow until Golda had to choose. She wanted a child, but Morris refused to raise one in a communal setting. Years later, in an interview with a British journalist, Golda summarized her dilemma: "Morris had to follow me to Palestine to have a wife. I had to follow him [from the kibbutz] to Tel Aviv to have the child."[20] Though her departure would ultimately lead her to the pinnacle of Israeli public life, her failure to make a permanent home on the kibbutz rankled her for the rest of her life.

Their return to Tel Aviv was not triumphant. A few years prior, they had left for Merhavia as a young couple, anticipating a great life adventure, one that would allow them to realize the ideal of building the land and become genuine *halutzim*. They arrived back in Tel Aviv with this adventure derailed and their personal relationship in tatters. Feeling adrift and with no visible means of support, she and Morris were compelled to move in with Sheyna, whose approval she continued to crave. Shamai had arrived from Chicago. He and Sheyna were both working, she as head of the kitchen at Hadassah hospital and he as a bookkeeper. They had a home with indoor plumbing and enough money to live on. Golda, in one of her first letters from Tel Aviv, had insisted that "genuine Zionists" must come to the Yishuv and

"be ready for anything."[21] It is doubtful that she was ready for this setback.

She was offered a job by David Remez, the head of the Histadrut's construction effort, which eventually became known as Solel Boneh. He appointed her to be the cashier in the office responsible for distributing the workers' wages. It was neither intellectually nor organizationally challenging. Worse yet, it was emotionally searing. The office was often unable to pay the workers and Golda had to tell them this. She attempted various solutions, including relying on a private moneychanger. He charged an exorbitant fee, so that did not resolve matters. She was glad when Remez found work for Morris in Jerusalem, where Solel Boneh was beginning to construct the Hebrew University's Mt. Scopus campus. Shortly after their move, Golda gave birth to their first child, Menahem.

Her four years in Jerusalem were marked by motherhood, poverty, loneliness, and isolation. A few months after arriving in the city, Golda, possibly wanting to test a separation from Morris, took her infant son and returned to Merhavia. The kibbutz, which had never been a financial success, was now in even direr straits. Some kibbutz members resented her arrival. Without a male partner and with an infant, she did not increase the number of "productive" workers. Her presence only meant more mouths to feed. She left after a few months, attributing her departure to having made her choice. "I was married to a man I loved. . . . I wanted to remain his wife and to make him happy."[22] She returned to Jerusalem, but neither the marriage nor the happiness was to be.

In an attempt to augment Morris's salary, which arrived only sporadically from Solel Boneh, she did laundry and washed the diapers from the children's—there was now a daughter Sarah also—day care center. The family could not afford to properly heat their cold, damp Jerusalem apartment, and they suffered

an inadequate diet—they owed so much to the grocer that he refused to sell them bread and margarine on credit. In a humiliating yet lifesaving gesture, Sheyna would periodically send them fruit and vegetables. Even with this augmented diet, Golda feared that she was permanently damaging her children's health. All this was exacerbated by an overwhelming sense of isolation. Then David Remez, who had learned about her situation, threw her a lifeline. He was now director of the Histadrut's Executive Secretariat Committee. In what she described as a chance meeting in Tel Aviv—and others claimed was a tryst that was part of an already ongoing relationship—he asked her to become co-secretary-general of the General Council of the WWC. The job was in Tel Aviv.

Golda's move to Tel Aviv marked the end of her marriage. When a marriage ends, one often seeks a culprit. Many of Golda's biographers point to Morris, whom they depict, unfairly, according to Menahem, as "at best weak and dependent, at worst feckless . . . indecisive . . . always unsuccessful."[23] At bottom, while there may have been some truth to such assessments, these two people were simply wrong for one another. He was a private person; she was a public person. He loved solitude; she loved the madding crowd. She blossomed in the political turbulence associated with the enterprise of building a national Jewish home; he found the effort tiresome and often petty. She wanted to live in Palestine; he believed he could change her mind. Those closest to her knew that changing her mind about most things, in particular Zionism, was a Sisyphean task. Ironically and sadly, had their personalities been reversed—he the public person and she the private one—the marriage might have had a better chance of lasting.

3

Emissary to America

GOLDA'S MOVE TO TEL AVIV came at a most auspicious moment. The kibbutz may have been the "ideal" of Labor Zionist ideology, but it was in the Histadrut offices that the people who would shape the Jewish homeland were found. She was now part of that endeavor. The Histadrut would eventually become a massive entity, a state within a state with a hand in every sector of Israeli society. It would run a bus company, shipping line, egg and milk cooperative, newspaper, health-maintenance organization, cultural institutions, and much else. Israelis nicknamed its headquarters the "Kremlin." However, in 1928, when Golda arrived to assume the job of WWC co-secretary, it consisted of merely a few rooms with a couple of typists and one telephone.

A staunchly socialist entity, it determined salaries not on the basis of the job but on how many dependents a worker had and their job seniority. The woman who served the morning tea was the mother of seven children and had been at the organiza-

tion longer than Golda. Consequently, she earned a higher salary. In addition to this expression of socialist principles, the Histadrut adhered to a canon of austerity. Luxury was eschewed. Dress was simple. Men wore open-neck shirts and khaki shorts, the style favored by the British military stationed in tropical climes. The women wore plain skirts or dresses. Any form of makeup was forbidden, unless it was worn by a visiting tourist.

Golda immediately enjoyed a profound sense of camaraderie. Regarding her fellow workers, she writes, "We were, in the most literal sense of the word, *chaverim* [comrades] . . . we shared the same basic outlook on life and the same values." Even more important, they shared a common goal. "We were creating a society, not just a trade union."[1] That camaraderie was in stark contrast to the social and professional drought she had endured during her Jerusalem years. Engaged in building a state on staunchly socialist principles, she had found the sense of purpose she had sought in Merhavia. She was surrounded by ideological soul mates whom her son Menahem described as an "adopted family," one that could always be called upon "to help, to rally, to keep a secret and to counsel."[2] Five decades later, he remained in touch with the next generations of this "family." But Golda's new job offered more than a desperately needed social lifeline. She was working with Israel's "Founding Fathers" (and a very few solitary mothers). She was part of an ongoing conversation about every aspect of this national home, from the minute to the most significant. A woman who a few months earlier had been enduring a lonely and poverty-stricken existence was now living in what some might have called Gan Eden.

One should not paint too rosy a picture of the relationships among those at the Histadrut. Golda acknowledged, "We argued among ourselves all the time about details and techniques." Ben-Gurion biographer Tom Segev puts it more strongly. These leaders "hated and envied and thwarted one another."[3] While Segev may somewhat overstate the case, these fights were fierce and

concerned matters large and petty. Golda quickly learned to negotiate those political waters, as evidenced by her meteoric rise up the leadership ladder, one that began a short time after her arrival at Histadrut headquarters.

She was not the only woman in the leadership orbit. However, once again, she leapfrogged—or, more properly put, *was* leapfrogged by Remez—over the others, despite the fact that they had come to the Yishuv well before her. When Golda was giving soapbox speeches on Milwaukee street corners, these women were establishing women's agricultural training centers and cooperatives, smuggling arms, and most of all, working to ensure that women were equal participants in the Zionist enterprise. Though six years earlier these veterans had first spotted her talents and brought her into the echelons of leadership, she was now surpassing them. While she certainly was talented enough to warrant that rapid advancement, her view of the place of women's organizations within the Histadrut was far more amenable to the views espoused by Ben-Gurion, Remez, and other male leaders. Golda had already opined in 1922 that women's issues were a transitory problem best resolved by simply adhering to the principles embedded in Labor Zionism. Now the men leading the Histadrut asked her to chair the WWC. There were probably a multitude of reasons for choosing her: her innate talent, her view of the place of women's groups, and her intimate relationship with Remez.

In her newly appointed leadership role, she soon went to Brussels together with other prominent Histadrut leaders, including Shazar, Ben-Gurion, Ben-Zvi, and Yosef Sprinzak, to attend the Socialist International Convention. She had arrived in the Yishuv seven years earlier. Now she was joining her most important senior colleagues at a conference of leading socialists from around the world.

Even as she was finding her way in the Histadrut's leadership, the organization faced an existential crisis. It needed an

infusion of money. Whence would this help come? Turning to world Jewry, America in particular, seemed to be an answer. However, for many Labor Zionists this was an anathema. First of all, it smacked of the much despised *halukkah* system. For generations religious Jews in Palestine had depended on other Jews for support. The recipients contended that because they were engaged in fulfilling a religious precept—living in the land of Israel—other Jews were obligated to support them. Charity collectors would fan out in the world to gather funds. Everything about this stood in diametric opposition to the most fundamental aspects of Labor Zionism. Second, America was the epitome of the capitalist bourgeoisie. How could people living in such a society be asked to help? However, reality trumped ideology and rendered such opposition an unaffordable luxury. Ben-Gurion agreed. He had once thought American Zionists would immigrate to the Yishuv. He now recognized that he had been too optimistic.

However, he recognized that there was another potential resource in the American Jewish community: women, particularly those associated with Pioneer Women, the Labor Zionist women's organization. PW had been founded a few years earlier when Rahel Yanait (Ben-Zvi), one of the Yishuv's veteran women leaders, needed funds to dig a well adjacent to a women's agricultural school and tree nursery in Jerusalem. She turned to a small group of women in the United States who were sympathetic to Labor Zionism. These American women had previously worked with Manya Shochat, one of the earliest emissaries from the Yishuv, to raise money for women's agricultural projects. Shortly thereafter, in 1925, the same group of women founded PW, an autonomous socialist Zionist women's organization. Though PW had the same ideological goals as the male-dominated PZA, the male leadership opposed its creation. Echoing familiar critiques, they insisted that there was no need for an autonomous women's organization because PZA was committed to women's

equality and within the Labor Zionist context women were already emancipated. The women pointed to the small number of women who were PZA members, the absence of any women in leadership positions, and the way women were relegated to childcare and housekeeping duties. (When Golda volunteered at the New York headquarters she was handed a broom and told to sweep the floors. One of those who was in the office with her recalled, "She did a good job.")[4]

Ben-Gurion recognized that PW members were an undertapped resource. He envisioned a campaign that would appeal to them. However, in contrast to their earlier efforts, any funds generated by such a campaign would go directly to the Histadrut, not the WWC. To Ben-Gurion it was obvious who should coordinate this effort, as he wrote in his diary in September 1928: "Golda." She possessed the necessary linguistic skills, personal charisma, life experience, and to use a term that she would certainly have scoffed at, the emotional intelligence to connect the American Jewish community to the Yishuv.

Golda arrived in New York on December 1 for a six-month stay. She quickly made her mark. Within a short time after arriving, she addressed the National Labor Committee for Palestine, also known as the *Gerverkshaften* campaign, and its six hundred delegates. As had been her practice since her speech at the Milwaukee textbook rally, she spoke extemporaneously. Rather than an ideological harangue, which characterized many of the other speakers' presentations, she told a fable, painting a picture about two groups of émigrés from Russia. One traveled west to the United States and the other east to the Yishuv. No one thought the twain would ever meet. But the *haverim* in Palestine kept digging a tunnel to connect to their fellow Jews in the United States. Describing the sound of the hammers breaking down the wall between them, she declared that "the union . . . was coming." The *Morgan Journal* claimed that she "brought the convention to its highest pitch of enthusiasm."[5] Clearly, she

had sensed correctly that what the delegates needed was a vision of the possible, not an ideological jeremiad. Moreover, the portrait that she drew was of a partnership. This would become the leitmotif of the message she would transmit to American Jews for the next five decades. We are in this together. You are our partners.

This was the first of many trips she would make to the United States during the next few years. She adhered to a grueling schedule, traveling from city to city, delivering speeches, spreading the Labor Zionist message, and engaging in the ever-necessary fundraising.[6] Her Americanized English was an invaluable asset that most other emissaries lacked. After her first visit, she returned to the Yishuv in the middle of 1929, but was soon off on another trip, this time to Zurich for the sixteenth World Zionist Convention. At this meeting, WZO president Chaim Weizmann who, like Golda, had been a child in Pinsk, presided over the creation of the Jewish Agency. The Histadrut was building the future state's infrastructure, while the Agency served as its quasi-government during the Mandate period. Upon her return to the Yishuv, Golda continued to move up the leadership ladder. In January 1930 Ben-Gurion had overseen the merger of two Labor Zionist parties, Ahdut Ha'avoda and Hapoel Ha'tzair. The new party, Mapai, now the largest political bloc in the Yishuv, controlled the Histadrut, whose membership was growing rapidly. Golda joined its fifteen-member central committee. She quickly became the Yishuv's most valuable asset to foreign women, Jews and non-Jews. In June 1930 she gave a short speech at the Conference of Socialist Women in London. Ben-Gurion, who was also in London, wrote to his wife that though the speech was just a few minutes long, he heard it had "created a great impression."[7]

Golda was scheduled to go home after the meeting, but Ben-Gurion, excited by the reports about her, urged her to remain for the Imperial Labour Conference, a gathering of trade

unions from across the British Empire. There were many Arab delegates present. She was scheduled to speak, but the Zionists present, fearful that the Arab delegates would stop her, urged her not to do so. They warned her that the reception she would receive would be less than hospitable. Even Ben-Gurion wondered if it was wise. But Golda persisted. She strongly attacked British policy regarding the 1929 riots. Britain had, she argued, abandoned its Balfour Declaration commitments. Ben-Gurion was "stunned by the force of her speech" and the way it "shocked the conference." He described the moment in a letter to his wife Paula. "She spoke proudly, forcefully, bitterly, painfully and in good taste. Although I have heard of her success in the Women's Conference and at other meetings arranged for her by the Labour Party, her words came to me as an enormous surprise."[8] On their ride back to the hotel, Ben-Gurion told her that until that day, he thought "we had only two people who could explain things to the outside world and that was Weizmann and Shertok [Sharett] . . . but *you.*" Golda, engaging in a bit of low-keyed self-promotion, told him that he "underestimated" her. Publicly lauding her in *Hapoel Hatzair,* he described how he "trembled at her daring words. Her speech shook the convention. She spoke with genius, assertively, bitterly, with hurt and sensibly."[9] Such dramatic public praise from Ben-Gurion made it clear that her public career was arcing upward.

In the fall of 1931, Golda headed back to the United States for yet another fundraising tour. Having been apart from her children so often in recent years, she had resisted going. But Mapai leaders were not to be dissuaded. While in all likelihood it was true that she did not want to leave her children, such resistance was to become a pattern over the course of her career. She would be offered an important job but would decline. Told no one else with her attributes could be found to replace her, she would reluctantly accept the assignment. Although she may indeed have been reluctant to travel, this resistance was her way

of adhering to the Labor Zionist ethos that you did not seek prominence or greatness, only accept it when it was thrust upon you. She was well aware that she was capable, but to say so outright might have seemed inappropriate for a socialist and, even more so, for a woman. Remez told his colleagues that when it concerned America, she was indispensable: "We have seen that people we thought would succeed, did not succeed. There were doubts concerning Golda's candidacy, and now it is very difficult to come to America after Golda."[10]

Once again she crisscrossed the United States and Canada, speaking not just to Jews interested in Zionism but to non-Jews as well. One of the most important groups she addressed was the International Ladies Garment Workers' Union. (She was on the agenda on the same day as socialist icon Norman Thomas.) The attendees received her warmly and, more significantly, voted unanimously to support the Histadrut. Given the economic depression then prevailing in America, this was a notable development.

Within a short time, her trip was interrupted by a telegram from Morris informing her that their daughter Sarah, who had struggled with a chronic illness, was ill. Golda immediately arranged to return home. Before she left, she proposed to the PW leadership that she be given a long-term assignment in the States, where she could get better care for Sarah. In 1932, with Morris's consent, she and the children left for New York for a two-year stay. Upon arrival, she saw to Sarah's medical care. Her suspicions that the diagnosis they had received in Palestine was wrong proved correct. When Sarah soon began to recover, Golda resumed her peripatetic existence, traveling from city to city, delivering speeches and engaging in the ever-necessary fundraising. Her work entailed long absences from the children who, though they stayed with friends, were resentful. Years later Sarah recalled that weeks would pass without seeing Golda and that Menahem, who was slower to learn English, suffered dur-

ing her absences. To no avail, he would try to stop Golda from leaving the house. Golda knew that both children "dreaded" her long absences and lamented that they saw less of her than they should have.

One of the people she did see during that long stay in New York was Zalman Shazar, future president of Israel, with whom she had an intimate relationship. Though they were discreet, those in the inner circle were well aware of it. (Apparently, everyone in the leadership circle knew who was sleeping with whom. And there was a lot to know.) Shazar, whom contemporaries described as scintillating, was a mesmerizing speaker, leader, and scholar who, in addition to working for the Zionist movement, was attending Salo W. Baron's seminars in Jewish history at Columbia University. He was besotted with Golda. According to observers in New York at the time, he was willing to divorce his wife and marry Golda. It never happened.[11]

During her stay in the United States Golda fundamentally changed the PW. She helped convince it to use English, not Yiddish, as the organization's lingua franca. Some of the older leaders insisted that Yiddish, as a Jewish language and the one in which they were most at ease, should be retained. Golda disagreed. She knew that if PW, which had been founded by immigrant women, was to attract the next generation, it had to make the switch. And she was right. By 1939 over half of PW's clubs were English speaking. Some people called them "Golda Meyerson Clubs." In comparison to the nonpartisan and more middle-class Hadassah, PW paled both in size and fundraising prowess. Hadassah attracted more acculturated, American-born women. For many years, historians treated PW as a footnote in American Zionist history, relegating Golda's work to the same status. Some said she failed because she could not reach the German Jewish "plutocrats" and had to content herself with raising relatively paltry sums from eastern European immigrants. However, while PW did not raise sums as large as other orga-

nizations, the monies it did collect were targeted for women's projects, including those the Histadrut executive had neglected or deemed unimportant. PW bought land to establish a women workers' farm. It also provided much of the budget of the WWC during the years 1926 and 1931, thereby ensuring that projects assisting women were funded and the WWC maintained a degree of independence. It was, in fact, PW's growing ability to raise funds that made the Histadrut leadership notice the organization and decide to send Golda as an emissary. Historian Pnina Lahav accurately described the organization as a great episode in the history of Jewish women.[12] Within the first decade of its existence, it raised $383,000 for projects. By 1939 it had 170 chapters with seven thousand members in seventy cities.

PW's impact extended well beyond its members. It shaped a Zionist message that was in concert with fundamental American ideals of democracy, pluralism, and social justice. PW, with Golda's direct input, mythologized the image of the pioneer woman. She worked the soil, reclaimed the land, and rejoiced in so doing. Golda understood that this was an imagery that American Jewish women, including those who were well beyond PW's orbit, could and did embrace. In 1932 the writer Rebecca Kohut, who was not part of PW, praised the organization as the "buttress of spirit and substance of the working woman in Palestine." She lauded the *halutzot* in kibbutzim, farm schools, and cooperative ventures and the way PW made their work possible. Writing in the lyrical fashion of the day, Kohut described the woman pioneer: "With face uplifted toward the Eastern sun, her shoulders straightened by the new freedom, with her hands [she] eagerly mothers the neglected soil which she loves so dearly."[13] PW's mainstreaming of these images helped render Labor Zionism palatable to a broad range of Americans. Hadassah, a far more acculturated and gentrified organization, eventually came to perceive of the pioneers as an expression of American ideals, despite their socialism. When a Hadassah mem-

ber rather cynically observed that Labor Zionist organizations such as PW were only successful because they received the support of bourgeois capitalist Jews, Golda struck back, arguing that the growth of the Yishuv depended on both work and capital. Showing her propensity for smoothing out potential bumps in an ideological relationship, she argued that Labor Zionists did not oppose private capital. What they opposed was the use of such capital for private benefit, rather than for the needs of building the Jewish homeland. Her views, expressed in the early 1930s, would become a foundation stone in the relationship that a staunchly socialist State of Israel maintained during the first three decades of its existence with an equally staunchly capitalist American Jewry.

Golda was not the only emissary to come to the United States on behalf of Labor Zionist endeavors. When Yanait arrived, she made a side trip to the University of California at Berkeley to consult with the agricultural specialists there. As one participant recalls, there was "such a holy feeling" regarding such emissaries. They gave the women who adhered to this branch of Zionism "content . . . wings . . . imagination."[14] They all made a mark. Ultimately, however, Golda would emerge as an iconic figure among them. This rather lyrical account, written by a PW member as Golda was ending her two-year stay, gives voice to the exalted place she occupied among these American women. "Goldie brought us a waft of fragrant orange blossoms, sprouting vegetables, budding trees, well-cared-for cows and chickens, stubborn territory conquered, dangerous natural elements vanquished, all the result of work, work, work. . . . Her eloquence and sincerity, her poise and simplicity have instilled in her hearers a reverence for our cause and respect for our organization."[15]

Even as Golda was flourishing in the public sphere, she was waging another battle. Her sister and her mother were subjecting her to repeated barbs about her failure as a wife and mother. She had anticipated that Sheyna, who shared her dreams for a

Jewish state, would support her and felt deeply wounded by her criticism. In 1930, after one of her extended stays in the United States, instead of returning home directly, she stopped in London for the socialist conference. Aware that Sheyna disapproved, she implored her to understand. "I ask only one thing, that I be understood and believed. My social activities are not accidental, they are an absolute necessity for me. . . . Before I left, the doctor assured me that Sarah's health permits my going, and I have made adequate arrangements for Menahem. . . . But in our present situation I could not refuse to do what was asked of me. Believe me, I know it will not bring the Messiah, but I think we must miss no opportunity to explain to influential people what we want and what we are."

Sheyna, unpersuaded, accused her of turning into "a public person, not a home-body." Sheyna was then preparing to come to the United States with her youngest child for an extended stay in order to train as a dietician. Golda thought that, given Sheyna's forthcoming absence from her own family, she would be more sympathetic. She implored, "Sheyna, perhaps now you will understand me" and then highlighted the differences in their relationships with their husbands. While Morris had insisted that she "cut off my connections with all outside interests . . . your and Sam's [Shamai's] interests are one and he understands and respects your plans." Here too, Sheyna refused to bend: "Sam understands and helps me because he is all my life," something she seemed to think Golda should have allowed Morris to be for her.[16]

Syrkin illustrates the tension Golda faced with two diametrically opposed renditions of the same event, one from the perspective of the *haverim* and one from her family. In 1929 Golda returned from Europe in the immediate wake of an Arab uprising. It was a traumatic moment in the annals of Yishuv history as it made Arab enmity toward the Zionists abundantly clear. Golda went home but then left immediately to visit a guard

post run by the Haganah, the Yishuv's defense organization, to offer encouragement. Many years later, one who had been there recalled how uplifting her visit had been and praised her "resourcefulness and calm" during this crisis. Sheyna's description of the same event was far less positive. In a letter to Shamai she complained that Golda, despite having just returned, immediately left the children in Morris's and Sheyna's care in order to "take part" in events. Sheyna perceived Golda's visit to the guard post as a selfish desire to be at the scene of the action. Her words ringing with contempt, Sheyna said of her sister: "She neglects herself and us." Golda's successes abroad had caused her to forget that "her first duty is to the family." One wonders if Sheyna would have said the same thing had Morris been the one to go to America or the guard post. Eventually Sheyna became far less critical of Golda's professional choices. Golda's son speculated that her change of attitude resulted from her having left her own children in the Yishuv when she went to the States to become a certified dietician. This experience may have made her, Menahem speculated, "better able to understand mother's needs for a world beyond the home."[17] Maybe Sheyna had also come to recognize the pivotal role her sister was playing in realizing their shared Zionist dream.

During these years, Golda penned two essays that provide important insights into how she perceived of herself as both a woman and a mother. In *The Plough Woman*, a compendium of essays by Labor Zionist women, she described the "despair of the mother who goes to work" as "without parallel in human experience." Some mothers, she acknowledged, are "forced" by economic realities, such as a sick or absent husband, to work. Those mothers know that their children would go hungry if they did not work. Juxtaposed against them was the mother who works not for financial reasons but because "her nature and her being demand something more; she cannot divorce herself from the larger social life. She cannot let her children narrow down

her horizon." The words she chose to describe the situation—"worry," "haunts," "tenderness," "mother's kiss," "pain of a bruise"—indicate the emotional difficulty of her decisions. The rhetorical questions she asked in her final paragraph echo her exchanges with Sheyna. "Can the woman of today remain at home all day with her children? Can she compel herself to be other than she is because she has become a mother? And, the modern woman asks herself: Is there something wrong with me if my children don't fill up my life? Am I at fault, if after giving them, and the one other person nearest to me a place in my heart, some part of me still demands to be filled by activities outside the family and the home?" The working mother suffers from an "eternal inner division, [a] double pull." She perpetually feels as if she has not fulfilled her responsibility toward either her children or her work. This "is the burden of the working mother."[18] She could have justifiably and accurately written, this is *my* burden. Nearly a century later, her sentiments are echoed by many a working mother, including those with supportive husbands, mothers, and sisters. At this stage in her career, she had none of these.

During the same period, Golda wrote a rather different essay for a Yiddish newspaper. Entitled "What My Eyes Have Seen: Notes from a Journey in America," it was translated into Hebrew and reprinted in *Davar*. This work is harder to categorize. It began by acknowledging, in a very feminist tone, that women often suffer from "personal or social enslavement, [and] do not always achieve complete liberation in their lives by their own efforts." Then, rather than acknowledge that she had faced this dilemma, Golda switched gears and launched an attack on extremist feminists who see themselves in a "war against the male gender." For these women, "separation itself" becomes a major accomplishment as they "stand guard against this enemy"—men. They refuse to allow men to participate in their deliberations because they believe "women's independence will increase

in accordance with the growth of its war against the male gender." Their push for separation is a foil to disguise their own feelings of inadequacy.

In what can only be interpreted as a critique of the WWC veterans, she castigated those feminists whose only agenda item is women's issues. She claimed to have "learned from my own experience that the more adherence to feminism grows among women, the less they believe in a women's ability to understand and to act." She also criticized men, though a bit more tentatively, for their assumptions about women. She rather reluctantly admitted that "it is possible that many male members [of PZA] could not imagine that women could lead and organize serious matters on their own." Ultimately, as a result of working with women, some of the men changed their views and abandoned the "traditional wisdom that women are intelligent but with inferior abilities than men. . . . They have learned to work in partnership with women, and to see them as comrades with the same rights and obligations." She then pointed to a middle path, the one she had taken. There are women who "had doubts about and perhaps even opposed the establishment of a special 'women's organization.'" They would much prefer to be part of the general political party. Yet they see what happens to many women once they become involved in groups such as PW. They "learn to act at their own initiative and on their own responsibility and to believe in their own abilities."[19] She believed that women's organizations have a place, but that place is to teach women how to be part of the larger, more powerful male-dominated organizations.

How might we understand this second essay, particularly considering its attack on extremists or separatists? Golda had an abortion shortly after she married. She decided she was going to the Yishuv, with or without the man she loved. She left a husband in Jerusalem to move to Tel Aviv because she was professionally and personally miserable. She repeatedly traveled

abroad—no small feat in those days—while she had small children, including an ill daughter. Even when her children were with her, she left them for weeks at a time in a strange country, not to pursue personal pleasure but because of her commitment to an ideal. She also bore some of the scars familiar to many a working woman—personal guilt and external criticism. At this point in Golda's career, her family, who might have taken pride in her accomplishment had she been a man, incessantly dismissed her work as a betrayal. They did so despite the fact that her husband was unable to support the family.

At the same time, she also knew that women often faced hurdles that they could not overcome on their own. In the early 1930s, the Mandatory government agreed with the Zionist organization to favor male applicants for immigrant certificates. Over 70 percent of these precious documents were awarded to men. The only way many women could come to the Yishuv was by registering as a man's dependent. Recognizing the overt discrimination inherent in this policy, Golda joined forces with the feminists she so derided. Together, they fought this policy.[20] When others criticized her not being feminine "enough," she pushed back. At one point her American hosts accused her of talking "like a man" because, rather than waxing sentimental about the Yishuv, she discussed substantive issues, including immigration, the political situation, and the Histadrut in general. "No one weeps," they complained—and it was the weeping that persuaded people to give money. She dismissed their critique: "I really can't talk any other way."[21]

Francine Klagsbrun, in her expansive biography of Golda, interprets the second article as a message to the Histadrut male leadership that she not an "extremist." She was a leader of both men and women and was not going to be pigeonholed into working with women's organizations.[22] She wanted to enter the upper leadership echelons, and this was her assurance that she was one of "the boys." Golda had become an accomplished

player in the rough-and-tumble world of Yishuv politics. She was telegraphing to the leadership the message that she shared their view that building a Jewish national home was more important than dealing with inequities facing women.

After she left the United States in 1934, she never again lived there for an extended stay. She returned more frequently than can be enumerated, but her long sojourns were over. Her stay was considered a success, rooted in her ability to personally connect with her audiences. Histadrut leaders who saw her in action recognized her distinctive attributes. Joseph Sprinzak, who would become the first Speaker of the Knesset, described what he saw: "Golda is constantly on the road. She does very important work here. Her personal charm, manner of speaking, knowledge of America and her English education, she finished college here, prepared her for her successful work. Everywhere there is an attitude of appreciation and admiration for her. She is not content with her special mission, but appears at public meetings, party meetings, before non-Jews and universities. Of all the people who were here, she is probably by far the most suitable and successful for this place and for the existing situation." In a subsequent letter, he described her as "Golda Meyerson, the darling of the movement and those close to it. In the talent of her speech and the manner of her actions she combines the best of America and of our own movement."[23]

Golda returned from the United States in the middle of 1934. She had established her name. She was no longer in training. She was on her way to the echelons of the top leadership of the movement.

4

·•◆•·

Tel Aviv, 1934–39:
A Seat at the Leadership Table

Upon Golda's return from the States, her colleagues
recognized that she was more than a good speaker, successful
organizer, and hard worker. She knew how to attract American
support. Not surprisingly, they invited her to join the Va'ad
Hapoel, the Histadrut's Executive Committee. Within the year,
she had become a member of the secretariat, the small group
at the helm that made policy. Around the same time, Ben-
Gurion urged the leaders of the newly formed political party
Mapai to appoint her to the central committee. Though His-
tadrut and Mapai were two separate entities—one was a political
party and the other a quasi–labor federation qua trade union
qua employer—their leadership constituted an interlocking di-
rectorate. Labor Zionists' political clout was growing, and it was
this cadre of leaders, of which Golda was now part, that would
make decisions about all aspects of life in the Yishuv.

Her first assignment was to organize a tourist bureau for

important foreigners, people of political and economic influence, to showcase the Yishuv's accomplishments. Since quite a few of these visitors were from Great Britain and the United States, her English was an asset. In 1936 she assumed responsibility for all of the Histadrut's mutual aid efforts. In 1937 she became chair of Kupat Holim, the workers' sick fund, and soon thereafter she became head of the Histadrut's political department. In that capacity, she would eventually find herself negotiating with British authorities in Palestine. She was now at the table when crucial decisions were being made. At age thirty-six, she was among the twenty "movers and shakers" who were shaping life in the Yishuv. Given that she was surrounded by older, more seasoned leaders, men of ideas and of action, the kind of men she admired, she listened more than she spoke and executed plans others had devised. It quickly became clear to the men at the helm that she was someone who invariably got the job done. Ben-Gurion had the utmost faith in her. Writing in his diary about a project that had not worked out as he had wished, he lamented that "if only" Golda had been at the helm the matter would have succeeded.

She had returned to the Yishuv at a pivotal time. Labor Zionists were locked in a battle with the Revisionists. In 1925 Vladimir (Ze'ev) Jabotinsky, an accomplished journalist, gifted orator, and committed Zionist, had created the Zionist Revisionist party. Initially buoyed by the Balfour Declaration, he had concluded that the British were not really committed to a Jewish national home and were seeking every opportunity to retreat from creating one. An avid believer in Jewish self-defense, he had been a prime organizer of the Jewish Legion, a fighting unit part of the British forces in World War I. When the Arabs rioted in 1920, Jabotinsky loyalists, many of them Jewish Legion veterans, prepared to confront the Arabs, but the British waylaid them. A subsequent British committee of inquiry blamed the Zionists for provoking the Arab riots. Jabotinsky's faith in

the British was further diminished in 1921 when they carved out Transjordan from land on "both sides of the Jordan," land that Zionists assumed would be included in the Jewish home.

Tensions between Labor Zionists and the Revisionists grew markedly over the decade. One of the most substantial differences was Jabotinsky's opposition to socialism and his belief that the Zionist movement should be building urban centers rather than investing primarily in agricultural endeavors.[1] Golda, like so many prominent Zionist leaders, had spent most of her life in a city. Nonetheless, she ardently subscribed to the notion that Zionism's objective was to convert an urban people into farmers who worked in a socialist context. In contrast, the Revisionists focused on urban centers and believed in building a capitalist economy. Eventually, Labor Zionists recognized that among the Jews arriving from Germany, Poland, and other parts of Europe were shopkeepers, artisans, and wage earners, none of whom wished to become farmers. They determined that if the urban population were to grow, it should do so on socialist principles. If these newcomers wanted work, they should find it through Histadrut institutions. While Jabotinsky deeply resented labor's stranglehold on the right to work, Golda, who saw it as the means to build a society on socialist principles, celebrated it.

Tensions escalated markedly in June 1933, when one of the younger and much-admired members of the inner circle of Labor Zionist leaders, Haim Arlosoroff, was murdered on the Tel Aviv beachfront. He had just returned from negotiating the *Haavara* (Transfer) Agreement with the German government, which enabled Jews leaving for Palestine to salvage a portion of their property from the ever-increasing emigration tax. They placed whatever funds they could hold onto in a special bank account. Yishuv representatives then purchased German goods with them. Upon arrival in Palestine, the immigrants were credited for their deposited funds. The agreement facilitated emi-

gration. However, it also boosted German exports, something that supporters of a German boycott, which included the Revisionists, considered a direct contradiction to their efforts, a betrayal of Jewish honor, and a pact with the devil. Jabotinsky accused Labor Zionists of being "Hitler's allies," while Ben-Gurion dubbed Jabotinsky "Vladimir Hitler."[2] The fact that members of Betar, the Revisionist youth movement that often provided "security" for Jabotinsky, wore brown uniforms led many of their opponents to accuse them of aping Nazis. (In fact they had chosen their uniforms well before the Nazi rise to power and had no connection to National Socialism.)

Golda had attended the nineteenth Zionist Congress where the Transfer Agreement was discussed. Responding to those who opposed the agreement because it violated the boycott, she argued that while forging an agreement with the Reich might be distasteful, it was a chance to do more than "wailing and protesting. . . . We now have practical possibilities of doing something real to save tens of thousands of Jews."[3] Her optimism that the Transfer Agreement would save tens of thousands of Jews from Germany would not be fulfilled, but her sense that something had to be done was correct.

Then came Arlosoroff's assassination. Revisionist publications had advocated the use of violence, including political assassinations. Consequently, Golda and her colleagues immediately suspected Revisionists were responsible. (To this day there is no firm proof as to who committed the murder. Among the suspected parties are, in addition to the Revisionists, Arabs or even Hitler's emissaries.) When three Betarniks were charged with the murder, Ben-Gurion, despite having no evidence, accused Jabotinsky of masterminding the plot. Golda, then in the United States, declared the Revisionist leader a power-hungry general with dangerous political instincts. American Revisionists, irate at her stance, disrupted Histadrut events where she was present.

But a rift developed among Labor Zionists regarding how best to react to this violence. The leaders with whom Golda most identified, Ben-Gurion and Remez, counseled caution and restraint. But younger factions felt otherwise. This question became more fraught when one of the accused was acquitted because the evidence against him was quite sketchy. When some younger Mapai members learned he was to be at Tel Aviv's Great Synagogue on a Shabbat morning, they planted themselves within the congregation. When he rose to be honored, they began to throw things—including prayer books and benches—effectively disrupting the service. Golda was distressed by this, but it was a subsequent more egregious event that made her erupt in anger. In Haifa, fifteen hundred Mapai members disrupted a meeting of approximately one hundred Revisionists. They shouted, threw projectiles, and then celebrated their putative victory with songs and demonstrations.

The Mapai Central Committee deliberated how to respond. Some members, accusing Revisionists of fascistic behavior, argued that this show of force was a justifiable deterrent. Violence, they argued, even if directed against fellow Jews, had to be part of Mapai's and Histadrut's arsenal of responses. Ben-Gurion took a more nuanced position. Violence, when not sanctioned by the party, as had happened in Haifa, was wrong. However, he contended, sometimes it was a wise and necessary act. Golda was upset by the violence but even more so by the subsequent celebrations: "How could our people sing that night in Haifa?! The youngsters who participated in the action should at least have been ashamed and not flaunted their 'victory.' . . . I can't justify all violence, and yet I can understand using force against strikebreakers. . . . But to organize 1500 people in order to throw eighty Revisionists out of a closed meeting, that's not brave . . . those who usually supported the use of violence had trouble swallowing the triumphal march." Given her devotion to Labor Zionism, it was no small thing for her to declare her-

self "ashamed" to be in a movement such as this. Her shame was certainly exacerbated by her recognition that these events totally contravened the message she had been delivering to American audiences. In a meeting of the Mapai Central Committee held in the wake of these events, her lament was both ideological and personal. How, after repeatedly extolling Zionism's elevation of the Jew's body and soul, could they rationally explain Zionists attacking one another in a civil war? After waxing rhapsodic to thousands of American Jews about how Zionism infused Jews with a newfound self-respect, she now believed "that what I said was a lie."[4] (This was a hyperbolic statement. It is doubtful she really believed all she had said was a lie.)

During this period, Golda, having risen to the upper echelons of leadership, was frequently traveling overseas. Long before it became more common for working mothers to rely on the help of nannies and au pairs, Golda eased some of her childcare challenges by having a succession of young women, a number of whom had been influenced by her to move to the Yishuv, to live in her apartment and look after the children, particularly during these trips. While she was gone, according to one of these young women, Morris would move into the small apartment and act as both father and mother, telling the children what to eat, reading to them before bed, and simply being a comforting presence. Though his relationship with his children was close, the friend recalled him as being very sad. Since Golda had left Jerusalem, the two had lived separately, but they never divorced. Golda insisted she never wanted a divorce, but some of her friends speculated that Morris had refused to agree to one out of spite or because he harbored the illusion that the marriage could be resurrected.

Despite, or possibly because of, the intense demands on her time and her frequent separations from her children, Golda seemed to bend over backward to prove, if only to herself, that she was a devoted mother. Acting in a manner that would be

familiar to many a working mother, she would return home from work and spend the night preparing food for the children, mending their clothing, and tending to their other needs. Every week she cooked a Shabbat meal, complete with homemade hallah. One of the women who lived in the house and became a de facto member of the family recalled that while Golda could be curt with other people, she was never so with the children and, when home on Shabbat, she always baked a cake. "It made her feel like a mother." These efforts notwithstanding, she knew that the conflicting demands of home and work took their toll on her and her children, affecting their relationship. As adults, Sarah and Menahem both described, with a particular poignancy, the loneliness that beset them when she traveled. Whenever a trip was in the offing, both children attempted to get her to remain home: "Why is such-and-such a mission necessary? Why must you, of all people, be the one to go? Why now?" Sarah recalled that sometimes they would not see their mother for weeks. Menahem remembered that she would sit with them "and patiently explain until she gained our 'consent.'" According to Sarah, those patient explanations did not make the children feel better. Because they saw so little of her, they were "always lonesome for Mother." Sarah added, possibly to soften her critique, that "she always brought us presents." (Golda often depended on Morris for suggestions of what to buy.) It's clear that both children would have greatly preferred their mother at home to the presents. Even when Golda was in Tel Aviv, the children saw little of her; she was at Histadrut offices from morning to night. On occasion the children would take themselves to the meetings she was addressing.[5] They would sit silently on the benches, a vivid reminder to her—and everyone else present—of her bifurcated existence. Golda also suffered from frequent migraines, further curtailing her time spent with her children. On top of all this, there were financial worries. De-

spite her promotions, money remained in short supply. Sarah described their economic situation as always precarious.[6]

In addition to the physical separations, there was also the matter of physical danger. By the mid-1930s Palestinian Arabs were increasingly attacking and occasionally murdering members of the Yishuv. Golda recalled that whenever she had to travel from Tel Aviv to Jerusalem, a not infrequent occurrence, "I kissed the children good-bye in the morning, knowing that I might well never come home again, that my car might be ambushed, that I might be shot by an Arab sniper at the entrance to Jerusalem or stoned to death by an Arab mob on the outskirts of Tel Aviv."[7]

But as much as she loved the children and worried about them, she considered her efforts on behalf of the Zionist cause of equal—if not greater—significance to her role as a mother. As long as she made the proper arrangements and organized the details, others—Morris, Sheyna, nannies, her parents, and an array of devoted friends—could see to the children's immediate needs. Years later, she reflected on the cost they all paid for her peripatetic life. "I've paid for being what I am. I've paid a lot. . . . In the sense of pain . . . I know that my children . . . suffered a lot on my account. . . . I was never with them when I should have been and would have liked to be." But then, after expressing this sentiment, she pulled back a bit, insisting that despite carrying a great "guilt" about this, deep in her heart she knew that she had given her children a "life that's more interesting, less banal than the ordinary."[8]

In response to the increasing upheavals in the region in 1937, the British appointed the Peel Commission to solve the ongoing political battle. Its proposal—that the country be portioned into two states, one Arab and one Jewish—provoked deep dissension among the Yishuv leadership. Under the plan, Jews would be allocated two thousand square miles, including

the Upper and Lower Galilee, the Jezreel Valley, and a coastal plain. This was less than a third of Palestine. The remainder was reserved for the Arabs. Jews would be allowed to use Haifa port under special arrangements. Once the Tel Aviv port was completed, the report stipulated, it would be managed by Jews and Arabs with British supervision. Jerusalem would become an international enclave and there would be a corridor linking it to the Jewish area. For all this plan's shortcomings, this was the first time a non-Jewish governmental entity proposed the creation of a Jewish state, however minimal its borders. Unimpressed, Golda thought the proposal grotesque. But David Ben-Gurion thought otherwise. It was one of the few times that Golda forcefully and unequivocally publicly parted ways with Ben-Gurion. Prior to the issuance of the report, Ben-Gurion had feared that Great Britain might put a cap on the number of Jews allowed to enter Palestine, rendering Jews a permanent minority in Palestine and leading to the Yishuv's eventual decline. He thought partition, an idea he knew the commission was considering, might be an alternative. He considered it, as he wrote his son Amos, not "as the end, but only the beginning."[9] For him the choice was between a tiny Jewish state and total nullification of the Mandatory power's commitment to Zionism. When he brought the idea to the Mapai Central Committee in January 1937, Golda openly challenged him, asking a question she would repeat often: what would happen when there were 3 million Jews in a state with a land mass unable to accommodate them? Ben-Gurion dismissed her objections out of hand, arguing that their concerns must be with the current generation and the contemporary situation and not what loomed in the future. It was a battle between the ideal and the possible: Golda was clearly wedded to the mythic ideal and Ben-Gurion, though no less an idealist than Golda, to what was realistically possible.

Over the course of time, her opposition to the Peel pro-

posal grew stronger. In addition to worrying about the proposed state's ability to absorb immigrants, she was convinced that it would be continually at the mercy of the far larger Arab state. At the twentieth Zionist Congress, she railed against those Zionists who were celebrating the idea that Britain was *granting* them the long-sought state. The British, she told the delegates, were not "giving" the Jews something. They were "robbing us of our land." Resolute in her opposition, she declared partition a "disaster."[10]

Taking such a public stance in stark opposition to Ben-Gurion, whom she revered, and David Remez, who was her colleague, mentor, and lover, could have stymied her political career. But she was not alone in her opposition. Berl Katznelson, whom Ben-Gurion considered his muse, described the offer as akin to the premature birth of a stillborn child. Ultimately, this partition proposal died because of Arab opposition. After the Holocaust, when numerous Jews perished because they had nowhere to go, Golda recanted regarding the Peel proposal. "We were wrong and Ben Gurion, in his greater wisdom, arguing that any state was better than none, was right." Golda derided herself as a "naysayer," acknowledging that she would not have been able to sleep at night if the plan had been turned down because of her opposition.[11] Luckily for her, she did not have to bear that burden.

In the wake of the Arab riots, the Jaffa port workers refused to transport cargo designated for Jews or assist Jewish passengers to disembark. In response, Remez proposed that the Jews create a maritime industry, including a harbor, passenger ships, freighters, fisheries, and canneries. Jews who arrived in the Yishuv would not have to depend on Arabs to transport them. Tens of thousands of jobs would be created. With an ear for the poetic, Remez proposed calling the enterprise Nachshon after the Israelite leader who, legend has it, was the first to jump into the Red Sea when the Jews reached its shores during the exo-

dus from Egypt. The idea was audacious. Golda's son dreamed of a day when his peripatetic mother would return from her trips on a ship flying the Zionist flag. But clever biblical references and children's dreams aside, such an endeavor demanded great funds. This, Remez insisted, with Golda's full concurrence, could only come to fruition through investment, not philanthropic efforts. Who better to invest than American Jews? And who better to solicit that investment than Golda?

Soon she was back in America. Speaking in the expansive manner she increasingly used when addressing American Jews, she declared that this effort would be akin to the creation of a new country. Golda described it as a territory for which they did not have to fight for every inch. She raised considerable sums, but never reached her goal of $500,000. No ships were purchased, no fisheries built. Nonetheless, in the greater trajectory of Golda's career, the effort was not entirely wasted. In contrast to earlier years, when she had collected small donations from women of modest means, this time she had also met with business leaders and wealthy Jews. She described for her Histadrut colleagues her interactions with these wealthy businessmen. (They were all men.) If you can capture their imagination regarding a particular endeavor and "excite" them, you can win their support. This was something at which she would excel in years to come.

Though she later dismissed this project as no more than a "romantic interlude," one that Ben-Gurion considered a waste of her time, she devoted close to three years to the effort. During that time, all she thought about were shipping and fishing. She talked about them so much that Katznelson took to calling her "Capitain."[12] Given her single-mindedness about this endeavor, she could not have been pleased when Remez and the other Histadrut leaders, in an amazing display of what can only be described as misogyny, did not consider her an appropriate candidate to head the company or even be on the board of di-

rectors, despite the fact that she knew more about the shipping industry than any of them. Once again, here was concrete proof that even among ardent socialists, some types of people were more equal than others.

By 1938, events in Europe had become a stark illustration to Golda of the imperative to have a territory governed by Jews. That sentiment grew even stronger in March when Germany entered Austria. After the war Austrians would insist that they had been "invaded" and were therefore the first victims of German aggression. In fact, they greeted this putative invasion with remarkable enthusiasm, which they demonstrated by engaging in unbridled acts of antisemitism. The *New York Times* reported that the Viennese quarter of Leopoldstadt, home to many Jews, was invaded by triumphant crowds. These marauders, who, the paper noted, were "Austrians, not invading Germans," raided Jewish shops, terrified the occupants of private homes, and compelled prominent Jews to scrub the streets—all the while delighting in the process.[13] The Jewish suicide rate skyrocketed.

Soon the SS took charge, and the oppression Jews faced became all-encompassing. A young SS officer, Adolf Eichmann, was entrusted with the job of ridding Austria of its two hundred thousand Jews—in the process enriching German coffers. He would do such an impressive job that he eventually became one of the Holocaust's chief operating officers. He placed the entire bureaucratic operation in one location, the Rothschild Palais. Every financial and legal obstacle put in the path of Jews trying to leave Austria—payment of utility bills, forfeiture of possessions, relinquishing of property, settlement of special taxes, and more—could be resolved there. One Jew compared the process to a "flour mill" that was part of a bakery. A Jew would enter the building possessed of a home, a bank account, perhaps a factory or shop. He or she would move from office to office, counter to counter, eventually emerging without any money, rights, or possessions. All they would have was a passport stipulating that

they must leave the country within two weeks or end up in a concentration camp.

But obtaining the precious exit visa was not enough. People needed a place to go. Few countries were accepting refugees—particularly if they were Jewish and bereft of all their assets. President Franklin Roosevelt, feeling the pressure to respond to events in Austria and the crush of people seeking refuge, announced the convening of a conference in Evian, France, to address the crisis. This initially seemed promising. However, it quickly became apparent that the gathering would constitute political theater rather than a serious effort to resolve the problem. Roosevelt announced that the meeting would facilitate the emigration from the Reich of "political refugees."[14] Tellingly, there was no mention of Jews. Moreover, the State Department assured invited countries that none of them would be asked to "receive" more immigrants than permitted by their existing legislation, and if they did perchance agree to take in refugees, private organizations would cover the costs. Finally, in order to ensure Britain's participation, Roosevelt promised that Palestine as a potential refuge would not be on the agenda. In essence, most of the options for rescuing Jews were off the table before a single delegate arrived in Evian.

While these developments did not bode well for a productive meeting, what actually took place was even more humiliating for the Jews present, Golda included. She attended as an official representative of the Yishuv. Since neither she nor the other representatives of Jewish organizations were part of a national delegation, they were assigned, as she described it, "the ludicrous capacity" of observers. It was not just being relegated to observer status that made this gathering so difficult for the Jewish representatives. It was having to listen to a series of delegates who, after decrying events in the Reich and even condemning antisemitism, proceeded to explain why their countries could not accept any refugees. They offered many excuses—

economic, political, or legal—but skirted around the true reason. Only the Australian delegate threw circumspection to the wind and declared: "As we have no real racial problem, we are not desirous of importing one by encouraging any scheme of large-scale foreign migration." In other words, Jews bring anti-semitism. We therefore don't want Jews. These protestations made Golda want to get up and scream, "Don't you know that these 'numbers' are human beings, people who may spend the rest of their lives in concentration camps, or wandering around the world like lepers, if you don't let them in?"

Yet the representatives of the Jewish organizations remained "disciplined and polite" throughout what she described as a "terrible experience." Forty years later, it still elicited from her "sorrow, rage, frustration, and horror." For Golda, the most disconcerting moment came when the representatives of the thirty-five Jewish organizations at the conference appeared before what she subsequently described as a "committee of Goyim" who did not want Jews to enter their country. The meeting with the British delegation lasted fourteen minutes.[15] Later, at a well-attended press conference, the two Yishuv representatives, Arthur Ruppin and Golda, spoke. One participant stated that Ruppin did a good job, but Golda's performance was "fabulous."[16] In what was becoming her familiar acerbic style, Golda assured the reporters that there was but one thing she did hope to see before she died: "That my people should not need expressions of sympathy anymore." The Hebrew press in Palestine covered the conference and her words closely. Her presence at the conference raised her public profile in the Yishuv. But it did more. It once again confirmed her Zionist credo that Jews could not depend on others to save them. They had to act on their own behalf. Though country after country had condemned Nazi Germany and decried its treatment of Jews, virtually none offered concrete help. It was not surprising that she left the meeting more convinced than ever that "Jews neither

can, nor should ever depend on anyone else for permission to stay alive."[17]

Golda and her colleagues were not the only ones to interpret Evian as indicative of the world's willingness to countenance Nazi persecution of Jews. The Reich reached the same conclusion. On November 9, there was a state-sponsored nationwide pogrom. Germans desecrated and destroyed synagogues and ransacked Jewish property. Close to one thousand Jews were murdered. Working from prepared lists, government officials arrested thousands of Jews and incarcerated them in concentration camps. In a letter to her children, Golda described the reports she had heard from eyewitnesses as "impossible to imagine."[18] (One source, Joseph Burg, who would go on to become a cabinet minister, said that Golda was in Berlin that night with Remez, but according to Golda she was in London. Burg may have assumed that because Remez was there, Golda was with him. As noted earlier, there were no secrets.) Determined to meet those who had suffered at Nazi hands, she rearranged her plans and traveled to Poland, where she encountered Jews who had been ejected from Germany during this period.[19] What she witnessed in July 1938 in a luxurious Evian hotel and a few months later in Poland reinforced, yet again, her conviction that an independent state was an absolute necessity.

5

<div align="center">━━━━━━◆◈◆━━━━━━</div>

The Apocalypse, 1939–45: "Shame on Us"

IN THE LATE SUMMER OF 1939, Golda was back in Europe. She described to her children the "heavy feeling" of war prevailing on the continent and said she could barely "contemplate the killing" that was in the offing.[1] What she could not foresee—no one could—was that in less than half a decade, one out of every three Jews on the face of the earth, including many she expected to come to the Yishuv, would be murdered. She would watch this unfolding tragedy struggling, with the rest of the Yishuv's leadership, to determine what they should and could do. Build the Yishuv or try to rescue Jews? Fight the British efforts to curtail immigration or work with the British to fight the Nazi threat? Do all these things simultaneously? Was that even possible?

Their options were severely curtailed by three developments: Germany's unrelenting antisemitism, Britain's retreat from its commitment to a Jewish national home, and the refusal of virtu-

ally every country in the world to admit desperate Jews. After Evian in the summer of 1939, that refusal was again graphically illustrated when the SS *St. Louis*, with approximately eight hundred Jewish émigrés aboard, was turned away by Cuba and the United States. After meandering aimlessly in the Atlantic, the passengers finally found refuge in Europe.

Britain, which welcomed a number of Jewish refugees, including trainloads of children, did something else that had a profound impact on Jews seeking refuge. In May 1939, aware that war was likely and desperate to ensure that the Arabs would be on their side or at least neutral, it issued a White Paper proclaiming that Britain's commitment to a Jewish homeland had been fulfilled and declaring "unequivocally," "It is not part of [the government's] policy that Palestine should become a Jewish State." Within a decade, a Palestinian state would be established in which the "rights of minorities" would be guaranteed. With a few exceptions, the decree stipulated an end to Jewish land purchases. For those European Jews seeking refuge, the most ominous aspect of the decree was that immigration would be capped at seventy-five thousand over the next five years. After that, Palestinian Arabs would have to give their acquiescence to Jewish immigration. Given Arab opposition to an expanded Jewish presence in Palestine, no one expected such acquiescence to be forthcoming. Zionists of all stripes had a uniform reaction. Jews seeking to escape the Nazis now faced a double death sentence: from Britain and from Germany.

Early in May 1939, prior to the issuance of the White Paper, Golda, writing as a "mother," penned an article for the Histadrut's WWC's periodical on the terrible dilemma faced by Jewish mothers in the Reich. She noted that at times of imminent danger, a mother instinctively draws her children close. Now, however, Jewish mothers in the Reich were asking for the opposite: "Take our children away . . . save them from this hell." Such a mother was willing to send her child away "with-

out knowing if she will live to see it ever again." It was the obligation of Jews to rescue these children "from the hell of the Diaspora" and ensure they reached the Yishuv. Only there would they be safe. Though Golda would hold many jobs during the war, this article presaged what she considered her "real preoccupation": rescuing Jews.[2]

Most of the children whom Golda hoped to bring to the Yishuv never made it. Britain did open its doors to ten thousand children through the much-heralded *Kindertransport* program but refused to allow the Yishuv to follow suit. Soon after the war began, Weizmann pleaded with Colonial Secretary Malcolm MacDonald to allow twenty thousand Jewish children in Poland to immigrate because of the looming catastrophe. (The request would have in all likelihood been impossible to realize.) The Zionist leader pledged that the economic burden of supporting them would be borne by the Jewish people. MacDonald considered allowing the children to go to Cyprus or some other British territory because that, he mused, would not "break our promise to the Arabs." However, upon reflection, he decided that since the Arabs might regard even this as a breach of Britain's commitment, this option should be rejected. He offered yet another rationale for his decision. Allowing those children to leave Poland would "simplify the Germans' economic problem," making it easier for them to successfully run the war. (One wonders how great a military advantage would have accrued to Germany if it had not needed to feed twenty thousand Jewish children.) MacDonald acknowledged that his decision "might sound" brutal.[3] He was wrong. It did not sound brutal. It was brutal.

In August 1939 Golda gathered with fifteen hundred delegates in Geneva for the twenty-first Zionist Congress. Her despondency over the White Paper was enhanced by the impending war. Her son Menahem recalled that he and his sister behaved differently than usual before she left. They did not de-

mand to know if she really had to go. "We asked nothing. No questions. We knew for ourselves that, if she was needed in Geneva, that was where she had to be." When the congress ended and the children assumed she was on her way home, Menahem wrote her that they were "so happy." When they subsequently learned that her return would be delayed, he reassured her, "Never mind if it takes another week or two, because I know that you're not abroad for your own sake."[4]

Midway through the congress, Germany and the USSR concluded the Molotov-Ribbentrop pact. Splitting Poland in half, it guaranteed that Germany would not face a war on both its eastern and western borders. Delegate and historian Emanuel Ringelblum, who would become the Warsaw ghetto's chronicler, described the remainder of the gathering's deliberations as taking place under the cloud of war. Delegates scrambled to adjust their travel arrangements and bid farewell to one another, anticipating that they would not meet again soon. What they did not anticipate was that most of them would never meet again.

Before the delegates scattered, they had to address how to respond to the White Paper. Ben-Gurion articulated his preferred policy: a two-front fight, one that he would encapsulate in an oft-quoted slogan: "We shall fight the war as if there were no White Paper and the White Paper as if there were no war."[5] Golda admitted that she thought this a ludicrous formulation. Had it come from anyone other than Ben-Gurion, she and her colleagues would have said so; the only reason they did not slough it off was that it came from their leader. But other Zionist leaders, most notably Chaim Weizmann as well as some American Zionists, were horrified. Given the Yishuv's weakness and dependency on British support, Weizmann considered this aggressive stance politically unwise. The ever-moderate Weizmann argued that even though he considered the White Paper a breach of faith and monstrous injustice, they had to continue

to operate within its framework.[6] Even Golda's good friend and acolyte Marie Syrkin was "startled by this bravura" and thought Ben-Gurion's proclamation "the speech of a fanatic," one that crossed the line between "vision and lunacy." Stupefied, Syrkin and her fellow Americans subsequently queried one another, did Ben-Gurion and those around him "mean it? And if [they] meant it, did it make sense?"

Before departing, Golda had to attend to yet another pressing item. She closeted herself with delegates from European youth organizations, among them Zivia Lubetkin, who would be one of the leaders of the Warsaw ghetto uprising. They held what Golda described as "relatively optimistic conversations" in which they devised all sorts of plans to maintain contact if—when—war broke out. Despite these hopeful arrangements, during the war contact was barely maintained and most of those gathered with Golda ultimately perished. As the conclave was ending, Syrkin sought out her friend to bid her farewell. She entered Golda's room expecting to find her packing to leave. Instead she was ensconced with these young Zionist delegates. When Syrkin urged her to leave in order to avoid being interned as an enemy alien, Golda deflected her concerns. "Who is going to make the plans?"[7]

Golda returned to Tel Aviv in the first week in September and plunged into fighting three distinct but highly intertwined battles: preserving the faltering economy, trying to smuggle as many Jews into Palestine as possible, and engaging in a "humiliating" effort to persuade the British to allow Yishuv members to participate in military actions. While she may have dismissed some of Ben-Gurion's exhortations as too lyrical to be taken seriously, there was one that became her mantra. "Jews should act as though we were the State in Palestine . . . until there will be a Jewish State."[8] She assiduously adhered to this strategy, acting as a member of a de facto government.

With the war, the already difficult economic situation be-

came catastrophic. All goods, including food and clothing, were in terribly short supply. Exports ground to a halt. Unemployment skyrocketed, surpassing nine thousand and eventually growing to over twenty-six thousand by 1941. Golda, as head of the Histadrut's mutual aid programs, had to address this growing problem. Insisting that socialism had to be far more than a convenient slogan or, as she described it, her "calling the janitor Shmuel and then his calling me Golda," Golda melded Jewish tradition and socialist ideology. She argued that help was a matter of justice, not charity. The unemployed had a right to expect justice from their fellow workers. (The Hebrew term for charity, *tzedakah*, comes from the *zedek*, or justice.) Trumpeting her socialist worldview, she told the Histadrut's Executive Committee that "we have to take from wealthy Jews what they owe."[9] Thus began a program to compel wealthy Jews and organizations to give more than they might have intended to give. But she did not stop with the wealthy. Individually employed workers also had a responsibility to support the Histadrut's aid program. Golda instituted a *mifdeh*, "redemption" tax to be levied on every worker.

Previously such a tax had been levied without too much opposition. This time was different. Many workers, feeling that they were already overtaxed, balked. In an attempt to quash the opposition, Golda visited factories and workshops. The more vocal the critics, the more adamant she became, declaring it irrelevant to her how difficult it might be for an employed Histadrut member to pay. Her stance on the *mifdeh* was certainly rooted in more than Jewish tradition and socialist ideology. It was personal. She had known deprivation and grinding poverty—in Russia, during her early years in Milwaukee, in Jerusalem. If she could endure such sacrifices, Histadrut workers could endure far less.

As the situation of the unemployed worsened, Golda's fury was focused not just on the recalcitrant workers but on Britain's

failure to provide the Yishuv with a social aid safety net. She had already voiced this anger in testimony before the 1936 Peel Commission when she castigated Britain not only for having no unemployment insurance plan but for refusing to help when the Histadrut set up its own plan. In addition to complaining to the commission about the government's meager assistance for education, she accused the Mandatory government of abdicating its responsibility for the Jewish population of Palestine. The only time they acted, she asserted, was when it concerned putting roadblocks in the path of the Zionist enterprise. Golda was not alone in complaining at the hearing. Henrietta Szold, the founder of Hadassah and a social service pioneer, protested that Great Britain had failed to provide public health facilities for the Yishuv. A hospital that the British promised to open in 1932 remained unbuilt. Once again, British policy and what Golda considered its indifference to the Yishuv's economic problems reaffirmed her Zionist conviction. As she reminded her Histadrut colleagues, they could make elaborate plans and levy taxes. However, as long as the Yishuv lacked governmental "powers of coercion," powers that could come only with independence, they could not make "laws that are binding on everyone." They could imagine themselves to be a government, but they could not truly act as one.[10]

Some Histadrut leaders suggested that rather than burden the workers with taxes, they should ask world Jewry, Americans in particular, for aid. Golda rejected this option outright. "We shall not go to the Jews of the diaspora to seek relief." American Jews could be asked to "enable us to build, to create new things," but not to deal with unemployment or hunger.[11] She grasped something that many other Yishuv leaders, particularly those who had not encountered American Jews, did not. A steady stream of emissaries, Golda included, had given American Zionists the message that the emerging Jewish national home was the locus of a new Jewish society and home to a new kind

of Jew. These were not Jews who needed charity. One could ask American Jews to fund the digging of a well, invest in a shipping line, purchase tractors, or rescue Jews, but not for charity to help the unemployed.

Golda had an alternative plan. In recent months, the Yishuv leadership had substantially accelerated the creation of kibbutzim and *moshavim*, cooperative agricultural settlements, particularly in the south and north, near the Lebanese border. Golda, believing this was an effort that would excite American Jews, exhorted the Histadrut's Executive Committee to immediately send a delegation to America to secure loans to fund these efforts. This astute sense of what to request from donors would eventually make her one of the Yishuv's and Israel's most successful fundraisers. But her ability to "read" the American Jewish community had its limits. She assured the Histadrut leaders that thousands of American Jewish young people could be convinced to come and help with *Aliyah Bet*, as the illegal immigration program was known. She was wrong. They did not come. It would take thirty years for that to happen.

She had yet another solution for easing the economic crisis: urban kibbutzim. Instead of Histadrut members cooking in their homes, she proposed that communal kitchens be established to prepare food. Children would receive their meals at school. Those who could afford to pay would do so. Those who could not would receive meals for free. "But," she added, channeling yet another primary aspect of the Jewish tradition of *tzedakah*, "the children wouldn't know about these differences." The Histadrut would keep the money that families would normally have spent on food and use it to aid the unemployed. It would buy clothes in bulk and sell them at a deep discount to those without work. Some of the unemployed, Golda proposed, could be sent to kibbutzim and other agricultural settlements.[12] All these proposals were spectacular failures. Most were never even attempted. Golda blamed a united political front against

them. In truth, while they may have faced a united opposition, some failed because they were impractical. Kibbutzim did not need additional workers. People in cities did not want to give up their kitchens. For Golda, this vision of an urban kibbutz may have reflected her never-fulfilled goal of moving back to the kibbutz. If she could not go to a kibbutz, she would bring kibbutz life to the city. In fact, her life in Tel Aviv already approximated a Histadrut kibbutz. The housing in which she lived, the bank she used, the schools her children attended (and the meals they received there), the bus lines on which she depended, and the cultural events she enjoyed were all built, run, supported, or organized by the Histadrut. Her neighbors were all Histadrut members who shared her vision of this new Jewish society. (It is no wonder that Revisionists increasingly felt shut out.)

Despite her efforts to get the workers to accept the tax, opposition continued. She was appalled when some of them broke into Histadrut headquarters. They demanded that acts of violence be sanctioned against employers and free food be immediately distributed. They accused the leaders of having forgotten their socialism—living relatively well while demanding sacrifice from workers—and called for them to resign en masse. Though the demands for resignation were not directed at her—she was known to be living an impeccably socialist lifestyle—Golda resigned as the Mapai representative on the Histadrut Executive Committee. Ostensibly, she did so because she was in charge of virtually all of the Histadrut's mutual welfare programs and these protests were against them. Klagsbrun considers her decision a savvy political maneuver. For the next few weeks, every Mapai Executive Committee addressed her resignation and strategized on how to convince her to change her mind. Finally she agreed to return, on the condition that her colleagues demonstrate their complete faith in her as she led the fight for the fourth round of what she recognized were "loathed" taxes.[13] Though the fourth round was successful, tension within the

ranks of Labor Zionists remained and continued to escalate. (Eventually, in 1948, tensions would rise to such an extent that some of these opponents, in alliance with other left wingers, would found Mapam, a Marxist party with significant allegiance to the USSR.)

All these protests were taking place against the backdrop of the bleak course of the war. In the spring of 1940, England stood alone against the Germans. Nonetheless, the Yishuv, continuing with *Aliyah Bet*, tried to circumvent British restrictions. The ships it used were old, barely seaworthy, and highly overcrowded. Many sank. Others were intercepted. Consequently, the effort did not materially enlarge the number of immigrants. Nonetheless, it gave Golda and her compatriots a sense of doing *something*, however paltry it might be. Soon that effort also came to a halt. In the fall of 1940 in Haifa harbor, the Haganah blew up the *Patria*, a ship onto which the British were transferring Jews from intercepted ships. It had intended to just disable the ship in order to prevent it from deporting these Jews; instead it sank it. Over 267 people were killed and many wounded. At a Mapai Executive Committee meeting, furious leaders railed against those who had given the Haganah permission to plant explosives. Golda vigorously defended the effort. One of those present at the meeting described her demeanor as "one of her strongest moments ever in the way she bore herself." She insisted that even with this tragedy, *Aliyah Bet* must continue. Nothing, she told the others, must curtail immigration.[14] Her protestations notwithstanding, such immigration ceased until late in the war.

Her wrath toward the British for the impediments they placed in the path of desperate Jews was intense. The British, poised virtually alone against the Germans, desperately needed the Arabs to be on their side or at the very least remain neutral. Golda saw it otherwise. The British fought "like lions" against the Germans but refused to stand up to the Arab world. Despite Britain's significant attempts to win Arab support, the mufti of

Jerusalem took refuge in Berlin, where he found an appreciative audience for his hatred of Jews. Iraq had a pro-German government. Many Egyptians sympathized with Germany and its allies. Golda, rather fancifully, imagined the British telling the Arabs: "You have nothing to worry about. Once the war is over, we will see to it that each and every clause of the White Paper is fully enforced. . . . But what is at stake right now . . . is the lives of millions of human beings."[15] Her musings remained a fantasy.

While her sense of what Britain could and could not do was somewhat skewed by the Zionist prism through which she viewed events, she never forgave the British for what she considered callousness. She recalled those occasions "when we proved to [British officials] that Jewish children could be saved." The officials' response was always: "There weren't any ships." Yet, she bitterly recalled—not without a touch of cynicism—there were always enough "ships to transfer Jews from this country [Palestine] to Mauritius, but not to bring Jewish children from Europe." She asked one British official: if the children had been British, wouldn't the ships have been found? She admired his honesty in not responding.[16]

But Golda's differences with the British concerned more than immigration. The Zionist leadership, Ben-Gurion in particular, had made the creation of a separate Jewish brigade as part of the British army a wartime priority. It would replicate the World War I–era Jewish Legion, which had also been part of the British army and had given the Zionist movement some standing in postwar peace negotiations. Golda fought Mandatory officials on this, arguing that Jews had to be able to fight the most formidable enemy they have ever faced and to do so as Jews. She quickly discovered that despite the fact that such a fighting force might benefit the war effort, London rejected the idea. The British thought, strategically so, that a Jewish brigade might arouse Arab suspicion and hostility and once again

leave the British with a political obligation to the Jews. Furthermore, any resident of the Yishuv whom they trained as a soldier could eventually become what they considered a "terrorist." Even after 1940, when Churchill, the newly designated prime minister, thought a Jewish unit a good idea, opponents to the proposal, both those in the government and the armed forces, made sure it did not happen. Weizmann and Ben-Gurion, who spent much of the war in London, worked together in an attempt to persuade the British to change their mind. (This was one of the few policies on which they agreed.) Britain stood firm in its opposition.

In the Yishuv, Golda negotiated—or, more properly put, fought—with British military and colonial officials about the myriad of obstacles they placed in the path of a population anxious to help the war effort. The Histadrut and Jewish Agency, following Ben-Gurion's dictum to act as if the Jewish state already existed, had issued so-called conscription orders for Jews to volunteer. The British, despite needing this assistance, were vexed at this quasi-governmental action. Golda brushed off the criticism and pressured those receiving the orders to actually volunteer. But even the volunteers encountered problems. The British considered all recruits from Palestine—Arabs and Jews—"natives" and thus treated them as they would the native populations in other parts of their colonial empire. They forbade them from serving in regular armed forces units, relegating them to serving as ambulance drivers and members of the medical corps or ordnance service corps. Golda argued with local British officials that this was unacceptable and a waste of talent. She also insisted that skilled Palestinian service workers should not be receiving the same salary as unskilled laborers in the colonial empire. But the British responded that "native" workers were ineligible to negotiate salaries. Payment was not the only issue on which she locked horns with British officials. The Brit-

ish contended that colonial authorities could fire these workers at will. All this was unacceptable to the Histadrut in general and to Golda in particular. After many a "stormy" meeting with army officials, she finally convinced the British to negotiate with the Histadrut. The bargaining was successful. As the Nazi onslaught gained momentum and Rommel's drive across North Africa brought the Axis frighteningly close to Palestine, Britain and the Yishuv reached a tacit truce. The two sides cooperated. Then Rommel was defeated, the German offensive against the Soviet Union was repulsed, and the Allies landed in Italy. The Yishuv's aid was no longer as essential as Arab neutrality.

While the British clearly had well-founded strategic reasons for favoring Arabs, that policy often found expression in more than just genteel antisemitism. On the eve of the war, when the Yishuv's chief diplomat, Moshe Sharett, was in London, he met with the chief of the general staff of the army to discuss European Jewry's precarious situation. In the course of the conversation, the general shared what he obviously considered a statement of fact: "Jews aren't a loveable people." He then added his personal sentiment. "I don't care for them myself." Nonetheless, he conceded, "that is not sufficient reason to explain [a] pogrom."[17] In 1943 the head of the Colonial Office, Lord Cranborne, expressed these sentiments even more directly. Afraid that Churchill might be sympathetic to a Jewish entity in Palestine, he told Foreign Secretary Eden that he favored a Jewish state in Africa, not because he had any sympathy for the Jews but because "only thus will we be able to silence the wealthy Jews in America who pay for this agitation without any intention of sacrificing their American citizenship." Lest there remain any question about his personal sentiments regarding Jews, he added, "And only thus will we be able to get some of the Jews out of the country, in which there are now far too many."[18] Such appraisals were not, of course, unique to the British. French

and American diplomats expressed similar sentiments. This was endemic to their upper-class culture, within which age-old, deep-seated antisemitism was a foundational element.

While this sentiment exacerbated Golda and her colleagues' stormy relationship with the British, cultural differences also influenced the relationship. British MP Richard Crossman, who was in Palestine in 1946, summed it up quite neatly. "It is easy to see why the British prefer the Arab upper class to the Jews. This Arab intelligentsia has a French culture, amusing, civilized, tragic and gay. Compared with them, the Jews seem tense, bourgeois, central European or even German." A British official accompanying him put it more starkly. There were, he observed, "two societies in Jerusalem, not three. One is Anglo-Arab and the other is Jewish. The two just can't mix."[19]

There was yet an additional factor that guaranteed the relationship would be tense. The small community of Palestine Jews behaved unlike any other population in the British Empire. The director of Solel Boneh, the Histadrut's building enterprise that worked closely with the British, captured the difference. These colonial bureaucrats who had been stationed in various British territories "had never met natives of our sort. We paid taxes, but we never went to the government schools. We went to our own schools, paid for with the money we collected from Jewry. The Weizmann Institute and the University [Hebrew University] belonged to us. . . . There were more English books in our homes than in their houses." A senior British political official echoed these comments in a report he wrote for London. He could have and may well have been describing Golda's demeanor toward British officials. "The Yishuv was meant to be subject to British rule. Instead, it behaved as if it were an independent nation. . . . The Yishuv is governed, not by Britain, but by a network of Jewish organizations, some open and established, others secret and illegal."[20] This, of course, had

been precisely Ben-Gurion's objective, one for which Golda labored assiduously: acting like a self-governing state will bring you closer to becoming a self-governing state. Golda also accurately assessed the personal element at play in this relationship. "Arabs recognized the British as their superiors. We looked upon ourselves as their equals, and that they couldn't take. And the Arabs were so nice."[21] One can debate whether the Arabs recognized the British as their superiors or just acted as if they did. What is not open to debate is that Golda and her colleagues neither behaved as if they thought the British their superiors nor saw any need to be "nice."

Golda repeatedly demonstrated this less than subservient behavior toward the colonial authorities, rarely showing Mandatory officials the respect they had come to expect was their due as representatives of His Majesty's government. In a 1940 meeting with the chief secretary of the Mandatory authority about land purchase restrictions Britain had imposed on Jews, she bluntly told him that Britain had stolen 95 percent of their land. In September 1943, she was called to testify in the military trial of two young Jews. Ostensibly, the trial concerned the defendants' alleged attempt to steal hundreds of rifles and over one hundred thousand rounds of ammunition from British storehouses for use by the Haganah. The British, now feeling more secure about the outcome of the war, intended to use the trial to portray the Jewish self-defense organizations as terrorist movements. The prosecutor, a Major Baxter, argued that the only reason Jews had enlisted with the British was to procure weapons. In fact, though some military supplies may have gone missing, Jews enlisted because they were desperate to fight the Germans. Golda was incensed by Baxter's accusation. Seething, she characterized it as more than "unjust . . . it was wicked." The palpable condescension with which Baxter and the court president, Major Russell-Lawrence, treated her only served to raise

her ire. In the witness box, she feistily returned their contempt measure for measure.

Q: You are a nice, peaceful, law-abiding lady, are you not?
A: I think I am.
Q: And you have always been so?

Baxter, without waiting for her to respond, read a quote from a speech Golda had recently given. "The whole Yishuv will join hands in fighting the White Paper. . . . We never taught our youth the use of firearms for offense but for defensive purpose only. . . . And if they are criminals, then all the Jews in Palestine are criminals." Baxter, convinced that he had exposed Golda as not the nice, peaceful, law-abiding lady she claimed to be, asked, "Well, what about that?" In response she simply repeated the precise sentence that so upset Baxter and his colleagues.

A: If a Jew, who is armed in self-defense, is a criminal, then all the Jews in Palestine are criminals.

When he asked her if she had trained Jewish youth in the use of firearms, she deflected the question and offered another version of her previous response.

A: Jewish youth will defend Jewish life and property in the event of riots and the necessity to defend life and property. I, as well as other Jews, would defend myself.

When he asked if she knew of the Haganah and the Palmach, the Haganah's elite mobile assault unit, she lied outright. Feigning ignorance, she claimed not to know if they were "still in existence." Baxter, well aware that this was impossible, asked if the members of these groups, as well as of the Histadrut, "were ready to do all that you said in your speech." At that point, Golda, who had entered the courtroom with the ostensible objective of not provoking the British, threw caution aside. "They are prepared to defend themselves when attacked." She then set

her responses in a personal context. After noting that she had arrived in 1921 in the wake of the Arab riots, she invoked history to justify her stance.

A: When I say we are ready to defend; I want to make myself clear. The defense is not merely theoretical. We still remember the riots of 1921, 1922 and 1929 and the four years of disturbances from 1936 to 1939. Everybody in Palestine knows, as do the authorities, that not only would there have been nothing left, but Jewish honor would have been blemished had there not been people ready for defense, and, if brave Jewish youths had not defended the Jewish settlements.

She then began to elaborate upon what happened in the 1920s, when unarmed Jews in Hebron, Safed, and Tiberias were attacked. At that point, the presiding officer interrupted. Wary of giving Golda the opportunity for a long discourse, he expressed his impatience, but did so in a fashion that seemed to make light of the persecution of Jews. He told Golda that her answers should be limited to this case and "not go backwards, or otherwise we'll soon be back to a period two thousand years ago." Golda's retort was swift, sharp, and not at all nice. "If the Jewish question had been solved two thousand years ago . . . ," she began. The presiding officer, now even more annoyed by her responses, cut her off mid-sentence with an order: "Keep quiet." Golda's response—"I object to being addressed in that manner"—tried his patience even more, and he admonished her: "You should know how to conduct yourself in court." Golda apologized, but not without an admonition of her own clearly indicating that she considered herself his equal. "I beg your pardon if I interrupted you, but you should not address me in that manner." This exchange, which was widely reported in the Palestine press, won her adulation throughout the Yishuv. Here she was, yet again, as she had done at Evian, speaking truth to power. In her memoir she never mentioned this Yishuv-wide

praise. She did recount one response. Immediately following the trial, she visited her parents in Herzliya. Greeting her daughter at the door, her mother announced: "Your father has been out all morning showing the newspaper to the neighbors and saying, 'You see, my Golda!'"[22]

She had one more rather bizarre encounter with Major Baxter, whose cross-examination she so resented. In 1975, when an American poll had just declared Golda "Woman of the Year," Baxter, who was then living in Northern Ireland, wrote to congratulate her. He reminded her of their previous courtroom encounter and, without any of his previous condescension, suggested, "If you are ever looking for a job, I can get you one here in Ulster, where your talents would be valuable."[23] Golda, who by then had retired, did not take him up on the offer.

Though her fights with the British were a constant source of tension, they were not what laid her low. In the fall of 1942 the rumors about the horrific fate of European Jews were confirmed. With all doubt erased, Golda was inconsolable, describing the news as a "message from another planet." From then on, her goal was simple. "There is no Zionism save the rescue of Jews." Though one might assume this was uncontroversial, some of her colleagues saw matters differently. Convinced that European Jewry was doomed and rescue a Sisyphean task, they wanted to devote all resources to building up the Yishuv's infrastructure. Golda demurred. Serious effort had to be made to rescue Jews and aid resistance fighters. She also abandoned what had been until that time the Labor Zionists' preference for immigrants who could be pioneers, that is, young, strong, and disproportionately male. Things were radically different now, she proclaimed. "Now it is a matter of bringing every Jew, not because he is a farmer, but because he is a Jew in the ghetto."[24]

Not all her colleagues agreed. Additional details about what we have come to call the Holocaust arrived in a particularly poignant form. None was more harrowing than the April 1943

message sent by Zionists in the Warsaw ghetto. Camouflaged as a wedding announcement, it poignantly melded Hebrew words with Polish suffixes. "Ami [my people]" and "Miss Hariegevitch [death]" are to wed. Would, the senders inquired, "Mr. Hatslaka [rescue] like to send greetings? If so, he should hurry." Though the Yishuv immediately dispatched 5,000 pounds, hoping it would reach the fighters, Golda was not satisfied. She insisted that they conduct a substantial fundraising campaign. She helped organize a series of small parlor meetings where wealthy people were urged, often strongly so, to give. She was frustrated—if not angered—that many people refused. They justified their reluctance by contending, with good reason, that they were not sure the funds would reach their target. A frustrated Golda complained at a May 1943 Histadrut meeting that people wanted "receipts from a ghetto." She acknowledged that the people responsible for transmitting the money to the Jewish resistance were not angels and that much of it would probably not reach the intended recipients. However, she insisted, that did not obviate the need to do something. In that spirit, she helped convene a workers' conference to organize raising contributions from individual Histadrut members. Participation was lackluster. Rather than concentrate on raising funds, different factions within the Histadrut expended their energies fighting with one another. When these efforts failed, some Histadrut leaders attributed the failure to raise funds to a lack of advertising. Golda dismissed such excuses, wryly noting that a tragedy such as this needed no advertisement.

On occasion, however, the question of what could have been done became quite personal. On the eve of the Warsaw uprising, when those planning the first armed uprising against the Nazis during the war sent Yishuv leaders their poignant message, they had asked whether they should make a last stand. Golda wondered by what right "we in Tel Aviv" could counsel them to die? As had been the case on other occasions, the de-

bate among Yishuv leaders dragged on, and to Golda's frustration, nothing was resolved. Then, as the matter was still being debated, word arrived that the uprising had begun. As Golda recalled after the war, "We broke up our discussions and without any speeches, without anyone saying a word, it was absolutely clear that our lives had been given fresh meaning." The pathos embedded in these recollections was intensified by when she articulated them: in 1946, when Zivia Lubetkin, one of the uprising's few surviving heroes, arrived in Palestine. Golda implored Lubetkin, whom she knew from prewar Zionist gatherings in Europe, to believe that, though she and her colleagues in Tel Aviv had been able to help only in a limited fashion, they had never forgotten these young fighters in Warsaw. "I don't know how to tell you how often we sat in this room throughout those terrible years consumed with only one thought and desire—to make a bridge from us to you, to give you a sign that we were one, to reach you with some act of salvation." She added: "We knew that we were the disciples of one movement, we the parents and you, the children, but on that day [when we learned the uprising had started] we felt the parents were unworthy of the children."[25]

Not content with just raising funds, Golda had looked for other ways to help. In April 1943 Britain and the United States organized the Bermuda Conference, ostensibly to discuss rescue. They rather cynically chose Bermuda precisely because it would be impossible for observers, including those from Jewish organizations, to attend. Golda and Remez hatched a scheme to circulate a petition demanding action. It was to be signed by 2 to 3 million people, Jews and non-Jews. Ben-Gurion, together with many of the other Yishuv leaders, correctly assessed it as a waste of time. It is doubtful that even such a mass request would have changed the minds of British and American policy makers, who were wedded to a policy of "rescue through victory." Notwithstanding the futility of a petition, her efforts to create

it are indicative of her desperate search for some form of response. When both her idea and the Bermuda gathering came to naught, she wondered: "What do we want from the Gentiles, if the *Yishuv* itself has not yet tried to move heaven and earth?"[26]

Finally, toward the end of the war, the British acceded to the Yishuv's request for permission to engage in an actual rescue operation. Golda had implored them to train one thousand people from the Yishuv and drop them behind enemy lines. The British consistently refused until late 1943; with the tide turning against the Germans and more details of the genocide reaching the Allies, they began to train people. After multiple delays, in April 1944 they parachuted thirty-two members of the Yishuv into Axis territory. Even then British officials demonstrated their antipathy toward Jews. Lord Moyne, the British minister for Middle Eastern affairs, approved of parachuting this group into Axis territory not because it might do some good but because it would deflect the "considerable criticism" the British had been receiving from both Jews and humanitarian groups regarding their failure to attempt rescue. The plan offered yet another advantage, Moyne cynically observed. It would "remove from Palestine a number of active and resourceful Jews." This was particularly advantageous since "the chances of many of them returning in the future to give trouble in Palestine seemed slight."[27] Though Golda described this rescue effort as a "desperate attempt to batter our way into Nazi Germany," it was hardly a battering ram. It was far too puny, too little, and too late. A few people were helped. Most of the participants were captured. Some were, as Moyne predicted, killed. And nothing changed. Golda had met with some of the group prior to their departure. Overwhelmed, she sat silently, tears streaming down her face. She may well have come to the same conclusion as Moyne: most would not return. In retrospect, this project could be described as merely a gesture designed to assuage the Yishuv's feelings of guilt or as a desperate attempt to do something, how-

ever limited the chances for success. Years later, historian Dina Porat asked one of the surviving emissaries what they accomplished. His response was unequivocal. "Nothing."[28]

Though Golda kept insisting that the Yishuv do everything possible to help European Jews, there was a fundamental problem. They were powerless. She never explicitly acknowledged it, but she knew it. She had been witness to that powerlessness in Evian. Then she had dreaded what might happen to her fellow Jews. In February 1944, when she spoke to a Histadrut Executive Committee meeting, she knew that Jews had been murdered and the rest of the world had abandoned them. "We have come to realize that there is no friend in the world who will look after our needs with us. . . . What happened in the world in recent years did not increase in me the belief that some international agency, some sort of a League of Nations that will arrive tomorrow, will protect us and help us. . . . Why am I expected to believe that those who did not rescue millions of Jews from death will enter into a quarrel with the Arabs tomorrow because of us? . . . What happened in those years did not intensify in me the trust in an international mandate."[29] The lesson she had learned in Russia as she watched her father nail the boards to the door had been reaffirmed yet again. It would shape the rest of her career.

Not only did she know the Yishuv was powerless, she also knew that most of her efforts made no difference. It is in this context that one can understand Ben-Gurion's surprisingly personal statement about her in 1961. In an informal meeting with a group of foreign students he spoke of Golda, saying, "Lives inside her the Holocaust." It lived inside him too, he told the students, but unlike her, he forced himself to look to the future.[30] While Jews everywhere were shattered, the Yishuv's failure—her failure—to rescue Jews left a visceral imprint on Golda. She believed that she should have been able to do something. The reason for their failure was clear to her; as

she observed in the Knesset years later, "We were weak, we did not have influence, we did not have a state. . . . We did what we could according to our power and it was not much."[31]

In that 1946 encounter with Lubetkin, she stressed how devastated they had been, not just by the news but by their inability to help. Ultimately, however, her April 1943 unrehearsed response when she learned of the devastation of the Warsaw ghetto may have said it better: "Shame on us."[32] She carried that shame with her for the rest of her life. As Ben-Gurion put it: "Lives inside her the Holocaust."

6

<div style="text-align:center">◆┼◆┼◆</div>

"Imagine, We Have a State"

MANY A WORLD WAR II movie or novel depicts concentra-
tion camp survivors raucously cheering as the Allies arrive to
"liberate" them. While this did occur in some places, most camps
were not liberated in the conventional sense of the term. The
guards disappeared. Survivors awoke to find their captors gone.
They soon discovered that their families and communities were
gone too. With little to cheer about, they pondered what was
next. Golda, who was in Tel Aviv, had a similar response. On V-E
Day people in Allied countries were dancing in the street, but
for Jews it was different. It was "not a real day of rejoicing for
us. . . . We couldn't go out in the streets feeling that victory was
ours, knowing, as we did, that a whole third of our people was
no more."[1] In London, Ben-Gurion reacted similarly. Watching
from his hotel window as jubilant crowds celebrated below, he
wrote in his diary: "The day of victory. Sad, very sad."[2]

However, Golda knew precisely what needed to be done

for the survivors. They were to be brought "home," and that homecoming would a step toward the establishment of the state. Though it was unclear if this was where most of the survivors truly wanted to go, Golda operated on the premise that it was. The Yishuv had been unable to rescue them during the war. A determined Golda insisted that this time it would not fail them. Her determination notwithstanding, there still was the matter of the White Paper. The leadership's mood was lightened considerably when, in July 1945, the British Labour Party gained a majority in Parliament. Churchill was out. Clement Attlee replaced him. The British government was now led by a party that had declared itself not bound by the White Paper. Golda, sure that a shared working-class solidarity would cement the alliance between the Labour Party and the Yishuv, fully anticipated that the policy would change. It did change. Quickly. But not in the way Golda and her colleagues anticipated.

Prime Minister Clement Attlee and Foreign Minister Ernest Bevin, strongly influenced by the Foreign Ministry's insistence that the Arabs had to be appeased, became ardent advocates of Britain's existing Palestine policy. (Some of Labour's left wing opposed this decision, but to little avail.) Sounding just like the previous government, the new one argued that it could not risk threatening Arab sensibilities by favoring Jews. Britain had fulfilled its commitment to the Jews. The British had good reason to favor the Arabs. They needed to be wooed, while the Jews had no choices. Golda felt a deep sense of betrayal and dismissed Labour's previous opposition to the White Paper as a political ploy.

In late 1945 the Americans entered the debate, and the fate of the Jewish displaced persons (DPs) took center stage. President Truman, having heard reports about the dismal state of affairs in the camps for Jewish DPs, dispatched University of Pennsylvania Law School professor Earl Harrison to assess their situation. In his report, Harrison described the DPs as "non-

repatriable"; they did not wish to return to their former homes but were intent on going to Palestine. While the extent of their interest in Palestine was open to debate, what was beyond doubt was that few wished to return to their European homes. Harrison acknowledged a certain discomfort in singling out a "particular racial or religious group"—that is, talking only about *Jewish* DPs. However, he argued, in surprisingly straightforward and logical language: "The plain truth is that this was done for so long by the Nazis, that a group has been created which has special needs." Addressing the British refusal to acknowledge the Jewish DPs' particular status, Harrison wrote: "Refusal to recognize the Jews has the effect, in this situation, of closing one's eyes to their former and more barbaric persecution, which has already made them a separate group with greater needs." Truman accepted Harrison's conclusions and immediately urged the British to allocate one hundred thousand immigration certificates to the DPs. "No other single matter," he wrote Attlee, "is so important for those who have known the horrors of the concentration camps . . . as is the future of immigration . . . into Palestine."[3] Truman left unsaid that making Palestine the focus of where the DPs wanted to go also conveniently lessened some of the political pressure on him regarding their entry into the United States.

One cannot but wonder what would have happened had Britain simply agreed to Truman's request. They would have had to placate Arab anger but would have significantly defused the immigration issue. Attlee and Bevin did the exact opposite and more. Instead of just rejecting Truman's request, they engaged in a series of ham-handed decisions, providing the Zionists with a significant public relations cudgel. Using what many people considered barely concealed antisemitic imagery, Bevin famously declared that the recently liberated concentration camps contained people of every different race—Jews, therefore, should not push themselves to "the head of the queue."[4]

Foreign Ministry officials echoed this in their communiqués to their American counterparts. They informed State Department officials that "the Jews are not the only persecuted group" and, in a shocking misstatement of historical fact, contended that "German Christians have, in many cases, suffered almost as badly." Then, exacerbating the situation, they argued that by according the Jews special treatment, they would be validating Nazi ideology by "conceding the contention of the Nazi regime that there should be no place for Jews in Europe."[5] (This was similar to the State Department's stance regarding making the focus of the Evian conference "political refugees" rather than "Jewish refugees." Officials argued that to single out Jews would support what the Nazis were doing—singling out Jews. It was a spurious argument whether it came from Washington in 1938 or London in 1945.)

Yishuv leaders recognized the British missteps and quickly exploited them. Golda knew that having the DP issue on the international agenda handed the Zionists a great propaganda tool. Noting that Bevin was advocating that Jews return to their European homes, Golda asked rhetorically, "This he says in the year 1945, after this war?"[6] As we have seen, Golda had encountered this latent—and sometimes not so latent—hostility regarding Jews among the British officials stationed in Palestine. Now she did so again. The Mandate's chief secretary said to her in a meeting, "Mrs. Meyerson, you must agree that if the Nazis persecuted the Jews, they must have had some reason for it." She stood up, walked out, and never consented to see him again. What confounded her the most was that he made the statement "pleasantly" and was subsequently perplexed as to why she was "so enraged" she did not come to see him anymore. When his colleagues pointed out how appalling his comment was, he insisted, in a stunning example of what might today be called "unconscious prejudice" or what has long been known as the "some of my best friends are" syndrome, "But she knows I did not mean *her*."[7]

In the fall of 1945, as the situation in Palestine deterio-
rated, a frustrated and angry Bevin, having drawn the Americans
into the attempt to find a solution, announced the establish-
ment of an Anglo-American Committee of Inquiry on Palestine,
known as AACOP, to resolve the problem. As the AACOP's ar-
rival in Palestine drew near, Yishuv leaders were divided about
whether to participate or boycott it. Ben-Gurion was skeptical
as to whether anything good could come from such an endeavor.
Others feared that their cooperation would oblige them to sup-
port AACOP's final decision. Golda took a different approach.
In a meeting with her fellow Mapai leaders, she stressed her
knowledge of America and argued that the American public
would not understand why Zionists had boycotted an investi-
gatory commission that gave them the chance to argue their
cause. Her views prevailed, and she was designated by the Jew-
ish Agency Executive as one of seven witnesses to present the
Zionist case. Though she was the Histadrut representative, she
hardly discussed the organization. Instead she devoted most of
her testimony to impressing on the commission the political
immediacy and historic validity of Zionist demands. She began
rather elegiacally with a stanza from Chaim Nachman Bialik's
poem "City of Slaughter." Bialik, whom she rightly described
as the "poet laureate of the Hebrew language," had written the
poem in the wake of the Russian pogroms in the beginning of
the twentieth century.

> I grieve for you, my children, my heart is sad for you,
> Your dead are vainly dead and neither I nor you
> Know why you died or wherefore, nor for whom,
> Even as was your life, so senseless was your doom.

Bialik's poem had resonated, she noted, for the early Zion-
ists. They had decided an "end must be made to [Jews'] senseless
living and senseless dying." Now, in the wake of a senseless dying
that was beyond anyone's imagination, she told the commission

that the creation of an independent Jewish homeland was imperative. Quite strategically, she chose not to describe the horrors of the Holocaust, stressing instead how the Yishuv had been "cursed by helplessness" during those terrible years. Though willing to do anything to help the war effort, there was little the British allowed them to do. Then she essentially threw down the gauntlet, asserting that Jews had decided now was the time to end "this helplessness, this lack of security, this dependence upon others." She concluded in a personal—and decidedly undiplomatic—vein. "I don't know, gentlemen, whether you, who are fortunate enough to belong to the two great democratic nations of Britain and America can realize—with the best will and intention to understand our problems—what it means to belong to a people which is constantly questioned about its very existence. We are constantly being questioned as to whether we have a right to be Jews." When a commission member wondered whether she and her fellow Jews would be satisfied with being granted the same minority rights she was promising the Arabs, she returned to the notion of a Jewish *national* identity. "No sir, because there must be one place where Jews were not a minority." Another member, noting the Yishuv's reliance on Hebrew as its primary language, wondered whether that was an efficacious "means of uniting people in different countries?" Golda returned, yet again, to the notion of a Jewish national identity. "Hebrew is our language, just as English is your language, just as French is the language of the French."[8] (Ironically, she, of course, was more comfortable in English than in Hebrew.)

Her performance won praise from commission members, her colleagues, and the press. It was an antidote to the long, tedious talks by the other—all male—witnesses. The Zionist press waxed rhapsodic, praising both her content and style. The *Palestine Post* said her testimony had "dispelled the uncomfortable court-room atmosphere, the irritation and boredom that had prevailed" by her "direct approach to the essence of the Jewish

problem, her assumption that it was understandable and human." One observer lauded her for having "stolen the show."[9]

But the AACOP visit and Golda's unapologetic testimony did nothing to change British policy on refugees. While the commission was preparing its report, the British waylaid two refugee ships before they could even sail from the Italian Riviera. The passengers began a hunger strike. Golda, attuned to the power of public opinion, especially in the United States, urged the Jewish Agency to organize a corresponding strike by Yishuv leaders. Nine leaders, each representing a different group in the Yishuv, were designated to fast in sympathy. Golda represented the Histadrut. Immediately before they began, she went to the chief secretary of Palestine to urge him to grant permission for the passengers to enter Palestine. The diplomat rather condescendingly inquired: "Mrs. Meyerson, do you think for a moment that his Majesty's government will change its policy because *you* are not going to eat?" She responded with a retort that went straight to the heart of the matter. Assuring him she had no such expectations, she observed, "If the death of six million did not change government policy, I don't expect that my not eating will do so."[10]

The fast, which took place in the Jewish Agency building in Jerusalem, became a national event. People came to offer emotional support. The press, both foreign and domestic, regularly reported on the condition of the fasters. Reporters gravitated to Golda, who had emerged as the group's main spokesperson. By the end of the event, one aide recalled, "There was nobody who didn't know who Golda was." Her son Menahem observed that she had become "more of a VIP, if not a celebrity" and began to worry that the women he dated only liked him "because I am Meir's son."[11]

The AACOP issued its report shortly thereafter, proposing that the land be divided between Arabs and Jews under a UN trusteeship. While Zionist leaders were disappointed that it did

not call for an independent Jewish state, they were pleased that it advocated abolishing the White Paper's immigration limits and immediately admitting the one hundred thousand. Truman was pleased. Bevin was not. Responding with yet another of his tone-deaf comments, he attributed the Americans' support of admitting the one hundred thousand to the fact that they "did not want too many of them [Jews] in New York."[12] (He was not entirely wrong in his assessment of the Americans' strong opposition to the DPs' immigration to America. However, his phrasing was inept at best, and fodder for antisemites at worst.)

On the last Saturday in June 1946, in response to increasing attacks by the Yishuv on Mandate installations, the British imposed a curfew throughout the country, raided Jewish Agency offices, and arrested almost all the leading members of the Zionist Executive and Histadrut. Close to three thousand people were detained in what Golda described as a "war on the *Yishuv*."[13] Strikingly, Golda was not among them. Abba Eban claimed that she resented being excluded and attributed it to a British plot to reduce her standing in the public's eyes to prevent her from rising to higher political office. How important could she be if she were not among those imprisoned behind barbed wire? If Eban was correct that the British aimed to lower her status, they did not succeed; the opposite happened. She became the interim head of the political department of the Jewish Agency, replacing Moshe Sharett, the second most powerful man in the Yishuv, who was among those detained. Officially, she was now second to Ben-Gurion. But he was out of the country.

Support for her holding this position was hardly unanimous. The religious parties considered having a woman in such a high position a violation of "natural law." Even some of her Mapai and Histadrut colleagues contended she was unfit. In addition to speaking Hebrew badly, they argued, she was uneducated and acted based on her emotions, not her intellect. The implicit and overt misogyny in these critiques was not limited to

the Yishuv. Marie Syrkin recalled listening to a group of American Jewish leaders speculate as to who was capable of leading the Yishuv and standing up to the British now that so many leaders had been arrested. When Syrkin mentioned Golda, one participant condescendingly dismissed the suggestion: "A lovely lady. A good speaker, but are you kidding? A woman?"[14] The debate ended when Ben-Gurion supported her appointment. Though Sharett insisted on being consulted, Golda was soon making most of the daily decisions.

The immediate issue was how to respond to the British action against the Yishuv. Golda's support for a maximalist but nonviolent response—nonpayment of taxes and total lack of cooperation with Mandatory officials—was opposed by Chaim Weizmann who, as president of the World Zionist Organization and chair of the Jewish Agency, was still the titular head of the movement and the best-known Zionist worldwide. Weizmann still maintained his faith in the British. Golda disagreed, warning him that after thousands of Jews had been arrested, something had to be done. She had another concern that led her to push for some reaction. She feared that if the Jewish Agency and the Haganah did nothing, they would appear passive in the eyes of members of the Yishuv. The appearance of passivity would enhance the popularity of the two secessionist organizations, the Irgun and Lehi. The Irgun, also known as Etzel, had been formed in the 1930s by young people who had grown disillusioned with the Haganah's policy of "restraint," which precluded terrorist actions against Arabs. During World War II, the Irgun had backtracked on its separatist stance and joined the Haganah in working with the British. However, the more extremist members within its ranks opposed this policy. They broke off and formed Lehi, which the British would dub the Stern Gang.

Golda, fearful that appearing to do nothing would drive young people into the ranks of these two groups, proposed a

campaign of civil disobedience—total noncompliance with the British. Weizmann initially agreed to such a campaign, as long as all attacks on the British and their facilities ended. Golda, feeling that she had no choice, agreed. However, Weizmann soon backed down and returned to his traditionally moderate position. His change of stance left Golda angry, though, unlike Ben-Gurion, she did not openly criticize him. She knew that Weizmann was still the worldwide public face of the Zionist movement and the revered "elder." Ben-Gurion, who was jockeying for control of the movement, could afford to fight with him. She could not. Nonetheless, possibly recognizing that a Yishuv-wide campaign of civil disobedience would be impossible without Weizmann's full support, she pulled back from advocating for this policy.

Within a short time of assuming her position as head of the Jewish Agency's political department, matters were further complicated by the Irgun attack on the iconic King David hotel. Golda claimed to have been completely surprised by it, a claim that beggars the imagination. She may have been surprised by the actual occurrence of the bombing, but Labor leaders knew such an attack was in the offing. For a period of time the Haganah had, in fact, officially cooperated with the Irgun and Lehi. In the wake of the mass arrests of the Yishuv leaders, the Labor leadership, in an effort to coordinate activities with the Irgun, had given the plan tacit approval. However, before the attack was launched, the Labor leadership backed out of this arrangement in response to a demand by Weizmann that the Haganah cease all assaults on the British. The head of the Haganah was to tell the Irgun leaders to cancel the plan. He, however, objected to the cancellation and asked the Lehi command to simply postpone it. The Irgun postponed the attack for a couple of days, but on July 22 proceeded with it. Golda may have anticipated that the attack was cancelled, hence her surprise. The loss of life and injuries were far greater than even the perpetra-

tors anticipated. Opprobrium rained down upon those who organized the bombing from all quarters, including the Yishuv.

Years later, after stepping down as prime minister, Golda would insist that she and her colleagues never cooperated with the Irgun in any operation that might take lives. That claim can be strongly disputed. They may not have been part of operations deliberately *aimed* at taking human life, such as assassinations, but the chance that human life would be taken was always a strong possibility, if not probability, particularly when the Irgun was involved. What was beyond doubt was that in the wake of the King David bombing, any cooperation with these underground groups and their attacks on British installations was now over.

Shortly thereafter a proposal was put forth by Deputy Prime Minister Herbert Morrison and U.S. Ambassador Henry Grady calling for a British trusteeship over autonomous Arab and Jewish areas. Golda considered this even more disastrous than the plans that had preceded it because the British would still be in charge. The plan elided the DP issue in the apparent expectation that once the survivors saw this option languishing, they would return to their homes. Both Arabs and Jews summarily rejected the plan. These developments made the subsequent meeting in August 1946 of the Jewish Agency Zionist Actions Committee in Paris all the more significant. Golda, speaking rather hyperbolically, condemned the British arrests and aggressive searches for armaments as a "pogrom" and concluded that the time for passive resistance had passed. Fearful that Weizmann would be, as he often was, more compliant with the British than the other Zionist leaders wanted him to be, she decried the Morrison-Grady plan as a "trap" and proposed to Ben-Gurion that they fly to London to meet with Weizmann, the aging leader. In their meeting, Weizmann insisted that the Morrison-Grady proposal include room for negotiation and suggested that the Yishuv had provoked the British crackdown. Golda walked out, leaving no doubt that regarding the British, she

was firmly in Ben-Gurion's camp. It would take a long time for her to repair her relationship with Weizmann.

Those gathered in Paris also authorized Nahum Goldmann, who represented the Jewish Agency in Washington, to tell the Americans that the World Zionist Organization supported a partition plan. Ben-Gurion, fearful of being arrested by the British, remained in Europe. It was left to Golda to convince Mapai to accept this decision. Well aware that Haganah members were chomping at the bit to fight, she urged them to accede to a truce and to allow the political leaders, herself included, to decide when force was to be used. Somewhat reluctantly, they agreed.

In 1946 Britain adopted a new, more stringent position regarding the illegal immigrants. No longer would they be detained in Palestine; they would be taken, forcibly if necessary, to camps in Cyprus. Golda recognized that the British were yet again handing the Yishuv a propaganda tool. The optics alone were counterproductive to the British cause. The very people British forces had recently liberated from Nazi camps were now being penned in camps. The very same soldiers who had liberated them were now patrolling the barbed wire that surrounded the camps. As this situation dragged on, Jewish Agency leaders became increasingly distressed by the presence of orphaned and young children in the camps. They arranged with the Mandatory officials to prioritize the children's applications instead of applying a "first in, first out" policy. It was Golda's job to arrange this with the British officer in charge of the Cyprus camp. When she arrived, the officer treated her in a decidedly unpleasant manner and claimed to be unaware of any such arrangements regarding the orphans. Suddenly, in the course of the conversation, his attitude changed. Confused as to what had prompted his change of heart and his willingness to let the orphans leave, Golda later learned that he had received a telegraph from the chief secretary: "Beware of Mrs. Meyerson she is a formidable person."[15]

The subsequent Zionist Congress, the first to meet after the war, was, Golda recalled, less like a political convention and more like "the gathering of a terribly bereaved family mourning the death of multitudes." At the meeting Golda addressed the delegates in Yiddish, still the language in which she was most at ease. Adopting and adapting Natan Alterman's "A Response to an Italian Captain," his well-known ode to the efforts of *Aliyah Bet* to subvert the British blockade and bring in immigrants, she colorfully and emotionally depicted how the Yishuv's young people, the proverbial sabras, reacted when the ships carrying the immigrants neared the shores. They forded the Mediterranean's waves and bore these "Jews ashore on their shoulders." She was not, she told her audience, speaking rhetorically but telling them the literal truth: sixteen- and eighteen-year-old Palestinian girls and boys carried the survivors on their backs. (Alterman had witnessed this from the beach.) She told the delegates that while the tragedy of the Holocaust had decimated the Jewish people, it had only "strengthened our determination to demand that full measure of political independence . . . the establishment of a Jewish state."[16]

By early 1947, Great Britain gave up. Stymied by the political morass, it threw the issue of Palestine into the hands of the United Nations. Once again, another commission, the United Nations Commission on Palestine (UNSCOP), arrived to study the situation. Golda was immediately struck by how little history or background the commission's members knew. On a personal level, there was something even more problematic for her. Sharett, well aware of the great diplomatic significance of the visit, came from Washington to oversee the proceedings. He and Ben-Gurion sidelined Golda. She would not testify or participate in an official capacity. Given her previous highly praised testimonies, public appearances, and interactions with foreign officials, her exclusion was notable. One observer, a graduate of Exeter and Oxford and who went on to a career in Israel's

Foreign Ministry, thought the decision strange, given her great skill at "explain[ing] Jews to non-Jews," something she could do, he observed, "better than almost anyone. She could do it in a time when most of them knew nothing at all about the problems in Palestine. . . . In those days there was a crisis every day and the journalists pulled no punches at the press conferences. But she could handle them, all of them."[17]

Golda decided to attend the Socialist International Conference in Zurich. She was accorded half an hour to address the delegates. She used the time to attack British policy and was received quite positively. But then she did something that surprised and alienated some of those present. The German delegation, headed by Kurt Schumacher, had come hoping to be accepted back into the organization. Schumacher, who had been arrested by the Nazis as a socialist and spent much of the Nazi era in concentrations camps, was among a handful of Germans who, in the immediate postwar period, spoke openly about the genocide of the Jews. However, not everyone in the German delegation had the same impeccable anti-Nazi credentials. Golda was aware of this. In his speech to the gathering, he made but brief mention of the genocide. Golda, who had been dubious about allowing the German socialists back into the organization, determined that their application should be rejected. Despite requests from British, French, and Belgian delegates, she voted against their admission. Then she made matters worse. When Schumacher approached her in an attempt to repair matters, she refused to shake his hand. Some considered this as a principled stand, while others felt it was a major blunder, particularly in light of the Yishuv's need for strong international support. To her critics, it seemed to confirm claims that she acted impulsively and emotionally.

She returned to the Yishuv on the eve of UNSCOP's arrival. Though not among those designated to testify before the delegates—those roles were limited to Weizmann, Ben-Gurion,

and Sharett—she did have informal meetings with them. Nothing they heard from any Yishuv leader, however eloquent or persuasive, could have had the impact of the scenes that they witnessed unfolding in Haifa. The *President Warfield* was an immense ship that had seen service in World War II. After the war, it served as a ferry on the Chesapeake Bay. Badly in need of repairs, it was mothballed. Then the Haganah bought it and renamed it the *Exodus 1947*. They crammed it full of bunk beds and, anticipating a British attempt to board it and prevent it from reaching Palestine, outfitted it with added devices, including barbed wire and pipes that shot hot steam and oil. They sailed it to France, where it was to collect forty-five hundred DPs. The British, who knew about the boat prior to its sailing, appealed to the French to waylay it. When they did not, Bevin exploded and, in one of his not atypical inept outbursts, condemned this "illegal Jewish traffic," which he claimed was really "a financial racket controlled from New York." Three Royal Navy destroyers followed the ship across the Mediterranean. While it was still off the coast of Palestine, British forces boarded the ship. The passengers fought back, hurling whatever they had at the boarding party. The British used tear gas and gained control of the ship. Then the passengers, together with the Haganah representatives on board, raised two enormous banners with the Star of David. The Haganah, attuned to the power of international public opinion, had installed an elaborate radio network and broadcast bulletins regarding events on board. At the last moment, some of the Haganah officers proposed trying to beach the ship in order to allow the passengers to be spirited away. The Jewish Agency leadership, Golda among them, vetoed this proposal. They apparently recognized that the ship was a useful tool to sway international public opinion, especially with UNSCOP still in Palestine. What they did not anticipate was how the British would aid that effort.

The British brought the now disabled ship into Haifa har-

bor, where a number of UNSCOP delegates watched as British soldiers transferred the disheveled and exhausted passengers to prison ships. Everyone, including the assembled reporters, assumed the passengers would be taken to Cyprus. But Bevin had decided to make an example of the *Exodus*. Reasoning that to bring the passengers to Cyprus would constitute a British defeat, he ordered that they should be returned to France. When this became public, the French announced that no one would be forced to disembark. The passengers began a hunger strike. Bevin then demonstrated his unique propensity for enflaming a bad situation. Ignoring warnings from British diplomats that he was providing the public with lurid anti-British propaganda, he instructed that the passengers be compelled—by force if necessary—to disembark in France. While a few passengers got off, the majority refused. Bevin let the ships sit in the summer sun. Conditions were so difficult that some described it as being aboard a "floating Auschwitz." British officials, in a final attempt to get the passengers to disembark, asked Golda to persuade them to do so. She summarily refused, claiming that no Jew would tell a refugee to go anywhere but Palestine. Stymied by passengers who would not disembark, Yishuv leaders who would not tell them to do so, and French officials who would not compel them, Bevin chose an alternative. Once again handing the Yishuv a public relations gift of unimaginable proportions, he ordered that the remaining passengers be taken to the British-occupied zone in Germany. It was not lost on observers that he was returning them to be interned in the country that had murdered their families and rendered them stateless.

As the ships carrying the passengers were preparing to head for Hamburg, Golda spoke to the Va'ad Leumi. Displaying her exquisite ability to hone in on the irony implicit in even the most horrific situations, she noted that passengers who had been killed in the altercation with the British were allowed to remain in the Yishuv, albeit to be buried, while those who survived were

not. She then offered the British what essentially constituted a declaration of war. "Let Britain know that each and every one of us will certainly do what is demanded of him. . . . They will keep on coming and they will enter the land."[18]

While the fate of the *Exodus 1947*'s passengers was being determined, another story was unfolding simultaneously. The British had captured a member of the Irgun who had attacked the Ramat Gan police office. They sentenced him to death. In an attempt to stop his execution, the Irgun kidnapped two British officials and threatened to assassinate them. Golda worried that these Irgun actions would hand the British an excuse to impose martial law on the Jewish inhabitants of Palestine. Her fears were confirmed when she, together with Eliezer Kaplan and Tel Aviv mayor Israel Rokach, were summoned to the high commissioner's office to receive an ultimatum: return the hostages or we will declare martial law and suspend civil liberties. Golda, who loathed the underground groups' "go it alone" strategy, understood the dire implications of the situation and told the high commissioner that the Zionist leadership was thoroughly ashamed. She also recognized that the broad international sympathy for the *Exodus* passengers would dissipate quickly if the British soldiers were killed. Speaking on behalf of the Jewish Agency, she officially refused to help the British find the culprits. Yet that refusal may have been more pro forma than real. The British quickly arrested an array of underground leaders. Despite Golda's claims that she had not aided the British, she was the one the underground blamed. As the chair of the political department, she was the person with the most regular contacts with Mandatory officials. The underground launched a vitriolic campaign dubbed—dispelling all doubt about whom they held responsible—"Operation Golda."

In early September 1947, UNSCOP recommended the partition of Palestine into a Jewish state and an Arab one. Golda, who had so adamantly rejected partition a decade earlier, now

accepted it as a major achievement. Much to the surprise of the Yishuv leadership, the British, frustrated by the political quagmire in Palestine and financially strapped in the wake of World War II, abruptly announced that they would leave Palestine by August 1948, if not sooner. Golda knew that once the British left, the challenge of maintaining the domestic infrastructure would be in the Yishuv's hands. Some Yishuv leaders dismissed Golda's concerns regarding infrastructure as caring about the mundane at a time when the UN was deliberating their future and a conflagration with the Arabs loomed. She saw matters differently. The British, she believed, were not interested in ensuring a peaceful transfer. They preferred that their parting gift to the Yishuv be organized anarchy. They would purposely leave a serious vacuum behind, which meant, she warned her colleagues, no mail, trains, land registry, and money. Ben-Gurion, in a sign of his ever-increasing trust in her abilities, placed her at the head of a new body that would prepare for a general mobilization. But he soon had another task for her.

Ben-Gurion, painfully aware that the Yishuv was in immediate need of a massive array of weapons to fight a real war, dispatched Eliezer Kaplan, the treasurer of the Jewish Agency, to America to raise funds. He had a goal of $7 million. He was unable to raise even a portion of that. In the wake of Kaplan's failure, Ben-Gurion proposed going to the United States himself to raise the funds. Golda, insisting that his place was in the Yishuv, offered to go in his stead. She departed with a shopping list that included jeeps, rockets, speed boats, small warships, medical equipment, tents, blankets, and just about everything else a newly formed army would need. While her colleagues hoped she would fulfill Kaplan's goal of $7 million, she had higher aspirations: $25 million.

Prior to embarking on her fundraising efforts, she joined the Jewish Agency's mission to the United Nations and attended Security Council meetings as an observer. At a press conference

she gave at the United Nations' temporary home at Lake Success, she rather undiplomatically attacked the British for the deliberate chaos and bloodshed they were leaving behind. Not only were they failing to protect the Jewish community, they were arming the Arabs and doing everything possible to place obstacles in the path of a Jewish state.[19]

While her appearance at Lake Success was important, it was the fundraising she did that made this trip memorable. When she had previously come to raise funds, her audiences had generally been committed Zionists who were, like her, immigrants or the children of immigrants from eastern Europe. Their *mame loshn* was Yiddish. They had hosted her in their homes, forced her to sit up late into the night describing the Yishuv's wonders, and proudly contributed the few dollars they had saved. She had met some wealthy businesspeople in her aborted attempt to raise investments for Nachshon. But now she was going to meet a far broader, more powerful, and wealthier swath of the American Jewish community. The general assembly meeting of the Council of Jewish Federations was being held in Chicago. The participants represented the leadership, lay and professional, of virtually every Jewish community in the country. These were not the PW women who said they could smell the blossoms when she described the kibbutz orange orchards. These were certainly not people who ever contemplated, even for a nanosecond, that Palestine was a place for them. In fact, some among them had opposed the Zionist enterprise. In the wake of the Holocaust, their opposition had waned, replaced by a grudging neutrality. Now they were caught between two fears: that a Jewish state might make them less secure in America and that there might be a repetition of the Holocaust tragedy, with Jews again finding no refuge. The right message could push them to support building the Jewish state. The wrong one would confirm their fears and hesitations about such a state and its impact on them as American citizens. The federations' ambivalence

about the Zionist enterprise was evident in the fact that in the five months since the British announcement of their departure from Palestine and two months since the United Nations vote in favor of partition, they had not seen fit to include the topic of Palestine on their agenda. Admittedly, their main focus was domestic matters. Yet one would have imagined they would have addressed, in some context, the welfare of close to seven hundred thousand Jews in potential danger in the Yishuv.

Few of them had interacted with Golda previously. Those who had considered her a rather annoying Zionist apparatchik. Henry Montor, the professional leader of United Jewish Appeal, the organization that handled American Jewish overseas philanthropies, knew her as an "impecunious, unimportant representative, a 'schnorrer.'"[20] But he believed in the cause and knew there was a desperate need to house the DPs. Setting aside his reservations, he pressured the Council of Jewish Federations to make room for her on the agenda. They allotted her thirty minutes. Into that Chicago hotel ballroom on a very snowy Sunday, she brought the skills of persuasion that she had been honing since her Milwaukee textbook campaign. There is a Jewish aphorism: "Words that come from the heart, enter the heart." And so it was that day. Speaking without notes, she melded the Zionist message of Jewish strength with a very American "can-do" spirit. "The Jewish community in Palestine is going to fight to the very end. If we have arms to fight with, we will fight with them. If not, we will fight with stones in our hands. . . . If these seven hundred thousand Jews in Palestine can remain alive, then the Jewish people as such is alive and Jewish independence assured. . . . My friends, we are at war. . . . Our problem is time. . . . The question is: what can we get immediately? . . . I do not mean next month. I do not mean two months from now. I mean now. . . . I am not asking for something easy." Then, breaking with the predilection of some Zionist emissaries to paint Jews in Palestine as better, stronger, and more resilient

Jews than their counterparts outside the Yishuv (even though she probably believed they were), she told them: "We are not the best Jews of the Jewish people. It so happened that we are there, and you are here. I am certain that if you were in Palestine and we were in the United States, you would be doing what we are doing there."

While the Yishuv desperately needed American Jewry's financial support, she did not hesitate to insist that this time, contrary to the norm, the ones who paid the bills would not determine the tune. The Yishuv would make its own decisions. "You cannot decide whether we should fight or not. We will. The Jewish community in Palestine will raise no white flag for the Mufti. That decision is taken." But then making her audience almost full partners in the enterprise, she returned to the choice they could make. "You can only decide one thing: whether we shall be victorious in this fight or whether the Mufti will be victorious. That decision American Jews can make. It has to be quickly, within hours, within days."[21]

A clearly besotted audience member reported to those who had been unable to attend: "Every man and woman who was present . . . will remember. . . . For 35 minutes she spoke. . . . Without emotion, never raising her voice, she told calmly the story of the defense of Jews in Palestine, of their homes and families. . . . Few personalities have ever received the ovation that greeted this woman of valor." Montor, who had so personally disparaged her, recalled the "electric atmosphere" that prevailed in the ballroom, and quickly began to arrange meetings for her in every city where there was a major Jewish community. He traveled with her from place to place, remaining awestruck by her abilities. "She had swept the whole community."[22] And then she did it again. And again.

Her recollection of the greetings she received was a bit less self-centered but equally enthusiastic. "They listened, and they

wept, and they pledged money in amounts that no community had even given before." Within a few weeks she cabled Ben-Gurion: "Secured 15 million [dollars]. I believe by the end of the month, we will have pledges of 20 [million]."[23] Her audiences lived lives that were radically different from hers, yet they responded with unprecedented fervor. In a Miami ballroom filled with men in tuxedoes and jewel-bedecked women, they cheered and, far more important to Golda, they gave. At first she wondered, how "can I, in this beautiful atmosphere, tell what's happening at home?" Yet to her enduring amazement, she raised millions of dollars from those and other well-heeled Jews.[24] Ben-Gurion had hoped she would raise $8 million. She raised $50 million. Her success prompted him to observe that one day it would be said of her, "There was a Jewish woman who got the money to make the state possible."[25]

Her visit marked a number of beginnings. Listening to her speak, American Jews' internalized fear of a repetition of the Holocaust was replaced by—or at least conjoined with—a vision of a new future. She brought a message of hope, something that had been rare for Jews for the preceding decade. Her visit was also the beginning of a relationship Golda would have with the broadest manifestation of American Jewry. They would follow her loyally throughout her career, do what she asked of them, and embrace her in a way that many of her fellow Israelis would not. For this generation of American Jews, she came to epitomize the long-suffering but absolutely resolute mother who would do anything for her people—even at the expense of her own well-being. But she meant more than that. She also spoke of the new breed of Jew, the children at home, the ones who were ready to fight for their people's survival and not depend on others to do so in their stead. She did not look like the young, tanned, open-collared, swaggering sabra who farmed and fought. But she spoke in their name and demanded of American

Jewry that they not abandon them. From that visit on, she occupied a special place in the hearts of American Jews. Nothing would wrest her from it.

But this visit marked yet one more beginning, the beginning of the end of the American Zionist movement. The movement would, of course, grow exponentially during the 1950s and 1960s in the wake of the creation of the new Jewish state, when it would experience some of its strongest years. But Golda, in reaching out to the "whole" community, was telegraphing a new, more all-encompassing message. American Jews did not have to be committed Zionists to be part of this partnership. Their fellow Jews who were building the Jewish state needed help, and they could offer it. And she repeatedly laid out the terms of the partnership. It had its responsibilities. But, she reminded them, it also had its benefits and rewards: "We certainly cannot go on from here without your help. . . . Believe me, my friends, that's all we ask of you—to share in this responsibility with everything that it implies—difficulties, problems, hardships, but also joy."[26] Just three years after learning of the devastating reality of the Shoah, Jews were being asked to do something for other Jews—and to do it with joy. They were being asked to donate not until it hurt but until it felt good, joyously good. This was Golda's genius.

Ben-Gurion, who was regularly sending her reports on the situation at home, wrote that an attack was in the offing that would leave entire portions of the Upper Galilee and Jerusalem besieged and isolated. It may have been messages such as this that prompted her to speak in the most hyperbolic terms. At a large Madison Square Garden rally in New York, she told her audience that American Jews had a choice. They could "either meet in Madison Square Garden to rejoice in the establishment of a Jewish state or . . . meet in Madison Square Garden at another memorial meeting for the Jews in Palestine who are gone." Sheyna, who was with her and who would have been one

of those memorialized, was so appalled by this message that, according to Golda, she wanted to "choke" her.[27] But that did not stop her.

She was not, of course, the first to appeal to American Jews in the postwar period. Ben-Gurion had come and met with some of America's wealthiest Jews. They formed a secret group to buy weapons and retrofit equipment to eventually be shipped to Palestine. But on this trip, Golda did something that even Ben-Gurion, who would be uniquely revered as the first prime minister of the Jewish state, might not have been able to do. She connected with American Jews in a visceral fashion. With her youthful beauty dimmed, no-nonsense clothing, sturdy shoes, unmistakable midwestern accent, amazing talent for extemporaneous speaking, and unique ability to instill in her audience a sense of shared responsibility—some would describe it as guilt— she became and remained an iconic figure for American Jews. They both revered and loved her. She was one of them while simultaneously becoming, as Menahem described it, "a living embodiment" of Israel's rebirth. She was forging a persona that would endure throughout her lifetime. For American Jews, she was emerging as the biblical "Mother in Israel" or, to use the cliché, the Jewish mother who would do anything and everything for her brood but who also expected great things from them.

This was not the only traveling she did during this pre-state period. She took two other crucially important trips, both designed, as was her travel to the United States, to build a bridge that would ensure the fate of the Yishuv. But if her overseas journeys were smashing successes, these other endeavors were polar opposites. In November 1947 and again in May 1948 she met with King Abdullah of Jordan in an attempt to persuade him not to enter the war. He proposed that there be a unified country in which Jews would have autonomy in the areas where they were the majority. This arrangement would be valid for a year. After that, the country would be annexed to Jordan. Golda shot

that down immediately. "It's out of the question." In the second meeting, well aware of the funds that were now at the Yishuv's disposal and the arms—rifles, machine guns, bullets, and more—that were already arriving, she warned the king that their fighting force no longer resembled what it had been but a few months earlier. His autonomy proposal was now even less acceptable. "I believe that about a people that has waited 2000 years, you cannot say that they are 'rushing' into something." Golda assured the king that if there was peace and no invasion from Arab armies, the Yishuv would respect the borders. But if not, she told him, "We will fight and we will win." According to Golda's report, the king responded, "It is your duty to do so." She parted with the wish that "we shall meet after the war."[28] Ultimately nothing came of the exchanges. Jordan joined the war. They never met again.

There are those who argue that Ben-Gurion made a strategic error in sending a woman to negotiate with an Arab leader. Others contend that this was his way of demonstrating that in the Jewish state women would fill prominent roles. There is a certain irony implicit in this. If he was using Golda to make a point to the Arabs about women in leadership, his Yishuv compatriots were making a very different point. While she was in America being feted, cheered, and adored, at home her closest colleagues were determining who would be part of the provisional government. The governing council would have thirteen members, three of whom would come from Mapai. One of those would obviously be Ben-Gurion. He wanted Golda to be one of the other two and told the party leadership that while she deserved it on her own merits, selecting her would demonstrate to the world that this was a country committed to human liberty and equality. They ignored his entreaties; Golda was not chosen. This episode, which she elides in her autobiography and which came after her first meeting with the Jordanian king and while she was enjoying such critical success abroad,

was an early indication of how she would often be more revered outside of Israel than in it.

Upon her departure from the second meeting with the Jordanian king, she returned directly to Tel Aviv to tell Ben-Gurion something that probably did not surprise him at all. An invasion, including from Jordan, was inevitable. Though Golda was not a member of the thirteen-man governing council and thus did not have a vote, she nonetheless attended the meetings at which final decisions were made. The most crucial issue on the table was whether to declare the state or accept a UN-supervised armistice. Remez, her mentor and lover, uncertain of the ability of the Yishuv to withstand an attack by Arabs, wanted to wait. (It may have been Remez's moderate views that in part prompted Ben-Gurion to push for Golda's inclusion in the provisional government rather than Remez's.) She disdained moderation. Echoing Ben-Gurion, she insisted that despite the precarious military situation, "we must go all the way. We cannot zigzag." In his biography of her, Medzini suggests that her strong words helped to influence the decision to declare statehood.[29]

Golda was not scheduled to be present at the official declaration of the new state and the signing of its founding document. Anticipating an assault by Arab armies, Ben-Gurion insisted that she fly on May 13 to Jerusalem and remain there as the temporary liaison with the foreign consulates, the UN, and the Red Cross. Her plane took off but developed engine trouble and returned to Tel Aviv. The trip was aborted. She joined the final debates and the subsequent day's signing. (Prior to the signing, there was one matter that still needed to be resolved. It did not concern armaments, defense strategies, or foreign relations. As the soon-to-be-proclaimed state readied for an attack, its leaders debated whether—and, if so, how—to mention God in the Declaration of Independence. The Orthodox Mizrachi party insisted the text must include an explicit reference. The left-wing parties opposed with equal vigor. In the end the more

amorphous term "Rock of Israel" was used and the crisis was averted.)

On May 14, 1948, a weeping Golda, as a member of the People's Council, was among the twenty-five—just two of them were women—signatories. Then, two days later, she was on her way back to the United States. American Jewish leaders had cabled; she must come. There were funds to be raised, and no one could do that better than Golda. Upon her return to New York, she met with her good friend Marie Syrkin. Reunited for the first time since the state's establishment, they were engrossed in conversation when, Syrkin recalled, Golda stopped mid-sentence and said, "'We have a state; imagine, we have a state.'" Syrkin, moved by the "almost childish delight" with which she said it, found it "way more touching that the historic solemnity" that had accompanied the official declaration. Golda's "joy was personal, intimate."[30]

7

A Return to Russia

COUNTLESS PHOTOGRAPHS capture Golda's role in Israel's history, including her signing the Declaration of Independence, embracing a soldier at the Western Wall during the Six-Day War, sitting with heads of state, and meeting Egypt's president Anwar Sadat at the Knesset to welcome him to Israel. However, one picture stands out from the rest, despite the fact that it is not of the best quality and she is barely visible. It was taken on Rosh Hashanah 1948 in front of Moscow's Choral synagogue. Engulfed in a sea of Moscow Jews, she is so obscured in the photo that when it is reproduced, editors often place an arrow pointing at her head so the viewer can identify her.

She had arrived in Moscow a few weeks earlier to serve as Israel's minister plenipotentiary to the USSR. Estimates of the size of the crowd vary markedly, ranging from ten thousand to fifty thousand. (The Soviets reported ten thousand and the Israelis fifty thousand. The former may have been inclined to sup-

press the numbers and the Israelis to exaggerate them.) What is not in dispute is that the crowd, many of whose members had heard a rumor that she might be there, was far larger than those that generally gathered outside the synagogue on Rosh Hashanah. When Golda appeared, people cheered, applauded, reached out to touch her, and shouted greetings in Russian, Hebrew, and Yiddish.

Decades later, some Soviet Jews who led the fight for the right to emigrate cited this event as a pivotal moment in their personal history, one that helped awaken a "spark" in them. In 1972 an elderly woman at the Moscow synagogue pulled me aside and, after ensuring there was no one within earshot, quietly but proudly proclaimed: "When Golda visited, I was there." Americans asserting that their family had arrived on the *Mayflower* could not have boasted more fervently.

Today the encounter between Golda and Soviet Jews is remembered in one of two ways. Her admirers consider it an event that demonstrated her bravery in bucking Stalinist authoritarianism and helped lay the groundwork for the revitalization of Jewish identity in the Soviet Union. Her critics accuse her of thoughtlessly and needlessly precipitating a horrific wave of Stalinist persecution that would decimate the Jewish community for decades thereafter. There is both fact and propagandistic fantasy in each claim.

Her presence in Moscow as Israel's first representative to the USSR was not something Golda had anticipated. She did not speak the language, had little familiarity with the intricacies of Stalinist political intrigue, and was strongly associated by the Soviets with their existential enemy, the United States. Most important, she desperately wanted to remain in the new state for which she had worked so hard. Israel's own political intrigue served to send her to Moscow. While the appointment could be considered a great honor, it was also a move by Sharett, now the foreign minister, to sideline her. He had been conduct-

ing the Yishuv's international political negotiations in New York and Washington. Golda had been performing parallel tasks in Jerusalem as the Yishuv's primary liaison to the Mandatory power. But Sharett had returned and, anxious to secure his hold on foreign affairs, immediately absorbed both the tasks she had performed and her staff into his ministry's bureaucracy. He did not choose her for the Moscow position because of his high regard for her diplomatic abilities. Quite the contrary; he found her unprofessional and emotional, with an "inferiority complex" and a "half-bred education."[1] He wanted her out of the way. Sharett, aware that she had no portfolio and that her views were closer to Ben-Gurion's activism than his moderation, worried that she might inject herself onto his turf or, even worse, be designated by Ben-Gurion as the ambassador to America. Sharett had a candidate for that job who was entirely loyal to him. He needed to ensure that she did not trespass on his turf. Sending her to Moscow was the solution.

When Sharett initially offered Golda the job, she declined. But Sharett, having convinced Ben-Gurion of the wisdom of the appointment, announced it to the press. For her to back out after that would have caused a rift with Moscow. Sharett sweetened the deal by arranging for her daughter, Sarah, and son-in-law to be part of the delegation. Much of this political jockeying took place while she was raising funds in America. On the day before her return to Israel, the New York taxi in which she was riding was in a traffic accident. Although she was hospitalized with a seriously injured leg, the Foreign Ministry pressured her to return to Israel quickly so that she could assume the Moscow position. She left the hospital before her leg was fully healed, a decision that would cause her problems for the rest of her life.

She arrived in Moscow in late August. The Israeli delegation was to be housed at the Metropole, a legendary Moscow hotel. It had a rich history but was expensive, as was anything that might bring foreign currency to the USSR. Golda had a

limited budget and was loath, in any case, to be profligate. In order to conserve funds, she decided to organize matters along the lines of a kibbutz. No one received a salary. All expenses were paid from a central fund. Members were given pocket money. She and her aides bought food at the market. Meals, which she helped prepare, were eaten together in her room. (The staff resented this arrangement and ensured that it did not outlast her tenure. As soon as Golda returned to Tel Aviv, it was abandoned and, to the delegation's relief, salaries were reinstated.)

Now that she was a diplomat, Golda had to deal with issues she generally eschewed, such as what to wear to formal events, a topic to which she paid serious attention. But she did have more significant agenda items, primary among them fostering bilateral ties between the new state and the USSR, which now was a global power. While in retrospect, it is clear that Israel and Moscow would move in opposite political directions, this was still what Golda described as the two countries' "honeymoon" period. Israelis, Golda among them, hoped that the new state could politically align itself with neutral nations, rather than either the USSR or the United States.

The Soviet Union had been the third country to recognize Israel's independence. Since it had previously been decidedly opposed to Zionism and a Jewish ethnic state, this support came as a surprise. The reversal may have been prompted by an expectation that Labor Zionism, with its deep commitment to a socialist-oriented culture and economy, would prove an ally and allow the USSR to achieve a physical toehold in the Middle East. It may have also been an effort to split the postwar alliance between Britain and the United States. More than just recognize the new state, the Soviets allowed communist bloc countries to provide tangible support. Czechoslovakia sold Israel armaments and Romania sold oil. Yugoslavia had granted Israel landing rights to facilitate the transport of arms. This support was particularly important in light of the American-imposed

arms embargo. Golda hoped to also convince the Soviets to provide arms.

But Golda had yet another agenda item. She and the rest of the delegation were intensely curious about the Soviet Jewish community. In the aftermath of the government's announcement of its support for a Jewish state, Soviet Jews, throwing caution to the wind, had openly celebrated. One Soviet Jew described the reaction of his fellow Jews as akin to "an incurable paralytic who was suddenly told he would yet run. . . . To the cry of 'You—Yid' [the derogatory word Russians used for Jews], one could proudly answer, 'No, I am a Jew.'"[2] Intrigued by these reports, the Israeli legation arrived eager to connect with those who remained alive in the wake of Nazi persecution. Unsure whether this remnant could legitimately even be called a community, they decided there was one way to find out. It was the same way, thirty years later, Jews from abroad would physically make contact with Soviet Jews: at the synagogue. On the Shabbat following the official presentation of her diplomatic credentials, Golda and other members of the legation, including the military attaché in full uniform, arrived at Moscow's sparsely attended main synagogue. Golda, adhering to Orthodox custom, sat in the women's balcony. She was struck by the fact that the congregation was composed primarily of a few shabbily dressed elderly people. At the end of the service, she was surprised when, during his recitation of the prayer for the government and leaders, the rabbi included her name.

After the service, Golda descended from the balcony, approached the rabbi, and greeted him in Hebrew. According to a secret report submitted to Foreign Minister Molotov by the Soviet Council for the Affairs of Religious Cults, the agency tasked with spying on any religious gathering, she burst into tears. Since the report may have been written to demean her, whether she actually wept is open to question. (In fairness to the Soviet spies, she was known to cry a lot.) That she was deeply

moved by what occurred next is beyond doubt. One young member of the delegation called the scene "indescribable." One of the Israelis recalled that as they walked out of the service, "every man and woman shook our hands and heaped blessings upon us." They called out "*mazal tov.*" Some, with tears in their eyes, "whispered the *Shehecheyanu* blessing," the blessing Jews recite on momentous occasions.[3] Some congregants applauded. Others followed Golda back to the hotel, surreptitiously sharing words of greeting and blessing. In years to come, she frequently mentioned this event.

Unbeknownst to her, Stalin was already unnerved by the enthusiasm with which Soviet Jews had greeted the recognition of Israel. He had instructed the well-known Jewish writer and loyal communist operative Ilya Ehrenburg to write an article establishing that the Soviet political recognition of Israel was something wholly separate and apart from Jewish identity among Soviet Jews. After reading a draft of Ehrenburg's article, Stalin instructed that it be published in the most important newspaper, *Pravda*. Appearing less than three weeks after Golda's arrival, the article posited that Soviet Jews had no need for a connection to a Jewish state. It dismissed the notion that Jews in communist countries would ever be tempted by the "yoke of capitalist exploitation." The attempt to connect Israel with Soviet Jews was the work of "obscurantists," who ridiculously asserted "that the Jews of different countries are united by some mysterious ties." It concluded by declaring that "the fate of Jewish workers of all countries is not linked to the fate of the State of Israel, but with the fate of progress, with the fate of socialism."[4]

Ehrenburg's article was an unequivocal signal from Soviet authorities that they considered Jewish interest in and enthusiasm for the new state and its representative a provocation. A few weeks later, on Rosh Hashanah, Golda returned to the synagogue. She may have assumed that the Soviets, who appeared

to be supportive of the new state and were eager to bring it into the bloc of anti-capitalist nations, would countenance her appearance there. She clearly did not anticipate how different this visit would be from her first one. Russian Jews, having heard she might attend, packed the street. She described for her Tel Aviv colleagues how, as she made her way to the sanctuary, the crowds applauded and engaged in "thunderous cheers and cries in Hebrew: *heydad*, shalom." In the now-packed sanctuary, the rabbi, aware that government authorities were present, tried to quiet the gathering by telling them that such behavior was unacceptable in a synagogue. The ever-present Kremlin spies reported to Foreign Secretary Molotov that when the rabbi attempted to silence the crowd, many people expressed "dissatisfaction" and declared that "we have waited 2000 years for this event, how can you forbid us to display our feelings?" An American reporter who was present wrote that when Golda left the synagogue a "huge crowd formed a spontaneous procession." It emitted "an impassioned, almost hysterical outburst of feeling. . . . Jewish men and women broke out in tears and cried out aloud: 'Tomorrow to Jerusalem.'"[5] Golda knew that this adulation was not about her personally. Referencing this moment, she later observed, "If you had sent a broomstick to Moscow and said it represented the State of Israel, it would have received the same welcome."[6] But Tel Aviv had not sent a broomstick. It had sent her, and she would be forever linked to this moment.

When she and the delegation returned ten days later, on Yom Kippur, there was a similar scene. Clearly, Ehrenburg's assertion that the State of Israel meant nothing to the Jews of the USSR was wrong. His warning that Jews must stay away from Israel and Israelis had, Golda noted, "fallen on deaf ears." Her report to the Foreign Ministry evoked how this encounter had aroused her deep-seated emotions. "For thirty years we and they have been separated. Now we were together again, and as I watch them, I knew that no threat, however awful, could have possibly

stopped the ecstatic people I saw in the synagogue that day from telling us, in their own way, what Israel meant to them."[7]

Though Golda hoped these Jews would emigrate, she was exceptionally careful not to openly raise that idea with Soviet officials. She knew that they would never countenance even a suggestion that some Jews might be desirous of leaving a "workers' paradise," particularly if their destination was a non-communist state with a religious/ethnic identity. She repeatedly reassured her Foreign Ministry colleagues that in her discussions with Soviet officials, she "did not, by any means, ask for the emigration of Jews from Russia." She feared that should she ask for permission for them to leave and her request be rejected, all emigration from Soviet bloc countries would end. Within a few months of her arrival, she had correctly discerned that not only would there be no massive exodus from the USSR, but that the end of the exodus from eastern Europe was also in sight.

Golda did discuss with Soviet officials a specific group of Soviet Jews. She asked about the reunification of families who had been split up as a result of the war. Not surprisingly, the Soviets rejected the idea. She then raised a more modest idea. Some members of the Israeli delegation had elderly parents and siblings in the USSR, many of whom needed aid. The Israelis wanted permission to reach out to them, even for just a visit. After asking a number of times, Golda reluctantly decided that "it would be best to do nothing at all." Any form of contact with these families might hurt rather than help. That decision did not stop Soviet officials from subsequently accusing her of urging Soviet Jews to emigrate.[8]

Her certitude that no threat could keep these Jews away from seeing her was soon tested and found wanting. Jews heard rumors that the secret police planned to retaliate against this show of affection. They did not return. The crowds were gone. Jews, who had visited the delegation at their hotel, stopped com-

ing. When Golda first attended the Yiddish theater, she was often approached by Jews. Eventually, that too stopped. People grew afraid to speak with her. But not everyone was dissuaded. In November, at a party celebrating the Russian Revolution, Golda was approached by Polina Zhemchuzhina, Foreign Minister Molotov's wife, who began to converse in Russian. When she realized that Golda did not understand her, she, either recklessly or bravely, began to speak in Yiddish, proclaiming herself a *Yiddishe tochter*, a Jewish woman. With diplomats and Soviet officials listening, she praised Golda for having come to the synagogue and asked Golda's daughter to describe life on the kibbutz. (She was surprised to learn that everything on it was community property, noting that even Stalin permitted Soviet citizens their own possessions.) At the end of the conversation she embraced Sarah and, wishing her well, declared. "If everything goes well with you, it will go well for all Jews everywhere."[9] Zhemchuzhina was already distrusted and disliked by Stalin. This may have been the final straw. Shortly thereafter, she was exiled from Moscow to a labor camp, where she remained for a number of years. Stalin would soon impose terrible restrictions on Soviet Jews. Within a few months the Yiddish theater, newspaper, and publishing house were closed. Leaders—rabbis, intellectuals, and other prominent Jews—were arrested and deported to Siberia. Jewish institutions were shuttered. Over the following years, as Stalinist persecution intensified, Jews who had interacted with Golda, even as part of officially sponsored meetings, were arrested. Regardless of how they felt about Golda or Israel, Soviet Jews were frightened.[10]

Her Moscow tenure was becoming rather stultifying, at best. She discovered what many foreign diplomats already knew, that there was relatively little for her delegation to do. They could not interact with the media or public, as they might do in other countries. Any meeting with "regular" Soviet citizens was carefully orchestrated by the authorities. When she returned to Is-

rael in the winter for a visit, she quickly discerned how much there was to accomplish at home. Ben-Gurion, having promised her that the Moscow posting would be short, assured her that after the general elections in late January, she would get a government portfolio. Sharett, none too happy with the idea of her back in Israel, tried to extend her tenure but finally, in April, after getting the Soviets to accept the idea of upgrading the Israeli presence from a "legation" to an "embassy" and securing a beautiful and well-established building as a permanent home, she came home. At the end of her stay, she returned to the synagogue to bid farewell to those Jews who had risked so much to greet and celebrate her. This time, however, government pressure had accomplished its goal. "There were," she recalled, "no more crowds."[11]

The Soviets, anxious to diminish any affection Soviet Jews might have felt for Golda and to paint her in a dark light, spread the rumor that she had been recalled because she demanded that Soviet officials allow Jews to emigrate. She may have indirectly touched on this issue when she raised the subject of family reunification. However, she recognized that specific requests to emigrate were forbidden ground for the Soviets.[12] When she returned to Israel, she spoke little about her Moscow experience to avoid endangering those Jews who had greeted her. But she watched with dismay when Soviet satellites conducted a series of antisemitic show trials. Then, in 1953, the Stalinist campaign against Jews reached its peak. A group of leading Soviet doctors, most of them Jews, were arrested and accused of murdering a Soviet official and plotting to kill Soviet leaders. Ignoring the fact that this "Doctors' Plot" beggared the imagination, journalists as well as the public sought some rationale for the charges. Reporters asked Golda if the plot might have been connected to her time in Moscow. Assuming that it was safer to say nothing, she dodged their questions. Ironically, her refusal to speak out, coupled with the Soviet-inspired rumor campaign

against her, convinced many people that she bore responsibility. She may have underestimated Stalin's hypersensitivity to anything that smacked of an ethnic identity separate and apart from a Soviet one. But she had adhered to diplomatic niceties. Keenly aware of her lack of expertise in Soviet affairs, in virtually every meeting with government officials, she had brought one or two of her own experts with her.[13]

Tensions between Israel and the USSR escalated when a grenade was thrown at the Czech embassy and a bomb went off at the Soviet legation in Tel Aviv. Israel officially condemned the acts, but the Soviets severed diplomatic relations with Israel and recalled its representatives. In the subsequent debate in the Knesset, left-wing opposition parties, furious at this breach in relations, blamed Israel—and by extension Golda—for the rupture. Responding with a barely suppressed rage, she denounced the "spiritual pogrom" being waged by the Soviet Union against both Judaism and Zionism and described Ehrenburg, who had written the vituperative attack on those Soviet Jews who felt an emotional connection to Israel, as a person who had lost his self-respect as a Jew and a human being.[14]

The intensity of the Soviet campaign against Jews—together with the Soviet decision to rupture relations—prompted Ben-Gurion to conclude that Israel had to respond. He dispatched Golda to deliver Israel's response at the UN. By the time she arrived in New York, Stalin had died and the charges against the doctors had been dropped because, the new Soviet leadership acknowledged, they were false. The Soviets anticipated that this might end the issue, but Golda persisted. Addressing "the libel of an alleged world Jewish conspiracy," she denounced the use of antisemitism "as an instrument of policy." The Soviet charges were "evil nonsense" that could "degenerate" into acts that would bring "suffering upon the Jewish people." She concluded by articulating what she had so assiduously avoided saying in Moscow and in the years since her return. She demanded

that Jews living in the Soviet bloc be allowed "the normal degree of self-determination . . . and the freedom to join the collective efforts of the Jewish people in Israel."[15] She had put the issues of Soviet antisemitism and emigration, and the links between the two, on the international table in an unprecedented fashion.

Ultimately, the accusation that her behavior in Moscow had prompted Stalin to begin his antisemitic campaign is overstated. So too is the credit she often receives for arousing the passions of an oppressed people. Ultimately, it is highly doubtful that she was responsible for either. Stalin, whose paranoia about perceived enemies in general and Jews in particular was well developed, did not need her visit to the synagogue to provoke his antisemitism. He had commissioned Ehrenburg's article before Soviet Jews had demonstrated any interest in and affection for Golda. However, Soviet Jews' open expression of a deep connection to Israel and their unbridled joy at its creation may well have demonstrated to both Stalin and the Soviet leaders who succeeded him that Jews, as loyal at they were to the USSR, harbored a deep-seated connection to other Jews and to the new Jewish state.

Golda's decision to attend synagogue with the entire Israeli delegation highlighted both what had never been extinguished and what had been strengthened by the creation of the new state. Those passions could be suppressed by the authorities but, as the Refusenik movement of the 1970s and 1980 would eventually demonstrate, they could not be obliterated. I was in the USSR in 1972, at the beginning of the Refusenik movement. Most of those I met were quite young when Golda was in Moscow. But her presence remained a touchstone for them. Even those who were not alive when it happened seemed to "remember" it. She did not ignite the movement, but once it emerged, the memory of her visit fueled it for many Soviet Jews.

While her impact on Soviet Jewry is open to debate, what

is clear beyond measure is that Golda's time there, as brief as it was, awoke in her an emotion that she may not have been fully cognizant of until those encounters. She deeply identified with these Jews. She needed no reminding that had her parents not left, she would have been among them. But there was a "bigger" reason. Since the end of World War II, she had repeatedly given voice to feelings that she, together with the entire Yishuv, had not done enough to rescue Jews. "Shame on us," she had declared. When she met survivors, she often spoke of the burden of guilt she bore for failing them. In Moscow she encountered, in the words of the prophet Zechariah, the "remnant plucked from the ashes." They had survived the Holocaust, but they were still not free. Here was a community that needed to be rescued.

Privately, she was afraid that she had caused Soviet Jews harm. She worried that some of those who had reached out to her at the synagogue had been arrested or detained. In the wake of the Doctors' Plot, Golda had asked some Israelis still in Moscow to quietly investigate. Eventually that effort morphed into a secretive Israeli effort to reach out to Soviet Jews and try to assist them in strengthening their Jewish identity. Known as Lishkat Hakesher (the Liaison Office), the organization became one of the primary linchpins in helping the Soviet Jewry movement mobilize during the 1970s and 1980s. The office was officially situated in the prime minister's office, but during her years as foreign minister Golda maintained a close involvement with it and strengthened its infrastructure. Years later, while prime minister, she authorized the convening of an international conference on the plight of Soviet Jews. The 1971 Brussels conference, attended by eight hundred delegates from thirty-eight countries, helped transform Soviet Jewry from a fringe Jewish communal issue into a global international movement. A few years earlier, her predecessor, Levi Eshkol, whose concerns about oppressed Jews were probably as strong as hers,

had rejected the proposal. He may well have doubted the efficacy of investing Israel's limited resources in such an effort. Unlike Eshkol, Golda took the chance. One can only speculate whether she would have done so had she not been engulfed on a Moscow street on a Rosh Hashanah morning by that sea of Jewish well-wishers.

8

---◆|◆|◆---

Minister of Labor: "Seven Good Years"

GOLDA'S RETURN FROM MOSCOW to become minister of labor was the beginning of what she described, using biblical terms, as her "seven good years." Everything about both her status and her task was the polar opposite of her Soviet experience. In Moscow she, who had become known for speaking her mind forcefully with few restraints, had been stymied by having to adhere to traditional diplomatic niceties, niceties that were particularly opaque in Stalinist Russia. In addition, in Moscow she had to report to a bureaucracy led by a man who was not enamored of her. She was anything but an independent operator.

In contrast, being minister of labor was a task for which she was eminently suited and well prepared. It necessitated action. She had always cared about social welfare issues, and during her tenure she would put her personal ideological, social, and political stamp on Israeli society. Few among the many Israelis who today depend on their social security, consider their paid vaca-

tions an inherent right, enjoy some of the most generous laws regarding maternal leave, and are protected by a myriad of labor laws know that it was Golda who insisted, in the face of tough opposition, that these laws must be foundational elements of the State of Israel. Her impassioned—some would say stubborn—stances on immigration and social welfare legislation shape Israeli society to this day, even now when Labor Zionism is barely a shadow of its former self. The fact that she ferociously fought for social legislation in the face of opposition from her own political allies makes her accomplishments all the more remarkable.

When she assumed office in mid-1949, Israel faced a major domestic challenge: a surge of immigrants. Arriving at the rate of thirty thousand a month—one thousand a day—they came from European DP camps, Yemen, Iraq, Bulgaria, Yugoslavia, Syria, and Lebanon, among other countries. As a result, within a few short years, Israel's Jewish population would more than double. Golda was tasked with finding the immigrants housing and employment. The sheer size of the population surge would have challenged even the most highly developed country, which Israel certainly was not. But it was not just the scale of the immigration and Israel's defense challenges that made the situation difficult. The immigrants had significant social, cultural, and national differences. Some came from prosperous countries, while others had never seen or used modern conveniences such as flushing toilets. Some came primed with Zionist convictions, while others were simply anxious to find a refuge because their homelands had ejected them. Some were staunchly secular, while others were deeply observant. Even among the religiously observant, there were stark contrasts. The modern Orthodox Jew from Germany, who had found a means of negotiating religious strictures and secular opportunities, found it hard to relate to Yemenite Jew, whose traditions had barely changed in hundreds of years.

There was yet another challenge: the matter of trauma.

Though some of the newcomers were young and fit, many were elderly or beset by mental and social ills. Virtually all—young and old, fit and ill—had endured multiple traumas during and after the Holocaust, including the loss of their entire families, cultures, and traditions. Some had weathered DP camps, furtive escapes from Europe, and then internment by the British. Other groups, particularly those from North Africa and the Middle East, had not endured the Holocaust but had—through force or by choice—left countries where they had lived for generations, if not millennia, to come to the Jewish state.

And there was yet another fault line that Golda had to breach. It was the division between the veterans and the new immigrants. The veterans, those who built up the Yishuv despite British restrictions and Arab hostility, believed that now that the battle had been won, they deserved enhanced housing, a modicum of creature comforts, and fundamental improvements to the long-neglected infrastructure of their cities, towns, and villages. Meanwhile, immigrants were arriving in great numbers. Most were empty handed. They needed everything. Golda's sympathies were with the immigrants. She feared that two "separate nations" were emerging and that it might well become impossible to "bridge this abyss" between them. She warned the veterans that their demands for material comforts would come at a cost. When a veteran "sits at a table, puts on a suit, makes improvements to his house, does something for his child, he is doing so—let him realize it every minute of the day—at the expense of the immigrants." She then added the precisely aimed barb that she used so well: "Let's see how he'll enjoy life with this realization."[1] Her contempt for the veterans' "I deserve it" sentiment would become even more pronounced in coming years.

Some Israelis began to debate whether the government should institute a more selective immigration policy. Could a new state that had few financial resources and faced serious mil-

itary challenges afford a policy of "unrestricted immigration"? Ben-Gurion insisted that this must be Israel's policy. Everyone—regardless of their physical, emotional, or educational status—should be welcomed. Golda fully concurred with Ben-Gurion and devoted herself to realizing this ideal. For her, a Jewish state that had a "high standard of living, without a big Jewish immigration" was an oxymoron. Welcoming immigrants was, in Golda's estimation, more than just the realization of the Zionist ideal. It was a matter of rectifying history. She carried the emotional and moral legacy of her "failure" to rescue Jews during the Holocaust and the recent memories of her battles with the British, who had prevented Jews, including those fleeing persecution, from reaching the Yishuv. Her single-minded commitment to "rescue and redemption" had been reinforced by her encounters with Moscow's Jews. She believed time was of the essence. Doors, particularly those in eastern Europe, that were now partially open might soon be closed. (Her fears proved prescient.)

But not all her colleagues agreed. How, they asked her, could the state care for immigrants who were weak, ill, mentally unstable, and aged? Even veterans such as Eshkol, a future prime minister, declared, "Israel is a small country and cannot take in all the crazy Jews in the world." Kaplan, the minister of finance, put it slightly more delicately. "We need workers and fighters." The head of the Jewish Agency's Department of Immigrant Absorption was blunt: "Israel wants immigration, but the Israelis don't want immigrants."[2] While some might have felt the doubters were being painfully realistic, Golda saw irony, if not hypocrisy, in their stance. For decades they had fought the British restrictions on immigration. Now they seemed to be inclined to reinstate them.

The open immigration policy eventually prevailed, but it brought serious challenges that Golda was tasked with resolving. The immigrants needed shelter and employment. Their chil-

dren needed schools. Scrambling, she set a goal—thirty thousand homes in a year—that was clearly unrealistic, given the shortage of both building materials and experienced workers. She designed one-room homes to shelter entire families. Not only was it a single room but, channeling her starkest socialist impulses, she declared it would be spartan in the extreme. "We intend to provide a roof. Not a ceiling—a roof. No plaster—only whitewash." She had no doubts that the "immigrant himself will in time plaster the walls and add a ceiling. A few months later he will add a room and a porch." When her Knesset critics challenged her about this, she, the veteran of life in Merhavia, where tin cups were shared and everything was in short supply, justified the single-room concept, arguing that a family of three or even four could live in a single room.[3] But she had to fight for funds even for these simple structures. Eshkol, who was now finance minister, objected to allocating money for housing. Houses did not produce revenue. Houses did not produce milk. Cows did. There was money available for cows, not houses. But she didn't need bovines. She needed dwellings.

Ultimately, she prevailed and was allocated the funds, but given the growing rate of immigration, the allocations were always insufficient. Soon Golda was housing the newcomers in tents that in summer were unbearably hot and in winter too flimsy to withstand the wind and rain. Many people—both new immigrants and long-time residents—complained that these conditions were intolerable. She considered these complaints about conditions a luxury the country could ill afford. It is easy, particularly in retrospect, to critique what she was doing. But it was well-nigh impossible to plan for the systematic absorption of arrivals when no one knew how many would come or what their condition would be. This was something unlike anything ever accomplished—much less attempted—by another country. Golda, never hesitant to criticize those she considered duplicitous, called to account her fellow "old-timers," including the

much-revered kibbutz members, for their failure to help. They "sang songs and wrote articles, and made ardent speeches about immigrant absorption," but refused on ideological grounds to hire workers, including immigrants. What, she wondered, were they actually were doing to help "a Yemenite family advance to a home and the minimum necessary for existence"? Ben-Gurion, expressing a similar disappointment, declared he was ashamed of the kibbutz movement. Despite these critiques, little changed.

But the tension was rooted in more than just the divide between newcomers and veterans. Racism, both implicit and explicit, also played a role. Ashkenazim may have welcomed the Middle Eastern (Mizrahi) Jews, but they felt culturally and racially superior to them. Even those who were happy to see them come, which was probably the vast majority of Jewish Israelis, believed that if social integration succeeded, these Mizrahim would become like "us," that is, Ashkenazim. Even Golda, who regularly berated the veterans for not being sufficiently supportive of immigrants, gave voice to this patronizing attitude. During a debate on unemployment and the costs of resettlement, she mused: "Should we regret that Jews from Yemen, Jews from Iraq, Jews from Morocco and from Tunis didn't know how to work, weren't used to work and later they got used to it?"[4] Notably, she mentioned only Mizrahi Jews when she made the absurd and prejudicial suggestion that after centuries of lolling around, they only got "used" to work after they arrived in Israel.

All these obstacles and fights notwithstanding, Golda's accomplishments as minister of labor were impressive, even if the public rarely credited her for them. (She was perennially annoyed that when she visited immigrant neighborhood and absorption centers, all she heard were complaints, rarely a thank-you.) By the time she left office, 130,000 housing units had been built, 400,000 people had been employed, and 80,000 had

acquired a trade.[5] A network of roads had been constructed throughout the Galilee. Hospitals had been constructed. Millions of trees had been planted. The majority of the immigrant camps had been shut down. At the same time, kibbutzim and moshavim had been built up and expanded.

But her contribution to shaping Israeli society extended well beyond managing this vast migration. Over the opposition of other members of the government, she introduced and fought for the enactment of an array of social legislation, including social security for both men and women, pensions for the elderly, support for widows and orphans, and payment for soldiers who did reserve duty. She insisted that the state institute a system of grants for invalids, new mothers, and other vulnerable members of society. Long before many Western countries considered the idea, Israeli mothers received government-funded maternity leave.

She fought for legislation guaranteeing annual paid vacations, a ban on youth work, limits on the hours one could work, severance pay, and more. The opposition she encountered from fellow Labor Zionists was not ideological but practical. The state coffers were empty. Food was being rationed. Immigrants were living in tents. Her opponents considered social welfare legislation a luxury that should wait. But for her there was no waiting. If she waited, she was sure it would never happen. Economists and bureaucrats would always find a reason to oppose it. When she presented the proposed National Insurance law to the Knesset, a clearly emotional Golda framed it as an expression of the cross-fertilization between the two worlds she inhabited. She drew upon the Hebrew Scriptures, which repeatedly expounded on the responsibility to act "for the sake of the poor and widows." But her proposals were also reflective of what she considered the essence of Labor Zionism, linking "political independence with the principles of social justice." These social welfare protections were not entirely new. The Histadrut and

kibbutzim had already instituted many of them. But in proposing that they become the law of the land, Golda was realizing Ben-Gurion's goal of "stateism," the transfer of the panoply of quasi-governmental programs, which during the Mandatory times had been the province of the Histadrut and various political factions, to be under the aegis of the state. Some of Golda's Labor Zionist colleagues saw this as a threat to their party. Workers and new immigrants should, they argued, feel beholden to the Histadrut—and by extension to Mapai—for these benefits. Instead, they would now credit the state. (In fact, in a few decades their predictions would prove correct.) Golda, echoing Ben-Gurion's vision, disagreed. "By adopting this law," she told the Knesset, "we are moving from a voluntary framework to a binding one."[6] In short, they were building the social infrastructure of the state.

Though all these efforts were admirable, there were no funds to pay for them. Even the expenditures on military security had to be rationed carefully; at one point, to the dismay of the Israeli Defense Force (IDF) chief of staff Yigael Yadin, the army's budget was drastically cut. As the economic situation worsened in the early 1950s, it was American Jews who were called upon—often by Golda herself—to contribute. She knew that prolonged dependency on philanthropy was not a healthy way to build a state, particularly one founded on the notion of self-reliance. However, she saw no other option. In her fundraising appeals she returned to the same theme she had sketched in her memorable speech in Chicago in January 1948. The state of Israel was not a philanthropy but a joint enterprise. The donation system had its limits, but when Golda appeared in a community, the contributions generally exceeded expectations.

However, because the United Jewish Appeal assisted Jews worldwide, often half the funds would be designated to assist Jews outside of Israel. Golda, Kaplan, and other government ministers, together with American Jewish leaders, began to look

for a financial instrument that could circumvent this arrangement. They used as a model an agreement Golda and Kaplan, among others, had made with the International Ladies' Garment Workers' Union and its longtime head, David Dubinsky. In order to help finance the building of low-cost homes, the union purchased $1 million of Israeli government–backed bonds. Americans were quite familiar with the concept of state-financed bonds. They had bought vast sums of them during the war. For Golda, a socialist, the notion of relying on outside investors was a bit of an anathema. However, she believed it "more decent . . . normal . . . dignified" than the "abnormal relationship" that resulted from philanthropy. Bonds would free the state, at least in part, from the "kind and generous shackles" of philanthropy.[7]

Golda had important allies in this effort. Henry Montor, who had organized her 1948 visits and had become an exceptionally close friend, fought for this plan. He, in turn, galvanized former secretary of the treasury Henry Morgenthau Jr., who not only gave his own imprimatur to the effort but won President Truman's approval. At a conference in Washington convened to win the support of American Jews, Golda was tasked with converting the skeptics, of whom there were many, into believers. The sums she mentioned were staggering, even by American standards. For the new state to thrive, it needed $1.5 billion over the next three years. While Israel's 1 million citizens would be responsible for a third, the rest was to come from American Jews. In her effort to win American Jews' support, she did something that, had it come from anyone else, might have sounded maudlin and contrived. She offered the American Jewish communal leaders gathered in Washington a guarantee that could only have been accepted from the person they increasingly saw as epitomizing *the* "Mother in Israel." She described it as "gilt-edged" pledge. She offered as surety not just the people of Israel but also "our children, the children of the old-timers and the little Yemenite children and the Iraqi children

and the Rumanian children who are growing up in Israel—proud, safe, self-respecting Jews. They will pay back this debt . . . with interest."[8] Her strategy succeeded. A million dollars' worth of bonds were bought at this meeting. For Golda, these purchases represented more than just desperately needed funds. Bonds, she believed, meant that American Jews were beginning to think of the new state as a worthwhile investment, not just an object of charity. Charity was support given by donors to supplicants. Investments were made between equals.

Golda, whose stature was growing both inside and outside Israel, was one of the few—if only—political leaders willing to openly challenge the ultra-Orthodox. Ben-Gurion, in a political maneuver designed to win support for the new state, had exempted Orthodox women from army service. Within a few years, it became evident that many women were falsely claiming to be religiously observant in order to avoid such service. Golda strongly supported a bill requiring that those women who received an exemption from military service do a year of national social service. In response, the ultra-Orthodox community went on the attack. They organized protests not just in Israel but in New York as well, demanding that Jewish daughters be protected from the defilement certain to occur in the army. Livid, Golda minced no words, labeling these protestors a "mob" trying to "terrorize" the Knesset. Their accusations were worse than those from any "enemy" of Israel. The law passed.[9]

The ultra-Orthodox eventually had their revenge, but Golda may not have minded. In 1955, Ben-Gurion, wanting to ensure that someone from Mapai become mayor of Tel Aviv, urged Golda to stand for the position. In order to win, she needed the votes of the ultra-Orthodox members of the town council. Anxious for redress because of having lost the fight over national service and appalled by the thought of working with a woman as the leader of Israel's major city, they opposed her candidacy. Golda, who did not particularly want the job because it would

remove her from national politics, was enraged at what she considered their duplicitous political tactics: they claimed they could not work with a woman, yet so many of the ultra-Orthodox Knesset members did exactly that in their state agencies. She, who did not want to be mayor, happily remained in the government, but she did not forget this slight.

Though Golda faced many political imbroglios during these years, none presented her with a greater quandary than the question of German reparations. It put her at odds with Ben-Gurion. Ben-Gurion, so cognizant of Israel's dire economic and military situation, believed that Israelis had to turn to Germany for both political and financial support. He justified his decision by declaring that there now was a new or different Germany. This was not the Germany of the Third Reich. Golda disagreed. Unlike Ben-Gurion, she operated on the supposition that all Germans were "*a priori* Nazis" and consequently, guilty. She could not ignore that some of Chancellor Konrad Adenauer's closest aides were former Nazi operatives and that Germany, at that point in time, was generally disinclined to address its sordid past. In 1952, Adenauer, opposed to forcing these former Nazis out of the many government positions they held, told the Bundestag, "I think we now need to finish with this sniffing out of Nazis."[10]

But her unequivocal stance on this issue, notwithstanding, Golda was a realist. She pragmatically, albeit reluctantly, concluded that in the face of severe economic strictures, Israel could not "morally" turn down funds that might help rescue Jews or defend Israel's borders. She melded her sentiments— intense anger and painful realism—together. When the cabinet discussed Ben-Gurion's proposal for direct negotiations with Germany, she proposed relying on an intermediary, possibly one of the Allied nations. When that proved impossible, she offered detailed guidelines on how these negotiations should be conducted. Negotiators had to remain aware that they would

be coming into contact with "unclean people" and refrain from any act that might "lead to forgiveness and forgetting." These acts included free-flowing conversation, enthusiasm for these meetings, and even handshakes. She insisted that Israeli negotiators speak to the Germans "with pride, Jewish pride . . . in a manner which will add to the strength and honor of *Am Yisrael*." Nor should this behavior be subtle. When the negotiators and the Germans sat at the same table, the Germans should be made aware that they, "the vanquished," were sitting with the "victors." Above all, the negotiators must telegraph the very clear message: Israel was not coming as a supplicant. "We were masters of our own fate" and were "demand[ing] what is coming to us."[11] Subsequently, when the cabinet discussed sending an Israeli purchasing team to Germany to choose the goods to be included in the reparations agreement, Golda's directives extended beyond the negotiators' behavior. The negotiators' children, she declared, must not accompany them. She did not want Israeli children to live in Germany, attend German schools, or play with German children. Even the negotiators' tone of voice should not be like that "used with friendly nations." For her, a "German is a German" and "every German is guilty."[12]

Her opposition extended to cultural events. In 1953 the cabinet discussed allowing Germans to participate in a convention of the Israel Modern Music Society. Ben-Gurion favored it as long as the participants could prove that they had not been Nazis. For Golda, this was irrelevant. They were Germans—that was enough to make them personae non gratae.[13] When speaking of Germany during these years, she often sounded less like a member of Mapai and more like Herut leader Menahem Begin, who had organized a violent demonstration outside the Knesset when the topic of reparations was under consideration. Her position would evolve, though she would not step foot on German soil until 1967 and never spent a night there. By the time she became foreign minister, she recognized that

one day the two countries would establish diplomatic relations. Privately, she expressed the hope that when that day came, she would no longer be foreign minister, or if she was, that she would be ill and unable to participate in the formalities.

By 1953 Golda's energies were increasingly devoted to political matters beyond the design of immigrant houses, employment, social welfare legislation, and related issues. This attention to politics resulted from what she described as a "thunderclap": Ben-Gurion's resignation. Some of his biographers speculate that he, who thrived on crises, was bored by day-to-day governance. The state had been established, massive immigration had ceased, and thanks to an American loan and the promise of German reparations, the economic situation had stabilized. Others contend that he was simply exhausted from his years at the helm. Both may be simultaneously true. What is beyond debate is that despite Golda and her colleagues' entreaties to him not to abandon the leadership of the state, he refused to change his mind—at least for the next two years. He retreated to Sdeh Boker, the kibbutz in the Negev where he made his retirement home. In truth, even after his resignation politicians, among them Golda and Moshe Dayan, continued to beat a path to his door. He became a sort of de facto prime minister.

The question loomed: who would succeed him? Moshe Sharett had conducted foreign relations for close to two decades. He was clearly next in line. However, his worldview was diametrically opposed to Ben-Gurion's—and hence to Golda's. If Ben-Gurion was an activist who did not shy from confrontation, Sharett was the consummate diplomat who always sought consensus. If Ben Gurion—and Golda with him—downplayed the importance of world opinion, Sharett emphasized it. Sharett had often opposed many of Ben-Gurion's signature decisions that he, ever the moderate, feared might elicit a negative world reaction.

While the succession was being debated, there was a rumor,

probably unfounded, that Golda was among those Ben-Gurion might recommend as his replacement. Sharett, appalled at the possibility, disparaged her abilities. After hearing her speak to Jewish leaders from abroad, he conceded that she connected with Jews worldwide, particularly the Americans, in a way that he could not. The "music of her speech is always wonderful; her voice comes from the heart and goes into the heart." The problem, he continued, was not the tenor but the content of her words. To be more precise, for Sharett it was not the content but the lack thereof. Her comments were, he wrote in his diary, both anachronistic and devoid of "any new substantive ideas." They were filled with "Plain 'Zionism,'" something he dismissed as "hackneyed ideological clichés with a huge helping of arrogance dressed up as modesty in such language as 'we the sons of the *Yishuv* and the builders of the country.'" He was appalled by her tendency to sound like a struggling pioneer rather than a leader of a sovereign state. He attributed this to the fact that neither she nor Ben-Gurion had ever overcome their pioneer experience of leaving familiar surroundings, flouting familial opposition and being scorned by friends. The success of the new state notwithstanding, he opined that they could not "forgive others the sin of not immigrating to Israel."[14]

Sharett's fears that Golda might become prime minister were not realized. The cabinet chose him. He would now serve as both prime minister and foreign minister. Before retiring to the Negev, Ben-Gurion had installed a cadre of young stars in pivotal positions. Shimon Peres, who was not yet thirty, became director general of the Defense Ministry. Moshe Dayan became the IDF's chief of staff and Pinhas Lavon, who had been secretary-general of the Histadrut, was appointed minister of defense. Some of these appointments, Lavon's in particular, would prove problematic. Lavon, working as a lone operator and ignoring the army chain of command, launched a variety of military operations without the cabinet's or the prime minis-

ter's approval. Meanwhile, Egyptian-supported fedayeen were increasingly breaching the Gaza border and attacking Israelis.

Then came an event whose origins remain a matter of debate to this day. An Israeli plan was hatched to have some young Egyptian Jews attack British and American buildings. The assumption was that these attacks would compel these two superpowers, anxious to protect their interests in Egypt, to keep their troops in the Suez Canal zone. It all went terribly wrong. The Egyptian authorities uncovered the plot, arrested those involved, and sentenced some of them to death. When Sharett demanded to know who had ordered this operation, the Israeli chief of intelligence said he had acted on Lavon's orders. Lavon denied giving the order. (Regardless of who actually gave the order, Lavon's modus operandi of authorizing all sorts of unapproved actions seemed to have helped inspire it.) When a commission of inquiry could not determine who was responsible, Lavon or the chief of intelligence, Lavon demanded that Sharett fire Peres, who testified before the commission. Sharett refused and Lavon resigned. Golda always thought Ben-Gurion's choice of Lavon had been a disaster. (She compared, not without reason, Ben-Gurion's ability to properly size up people to that of her baby granddaughter's.) Nonetheless, she was convinced that only Ben-Gurion could both restore order to the defense arena and serve as a counterweight to the ever-moderate Sharett. Soon she was on her way to Sdeh Boker with other cabinet ministers to pressure Ben-Gurion to return as defense minister. He did.

Ben-Gurion became defense minister, but Sharett remained prime minister. Ben-Gurion, who for decades had been at the helm, was now second in command. Sharett reveled in the reversal. But his joy was short-lived. After the 1955 elections, the party reinstalled Ben-Gurion as prime minister. For the sake of continuity, he asked Sharett to remain as foreign minister. Sharett agreed, but soon became leader of an internal opposi-

tion. He repeatedly organized coalition ministers in the cabinet to challenge Ben-Gurion. Meanwhile, the fedayaeen attacks escalated, and President Nasser of Egypt secured a massive arms deal with Czechoslovakia. Ben-Gurion was fearful that if he wanted to take military action against Egypt, Sharett would stand in the way. Consequently, he began to seek a way to replace him with someone whose loyalty was beyond doubt and who shared his worldview. There was no one more suited than Golda. She was experienced, exceptionally capable, and her views, he knew, were in total synch with his.

9

Madam Foreign Minister

In April 1956 Ben-Gurion found his opportunity to rid himself of Sharett. Mapai needed a secretary-general. Though some party leaders pressured Golda to take the job, she resisted, as this would remove her from the government. At a meeting convened to discuss the matter, Sharett, in what he considered a "chivalrous gesture" to lessen the pressure on her, offhandedly proposed that he step down and take the Histadrut position. According to his diary, he assumed that no one "in his right mind" would take him seriously. Ben-Gurion, never one to miss a political opportunity, seized the moment and seconded the idea. With that, Sharett's continued tenure became a matter of debate, albeit one that took a number of months to resolve. It would end with Golda becoming Israel's second foreign minister. Not surprisingly, Golda, who always denied jockeying for a position, even when she was quietly doing so behind the curtains, described it as something that just happened. In fact, it

was not a serendipitous chain of events; Ben-Gurion had already discussed the possibility with her.

Neither Ben-Gurion nor Golda seems to have anticipated Sharett's determination to retain his position, which he considered rightfully his. In exchanges with friends and colleagues and in his diary he mercilessly decried Golda's appropriateness for this position. The possibility of her replacing him was a "calamity." She had to know "full well that the office is beyond her capabilities." She lacked the necessary "intellectual qualities" and was totally unfit for the position. She could not "prepare a speech properly. . . . Dictate a cable with instructions on a complex matter . . . write a comprehensive briefing."[1] He was most stupefied by the fact that she believed herself "truly worthy of the mantle of Foreign Minister" and that her appointment would be "in the country's best interests." He was appalled that when he briefed her, she "listened attentively" but took "not a single note." He categorized it as a "very strange phenomenon in the Foreign Ministry *as we know it*" (emphasis added).[2] He, who for the past twenty-five years had been the de facto foreign minister of the Yishuv and de jure of the state, clearly could not fathom that someone who followed him might have a different modus operandi.

On Golda's first day in office, he gave public expression to his conviction about her inappropriateness for the job. He rejected a suggestion, which was transmitted by one of his acolytes but clearly came from her, to escort her into the office. He demurred because that would constitute a "display of conciliation and friendship that were non-existent." He seemed unable to fathom that such a gesture, however much he disagreed with her appointment, symbolized the peaceful transfer of authority, the hallmark of a democracy. Ben-Gurion had played a tough game and won. Decades later this public rebuff still stung. In her memoir, Golda described entering the office alone on her first day, "feeling and probably looking miserable." Not sur-

prisingly, Golda told her son that at the ministry she was "not among my own." Foreign Ministry workers informed Sharett, whom they quietly kept abreast of all that went on in the office, of her overt sense of humiliation. That information did not seem to bother him.[3]

Though her performance at her first press conference won plaudits from the national and international reporters who crowded the room to hear her, Sharett dismissed it as having "no panache and . . . [saying] nothing new." He reveled in reports of her "feelings of inferiority and wretchedness" and was delighted when a column in the newspaper *Davar* bemoaned his ouster and noted that the question of how the ministry "will carry on is the cause of much anxiety for many people in Israel." It appears that he considered her reported difficulties her just deserts. When Sharett was about to leave on an overseas Asian trip, he came to the Foreign Ministry to be briefed. Golda joined the meeting when it was already in progress. She apologized for her late arrival. He later opined that "no one had missed her."[4] His incessant public and private carping suggests that he was convinced that the office, from which he had been legitimately ejected, was rightfully his and he alone could fill it.

In recent years some Israeli historians have called his ouster a tragic development. They describe it as the moment when the "moderate school" of Israeli foreign policy suffered an irreversible setback, defeated by the Israeli defense establishment. They seem to believe that Sharett would have been able to make peace with the Arab nations, though there is little evidence that they were ready to do so. Nonetheless, this charge—Sharett would have accomplished what Golda could not or would not—would follow Golda into the history books.[5]

Ben-Gurion, who was gratified to have a foreign minister on whose loyalty he could depend, then did something strange—but not out of character for him. Unbeknownst to Golda, he proposed that the erudite, Cambridge-educated Abba Eban re-

turn from serving as Israel's UN ambassador to become his personal foreign policy adviser. Eban perceived his objective as to be "a kind of watchdog" over Golda with "a direct line of command" to the prime minister.[6] When Golda made it clear she found the idea abhorrent, Eban understood that accepting the position was a recipe for interpersonal antipathy and declined the offer. Nonetheless, it must have been a devastating insult for her.

She was still accustoming herself to both her new office and her new name—Ben-Gurion believed that diplomats who represented the young state should have Hebraized names and therefore Meyerson was now Meir—when Egypt's leader, Abdul Gamal Nasser, tightened the blockade in the Gulf of Aqaba and nationalized the Suez Canal.[7] Egypt was now receiving weapons from the Soviet bloc. Regional power distribution seemed about to shift. At the same time America reneged on its offer to help build the Aswan Dam. IDF Chief Moshe Dayan and Shimon Peres, on whom Ben-Gurion increasingly relied for advice, particularly in relation to defense matters, pushed him to act before Egypt amassed even more power. Peres, already engaged in arms negotiations with the French, thought they might participate in an action against Egypt because they held Nasser responsible for abetting the Algerian uprising. Peres also anticipated that even the British, who felt humiliated at the seizure of the canal, might join in.

Ben-Gurion was intrigued. He had Golda lead a high-level, secret ministerial delegation, one that included Dayan and Peres, to assess the French commitment to a joint military action. Because secrecy was to be absolutely maintained, Golda instructed the delegation not to venture out in Paris. The only one who ignored her instructions was Dayan, who was also the only one who could be easily identified because of his distinctive eye patch. Despite the fact that no one seemed to notice him, Golda was furious that he jeopardized the meeting's secrecy and, one

can assume, had flagrantly ignored her instructions. His deci-
sion to deny her authority was a harbinger of things to come.
Upon their return to Israel, Dayan and Peres assured Ben-
Gurion that the French were committed to entering into a real
alliance. Golda, far more skeptical, feared that the French—and
certainly the British—could not be fully trusted. If it suited them,
they would leave Israel isolated on the world scene. Ultimately,
her assessments were correct. The French and the British joined
in the military assault, but when world criticism intensified, they
left Israel to face scathing criticism on its own.

Despite her distrust of these newfound putative allies, Golda
agreed with them that given Nasser's growing stature in the
Arab world, Israel had to act. Plans for the 1956 Suez campaign
intensified. Ben-Gurion made her one of the very small inner
circle of decision makers who planned this highly secret opera-
tion. The military operation was successful, but worldwide con-
demnation rained down upon Israel. It was left to Golda to
conduct what Medzini aptly calls a "political salvage operation"
at the UN. She became the public face of Israeli diplomacy.[8]
Unlike Sharett, who treated the UN with a degree of rever-
ence, Golda considered it irrelevant at best and hostile at worst.
She disliked the endless deliberations and diplomatic niceties.
She engaged in an ongoing round of negotiations with U.S.
secretary of state John Foster Dulles, UN secretary-general Dag
Hammarskjöld, and representatives of numerous countries. Her
blunt style, very unlike Sharett's, quickly became one of her
identifying characteristics. *Time* magazine would later describe
her style as "conviction, without compromise, and expressed
with all the subtlety of a Centurion tank."[9] Echoing Sharett's
worldview, Eban was appalled by her directness. He damned her
modus operandi with very faint praise. Her talent was "in the
simplification of issues. She went straight to the crux and cen-
ter of each problem." The problem was, Eban continued, that
with simplification came superficiality. True "foreign policy spe-

cialists . . . are conscious of the intrinsic complexity of international relations. They perceive the multiple elements that go into most decisions and policies."[10] Relations between these two were never truly amicable. At one point, when Golda was told Eban would try to become prime minister, she asked, "Of what country, I wonder?" When she heard that he was making fun of her limited knowledge of Hebrew and boasting that he knew over ten languages, she is said to have dismissed his linguistic abilities by observing that "so does the head waiter at the King David."

Golda's blunt diplomatic style was evident in UN corridors. In the immediate aftermath of the fighting, Golda encountered Lester Pearson, the Canadian secretary of state, who was trying to arrange a UN peacekeeping force. He insisted that as a result of defeat, Nasser's prestige had been significantly diminished. She brushed off his optimism. "Oh, he'll find some way to capitalize on it." When Pearson, the consummate diplomat, tried to reassure her that the United Nations would not accept the strictures Nasser was demanding, Golda undiplomatically—but accurately—dismissed his assurances. Nasser, she observed, was "not even allowing your own troops in the force." Taking a tougher approach, Pearson warned her that sanctions might be imposed against Israel. She responded with a thinly veiled threat. "We shall not give in . . . if we are driven too far, made to suffer too much, we may, in desperation, be forced to fight again."[11]

While Eban cringed at exchanges such as these, the "worst moments" for him were her interactions with Hammarskjöld. Eban respected him as a talented and accomplished diplomat while Golda, in addition to neither liking nor trusting him, thought him a subtle antisemite. Eban accurately noted that "her directness clashed excruciatingly with his subtlety." Eban's and Sharett's descriptions of Golda's almost anti-diplomatic behavior were accurate. What neither of them was willing or

maybe even able to recognize was her skill at human relations. Her aides credited her with a "fantastic intuitive sense" about people. Foreign policy analyst Michael Brecher notes that the same personal skills she used with potential donors she employed to influence "the uncertain among men and nations."[12] Surprisingly, some of the representatives who were most deeply wedded to traditional diplomatic styles were not put off by her modus operandi. Accomplished diplomat Selwyn Lloyd, who was British foreign minister during the Suez Crisis, found her the "easiest Israeli diplomat" with whom he had dealt since Sharett.[13] No divining of her intentions was necessary. She said what she meant.

The most difficult moment in the Suez saga came when Golda felt the United States had double-crossed Israel. She was convinced that she and Eban had worked out an agreement with the United States stipulating that Israel would leave Gaza, but Egypt would not return. In light of that putative agreement, Golda announced in the General Assembly that Israel planned a full and prompt withdrawal in return for freedom of navigation in the Gulf of Aqaba and the Straits of Tiran. Her statement was greeted with uncharacteristically warm applause from the UN members. Any satisfaction Golda might have felt was immediately dashed when U.S. ambassador Henry Cabot Lodge rose and, contrary to a written draft statement that Golda believed had been signed off on by Secretary of State Dulles, declared Gaza's future yet to be determined. Though Israel might get freedom of navigation, the Egyptian army would be back in Gaza. Golda felt duped by the foreign country she trusted the most. That night she summoned Eban and Israeli diplomat Gideon Rafael to her hotel suite for what Rafael remembered as an unpleasant and emotionally volatile harangue. America had betrayed Israel. Israel should, therefore, not withdraw. Eban strenuously objected, correctly asserting that such a course of action would irreparably harm Israel's world stand-

ing. In a style that many of her underlings came to know and fear, Golda turned on him, accusing him of presenting her with a fait accompli and not keeping her fully informed of his exchanges with Dulles. When she instructed Eban to cable Ben-Gurion to postpone the withdrawal, Eban refused, suggested she send her own cable, walked out, and, Rafael recalled, "shut the door behind him with audible emphasis." Rafael, in an attempt to defuse the situation, convinced her that if Ben-Gurion wished to withdraw from the agreement, he would do so on his own, without her cable. "She pondered a moment, sighed deeply, and, without any further comment, said, 'OK, forget it.'" (Ten years later, an assuaged Golda correctly credited Eban with having done much of the Suez-related hard negotiating and dissipating a significant portion of the American opposition to Israel's actions. She acknowledged that he was the one who convinced the secretary of state of the "merits" of Israel's case.)[14] These difficult moments notwithstanding, in the end, the war apparently yielded far more than it cost. In addition to a decade of quiet on the Egyptian border and the end of raids, Israel's position in international opinion went from being a "protectorate" of the superpowers to a military power that could stand on its own. No external body was going to dictate the parameters of its borders.

During this period, in her addresses to the General Assembly and interviews with journalists, Golda began to hone a theme that would characterize her speeches and policies for two decades to come. She contrasted Israel's behavior with that of its Arab neighbors. "Israel's people . . . built villages, roads, houses, schools and hospitals, while Arab terrorists . . . were sent to kill and destroy." Israel rescued Jews from Arab lands, educated the children, and cured them of diseases, while the Egyptian fedayeen threw "bombs at children in synagogues and grenades into baby homes." Israel wants peace. The Arab nations wish to destroy Israel. What upset the Arabs was not Israel's specific

borders but its very existence. She delivered this message at the UN and the Knesset, in private meetings with world leaders, and when marshaling the support of American Jewry.[15]

She fully shared Ben-Gurion's conviction that "the Arabs" had an implacable animosity toward Israel and only understood force. Some historians point to her comments and policy decisions as indicative of the fact that she was stuck in a simplistic perception of the conflict, one that allowed no room for compromise and failed to differentiate among the various Arab factions. When she became prime minister, one Jordanian minister described her as "hard as nails."[16] She never abandoned this conviction about the Arabs' attitude toward Israel. For her the issue was stark: us or them. She never believed they would accept her and her nation in peace. They were the Cossacks she had to live with. But now she had formidable weapons in her arsenal, more formidable than some pieces of lumber.

If Golda hated going to the UN, she soon found an international arena that she tremendously enjoyed and where she felt politically and personally affirmed. Many newly independent African countries were intrigued by Israel's military and domestic accomplishments. While he was in office, Sharett had ruminated about developing relations with these nations. Golda realized that dream. While Israel could not provide substantial foreign aid, it could offer human aid in the form of specialists who excelled in everything from agriculture to infrastructure. Her office found kibbutzniks who had developed ingenious means to conserve water, medical personnel who specialized in tropical diseases, construction experts who knew how to build cheaply but well, and an array of other specialists.[17] Golda assured the Knesset that this was not "a matter of philanthropy" but a wise foreign policy maneuver offering Israel much-needed "fraternity and friendship."[18]

Golda loved her African visits. Wherever she went, she was received with adulation that she rarely encountered at any other

locale, including at home. When the Liberian Gola tribe made her a paramount chief, she was escorted by two hundred singing and dancing women to a tiny straw hut. There she underwent a secret initiation ceremony, emerging in a chief's resplendent robes. Years later she still marveled that to "Golda Meir from Pinsk, Milwaukee and Tel Aviv this great tribute was being paid." She did things most foreign ministers would forcefully eschew, including making "not very graceful but very sincere attempts" to master African dance and teaching Ghanaian Foreign Office staff how to dance the hora. Her limited success at African dance notwithstanding, she was sure—and press reports seem to confirm—that "they couldn't help feeling how much I liked them." For her the effort was far more than an exotic adventure. When sixteen newly independent African states were admitted as UN members, she made a point of being present. The speech she delivered from the podium broke with diplomatic norms. As was the case when she spoke to Diaspora Jewry, the essence of her address was deeply rooted in both her personal history and that of the Jewish people. Declaring this was a "revolutionary moment in human history," she drew distinct parallels to Jewish history: "I speak on behalf of an ancient people whose past . . . has been full of tragedy, racial discrimination and humiliation. . . . How well we all know that independence is not only a culmination of ardent dreams and aspirations." Israel, then in its bar mitzvah year, and the newly emergent African nations shared more than a decidedly similar history. They shared contemporary challenges. "We should not be told to slow our development; we cannot wait. We must develop quickly. As a friend from Kenya who visited Israel said: 'Must I walk in an age of jet planes because those that now have jets were walking a generation ago?. . . . The cry that goes out from African and Asian continents today is: Share with us not only your food, but also your knowledge of how to produce it."[19]

She used this connection of a shared history of discrimina-

tion and persecution to give voice to her deepest moral convictions. In 1964 she visited Zambia to celebrate its independence. She and the other foreign dignitaries present were invited to visit Victoria Falls. When they reached the falls, which spanned Zambia and South Rhodesia, Rhodesian police informed the Black participants that they were barred from entering. Golda announced that if they could not go, neither would she. She remained on the bus with them. When they returned to Lusaka, she was received "as though I were Joan of Arc rather than just a woman who couldn't and wouldn't tolerate racial discrimination." When the UN voted to sanction South Africa for apartheid, most European and North American nations voted no or abstained. Golda insisted that Israel vote with the African nations. When South Africa dispatched a delegation of Jews to protest, Golda, echoing Ben-Gurion, who felt strongly that both as Jews and as Zionists, Israel must oppose apartheid, bluntly told them that while she was aware of the pressure the government was putting on them, this was a matter of principle for Israel. In 1963 she proposed that El Al stop flying to South Africa. Kenya was about to achieve independence and Golda believed that the country would forbid El Al planes bound for South Africa to refuel in Kenya. Golda argued that it was better for Israel to stop flying to the apartheid state of its own accord rather than do so because Kenya refused the airline permission to land there. South African Jews, who objected to Israel's votes against South Africa at the UN and wanted Israel to take a less aggressive stance, pushed back. They contended that Israel should not take the initiative in this matter. Golda reluctantly relented and, as it turned out, Kenya allowed the planes to keep refueling there.[20]

Although the African nations, as part of the third world bloc, generally voted against Israel in international forums, within a few years, Israel had six legations in Africa. By 1972 it had thirty-two. Golda believed the program succeeded because, as

she told the evangelist preacher Billy Graham, with possibly a slight tone of reproach, "We go there to teach, not to preach." Ultimately, despite the teaching and the lack of preaching, international politics took precedence; in 1973 most of these countries suspended relations with Israel.

During her decade as foreign minister, Golda often had to defend Israel's actions in the Middle East. In the spring of 1960, Golda was tasked with defending a different kind of action: an international kidnapping. Adolf Eichmann, one of the chief organizers of the Holocaust, had escaped to Argentina. Israel, aided by information it received from German officials, kidnapped him and brought him to Israel. Ben-Gurion told a stunned Knesset that Eichmann would stand trial. Argentina was livid. At a hastily convened Security Council meeting, its UN representative, Mario Amadeo, a Catholic nationalist who had supported Franco and Mussolini, demanded Eichmann's return. Golda, who had gone to New York for the meeting, acknowledged that it was regrettable that Argentina's laws had been broken. However, "speaking for millions who could no longer speak for themselves," she defended those who had committed this act as belonging "to a people whose tragedy . . . is unmatched in history. No people in modern times has ever mourned the loss of one third of its people in so short a period." Two crimes had been committed. However, she asked, which was the bigger one: the abduction of a murderer to stand trial or the failure to punish him?

She seethed with contempt when Amadeo asserted that Jews should be grateful for Argentina's lenient immigration policies, which had benefited Jewish refugees as well as people like Eichmann. Using her characteristically blunt language, she castigated Amadeo, declaring it "quite extraordinary" that he could "speak in the same breath of Eichmann and his victims." When he compared the abductors to a lynching mob whose violence threatened world peace and security, she pushed back, arguing that this

was something entirely different. Eichmann's captors could have lynched him by hanging him "on the nearest tree." Instead, they delivered him for trial by judicial tribunals. What, Golda asked, was a greater threat, "Eichmann brought to trial by the very people to whose total physical annihilation he dedicated all his energies . . . or Eichmann unpunished, Eichmann free to spread the poison of his twisted soul?"[21] Rarely had UN representatives and delegates heard anyone, including Golda, speak with such passion and directness. It was decidedly undiplomatic.

Israel tried to evade international condemnation by asserting that the kidnapping had been conducted by volunteers who somehow convinced Eichmann to come to Israel willingly. At the UN Security Council, Golda stuck to this charade, repeating that the volunteers "would not rest until they located him." She knew she was telling a half truth. Technically the kidnappers were volunteers, security personnel who had voluntarily participated in a government action. But Isser Harel, Israel's security chief, coordinated the operation with Ben-Gurion's imprimatur and Golda's full knowledge. Harel was in Argentina during the operation. El Al, the government-operated airline, spirited Eichmann and his captors out of Argentina. When the plane landed in Israel, Ben-Gurion and Golda were immediately informed by Mossad, the Israeli intelligence service, officials. That she made this claim at the Security Council is not surprising. But she repeated it two decades later. In her memoir she described Eichmann as having "been plucked [from Argentina] by Israeli volunteers." By this time Harel's book detailing his role in the capture had become an international best seller. It is possible that Golda did not acknowledge Israel's role because in 1960 she had so "emphatically" denied to the Security Council that the "state of Israel has violated the sovereignty of Argentina." Now she did not wish to admit she had lied.[22] Whatever the reason, close to twenty years after the capture, Golda still felt obliged to shade the facts.

It was not only the Argentinians who challenged Israel. Some American Jews did as well. The American Jewish Committee (AJC) was adamantly opposed to an Israeli-conducted trial. The AJC's leadership, still somewhat fearful about Israel acting in the name of world Jewry, urged that Eichmann be turned over to Germany or an international tribunal for trial. They seemed oblivious to the fact that Germany, reluctant to call attention to the many Nazis who lived quite comfortably in the country, was completely uninterested in conducting a trial and rather relieved that, if there was to be one, it would be held in another country. Moreover, there then existed no international tribunal with the authority to adjudicate individual criminal acts.

In an attempt to buttress their case, AJC leaders pointed to a *Washington Post* editorial claiming that Israel could not "act in the name of some imaginary Jewish ethnic identity." (The AJC's choice of this article was strange. The owner of the *Post*, Eugene Meyer, had been an ardent anti-Zionist. His daughter, Katharine, who was then married to the current publisher, did not even know her father was Jewish until her Vassar classmates inquired about her "Jewish blood." Who, Ben-Gurion and Golda may have wondered, gave the *Post* the authority to posit that Jewish ethnic identity was imaginary?) At a meeting in New York, the AJC leadership informed Golda that they had "arrived at a consensus." The trial should not be in Israel because a trial conducted by the Jewish state would obscure the fact that Nazis committed "unspeakable crimes against humanity, not only against Jews." One needs no written record to imagine her response to these American Jews informing her, the foreign minister of a sovereign state, that they had reached a "consensus" about what should be done. The minutes of the meeting, however, do record her unequivocal response to their concerns. The world, she reminded them, had proven itself completely uninterested in rescuing Jews before and during the war, even when there were options to do so. Nor had it shown any inter-

est in punishing the criminals afterward. Though many people had suffered and been killed, the Germans' objective had been the annihilation of the Jewish people. Israel, as the state of the Jewish people, was therefore, she told this group of naysayers, the proper venue.

When, after an extended trial, Eichmann was found guilty and sentenced to death, he petitioned Israel's president for clemency. Not surprisingly, the whole country began to debate the matter. Among the debaters was a group of leading Israeli intellectuals and artists, including some Holocaust survivors, that publicly called for clemency. In response, others, including survivors and those who had lost family members, wondered who gave this group of intellectuals the authority to determine how their parents' murderers should be punished. President Ben-Zvi asked the cabinet for its recommendation. A few ministers, including Levi Eshkol, who would become prime minister, felt that letting Eichmann live the rest of his life in jail was a greater punishment. Golda, not surprisingly, took a harder line. Noting that other nations, including Poland, Czechoslovakia, and Norway, had executed Nazi war criminals, she argued: "No one told them to display a higher sensitivity; this is only sought of us."[23] The cabinet voted to advise the president to reject the clemency request. He did.

A recently revealed postscript directly links Golda to one of the great ongoing controversies of this trial. Political theorist Hannah Arendt wrote a biting critique of the proceedings. It was first published in the *New Yorker* and subsequently as a book, *Eichmann in Jerusalem: The Banality of Evil.* A highly acculturated German Jewish refugee who escaped from Germany to France and then to the United States, Arendt was determined to be in Jerusalem for the trial. Completely misreading Israel's stated goals, she anticipated that it would highlight the dangers of totalitarianism, a topic about which she had written extensively. To her dismay and no one else's surprise, prosecutor Gideon

Hausner's primary focus was on the Jewish tragedy. She wanted a formalistic trial that focused solely on Eichmann's deeds. He, in a desire to emphasize the scope of the genocide, put witnesses on the stand who had no connection to Eichmann's actions. Arendt thought most of their testimony irrelevant and annoying. Her ire seemed most aroused by the fact that this trial, which she dismissed as nothing more than a Ben-Gurion-organized "mass meeting" and "show trial," was taking place in Israel, rendering Eichmann's offense a crime against Jews rather than a crime against humanity.

Her assessment of the trial cannot be separated from her rather ambiguous sentiments about the Jewish state. She had been an active Zionist during the 1930s, first in Germany and then in Paris. Soon, however, her position evolved. By the 1940s, having become convinced of the failure of Jewish assimilation and the ability of nation-states to protect minorities in their midst, she rejected both the nation-state and bi-nationalist concepts of Zionism. The former was Golda's ideal; the latter called for a state in which Jews, as a minority, would have equal rights with Arabs. Arendt, in contrast, advocated a multiethnic federation in which there would be more than two groups so that one could not dominate the other.

The historian Leni Yahil befriended Arendt during her Jerusalem stay, and one night she invited Golda to join them for dinner. Given that Arendt's worldview of a Jewish state was so diametrically opposed to Golda's, it is not surprising that the encounter left Arendt less than impressed. Arendt complained bitterly that the evening went on far too long because she did not know "how to get a foreign minister to stop talking and go off to bed." During the extended conversation, Golda declared that, while she did not believe in God, she did believe in the Jewish people. This incensed Arendt. "The greatness of the people was once that it believed in God and believed in Him in such a way that its trust and love toward him was greater than its

fear. And now this people believes only in itself." She branded Golda's comments "Zionist paganism" and a form of "idol worship."[24] But it was not only the nature of the Jewish state and their conflicting religious views that divided Arendt and Golda. Well before she met Golda, Arendt had expressed her disdain for what she argued was the idée fixe that prevailed among so many of Israel's leaders and supporters. In the wake of the Holocaust, they were obsessed with the "'Galut [exile] mentality' that . . . fighting at any price and . . . 'going down' [fighting to the death] is a sensible method of politics." They were convinced that "everyone is against us."[25] Nothing could have more precisely described Golda's Weltanschauung.

Yahil pushed back against Arendt's accusations about Golda. She acknowledged that the idol worship in which Arendt accused Golda of engaging in vis-à-vis the Jewish people certainly existed. But not in Golda, who believed in the Jewish people and their right to exist but did not "idolize" them. It was not, Yahil continued, "what" she believed but "how" she gave life to that belief. She was not like those people who have "certain spiritual-mental realities" and then render them "absolute." Yahil added, possibly in an effort to make it clear that her full-throated defense of the foreign minister was not personal, that Golda was not her "friend," as Arendt described her. She appended to her comments a description of Golda's special impact on the broadest range of people.

> If there is a single person (among those whom I know in this category) who does **not** cross this boundary, it is this very woman [Golda Meir] to whom you referred as my friend, a term I would not presume to use. In my opinion it is precisely this fact—the ability not to exceed the area of the powers laid down for an individual in his actions and thoughts—that explains this woman's special and unvarying effect on people, irrespective of their skin color, culture or intellectuality. I do not agree with you that it's her "Americanism," because it's

something that is too universal, and demonstrates its power with such different creatures, such as Negroes in new African states and sophisticated people like the Swedes, or a simple Yemenite woman, and Hannah Arendt.[26]

Separate and apart from this exchange, Arendt had, in her correspondence from Jerusalem, expressed her disdain for Israel in comments that were laced with racism, if not antisemitism. She complained that "honest and clean people were at a premium." She decried the "*peies* [side curl] and caftan Jews, who make life impossible for all reasonable people here." (She seemed to ignore the irony that these caftan Jews were the ones who fervently believed in the God that Golda had so glibly dismissed.) She was repulsed by the "oriental mob" of Jews that hung around the courthouse. She sneered at the Israeli police force, many of whose officers were Sephardic Jews, for speaking only "Hebrew and Arabic" and looking like they would "obey any order."[27] (This was a notable statement to make at the trial of a man whose defense was that he was following orders.) Despite Yahil's pushback, her encounter with Golda reaffirmed her preexisting ideological and social convictions about Israel.

During her tenure as foreign minister, one of Golda's primary objectives was to improve relations with America. During the Eisenhower administration, Israel found its reception by American diplomats chilly at best. Moreover, Washington steadfastly refused to supply Israel with arms. Then came the Kennedy campaign. Ben-Gurion, struck by Kennedy's youth and possibly remembering the pre–World War II isolationist tendencies of the candidate's father, did not have great expectations. Golda did. Her hopes were rewarded when President Kennedy agreed to sell Israel Hawk missiles, something it desperately wanted. Expecting Israel to be more pliant, Kennedy now urged it to accept a UN-backed plan in which Arab refugees would vote as to whether they wanted to return. Israeli officials did not like the plan, but Golda did not want to alienate the new

young president. Demonstrating her ability to be pliant when necessary and wary of an outright rejection of his entreaties, she agreed to discuss the matter with the UN representative. When they met, the result was less than harmonious. One participant described it as "mutual antipathy." Hoping to salvage the effort, Kennedy sent one of his advisers, Mike Feldman, to Israel. He met with Ben-Gurion and Golda for three and a half hours and then with Golda alone for six hours over a period of two days. He considered her "pretty tough [and] a difficult person to bargain with." Though they were at loggerheads over almost everything, he greatly admired her. While Golda was suspicious about this program, Kennedy officials assured her that her concerns would be resolved. Unbeknownst to the White House, the State Department, after consulting with the Arab states, had made all sorts of changes to the plan. When Golda saw the revised American plan, she was, Feldman recalled, "livid," insisting, "This was not the plan we agreed to." Kennedy and his advisers agreed with Golda. They had been blindsided by the State Department. It was, Feldman said a few years later, "disgraceful that a presidential mission should be undermined at the very time it was underway." (Even with the changes, the Arab leaders rejected it.) Golda insisted to Feldman, "Don't say we are breaching our faith, that we're breaking our word." Feldman acknowledged that the U.S. administration never blamed Israel and they considered the plan "dead."[28]

This action by the State Department may have laid the groundwork for Golda's next meeting with Kennedy. In late December 1962, at the Kennedys' Palm Beach compound, Golda and the president sat down for a long meeting. It was here that a new bi-lateral relationship was developed, one that would be sustained for decades. In her autobiography, Golda recounts how she opened the meeting by contrasting Jews' experiences with those of other peoples who had lost their sovereignty to foreign powers over the course of history. Generally, the con-

quered people were absorbed by their victors or dispersed. In either case, they disappeared as a distinctive body. Jews had been repeatedly dispersed. Yet somehow they had maintained their identity. Refusing to disappear had long been one of their unique characteristics. However, now, in the wake of the Holocaust, she did not believe they could do this again. The outcome might be quite different. "If we should lose our sovereignty again, those of us who would remain alive—and there wouldn't be very many—would be dispersed once more. But we no longer have that great reservoir we once had of our religion, our culture and our faith. We lost much of that when six million Jews perished in the Holocaust. . . . What is written on the wall for us is: Beware of losing your sovereignty again, for this time you may lose it forever." She told the president in conclusion: should the state be lost, "then my generation would go down in history as the generation that made Israel sovereign again but didn't know how to hold on to that independence." According to Golda, Kennedy kept his eyes on her the entire time she spoke. When she finished, he leaned over, took her hand, looked into her eyes, and solemnly said, "I understand, Mrs. Meir. Don't worry. *Nothing* will happen to Israel."

Though the White House protocol of this seventy-minute meeting makes Golda's presentation and Kennedy's assurances sound a bit less sentimental, the exchange can legitimately be categorized as a turning point in the American-Israeli relationship. In contrast to the previous administration, Kennedy demanded no territorial concessions. He raised the refugee issue but acknowledged that his administration's refugee plan was "gone" because of the lack of Arab support. Then, using words that would become the bedrock of American Middle Eastern policy for decades, he assured Golda that because of the United States' "special relationship with Israel . . . in case of an invasion the United States would come to the support of Israel." He gave added heft to his assurances by noting that America's

only other comparable relationship was with Britain, the country with which it had helped defeat the Nazis. He then added a personal imprimatur. The White House record reads: "This country is really interested in Israel, the President said, as he is personally. We are interested that Israel should keep up its sensitive, tremendous, historic task."[29] Though no public announcement followed this meeting, it was of historic significance. It laid the groundwork for a decades-long relationship that, albeit with some bumps in the road, remained strong. Many an Israeli prime minister, including Golda herself, would cite that "special relationship."

At the end of this lengthy conversation, Kennedy mentioned the nuclear plant at Dimona. During the Sinai campaign, Peres, with Ben-Gurion's blessing, had arranged for France to build a nuclear plant in the Negev. A number of Israel officials— Eshkol and the IDF's operation's chief (soon to become its chief of general staff) Yitzhak Rabin among them—knew of the plant and opposed it on political and strategic grounds. Better to invest in conventional weapons, they argued. Golda disagreed. She believed Israel's security necessitated the plant. The plant was a secret; Israel did not inform the United States of its existence. At the very end of the Eisenhower administration, a spy plane took pictures of it. When the Americans asked what it was, Israel insisted it was for peaceful purposes. Kennedy, skeptical about the claim and furious about the secrecy, pressured Israel to allow American inspectors into the facility. Ben-Gurion agreed. He and Peres devised a scheme to make it appear the plant was for peaceful purposes only. When Kennedy expressed his concerns about the proliferation of nuclear weapons, Golda quickly reassured him that Israel and America had no differences regarding Dimona.

In fact, there were serious differences between the two countries on this very matter. This was a military facility, and Kennedy was an ardent opponent of the proliferation of nu-

clear weapons. Golda considered Ben-Gurion and Peres's approach of lying to the United States about Dimona's true purposes exceptionally risky. She advocated telling the truth and explaining why Israel had the facility. She argued that Israel could bargain with the United States about the plant, but it could not bargain over something that officially did not exist. Nor could it tell the president of the United States that this was none of his business, but then demand that he support Israel. Finally, and possibly most significantly, if Israel lied about this sensitive issue, no one in Washington would ever trust the country again, even when it told the truth. Avner Cohen, who has closely studied this topic, believes Golda was correct to assume that if Kennedy had been fully informed about Israel's nuclear plans and reminded that the word *survival* had, in the wake of the Holocaust, an existential meaning for Israel that it did not have for other countries, he would not have countered Israel on this.[30]

As the 1960s unfolded, Israel's relations with nations worldwide—including Germany, Britain, an array of newly independent African nations, and especially the United States—were stronger than they had ever been. As Israel's stature grew, so too did Golda's. She had become one of Israel's iconic faces, her fame eclipsed only by Ben-Gurion's. While she was increasingly respected in the international arena, domestically she confronted political slings and arrows. Most painful of all was that her mentor Ben-Gurion seemed at times to deprecate her efforts. Her relationship with the man most responsible for the creation of the Jewish state defies easy categorization. He was her mentor and shaped her worldview on many issues, foreign and domestic. She was a loyal "soldier," supporting him and espousing his views. Many, if not most, of the foreign policy initiatives she pursued were in total synch with his views. On occasion he relied on her judgment, especially when it concerned America. He was duly impressed by her ability to win over foreign visitors

and turn non-Zionist American Jews into some of Israel's biggest supporters. When she believed him wrong, she said so, though often privately. He respected her decisiveness and strength.

But he was also capable of emotional cruelty that he directed not just at his enemies but at his allies, Golda included. Some of the pain he caused might be attributed to a tone deafness—what today might be described as a low emotional IQ. He did not bother to sugarcoat his views. Even his praise was sometimes laced with condescension. He may have been oblivious to this tendency he had. During the Suez Crisis, Golda, working closely with Eban, salvaged what could have been a diplomatic disaster for Israel. Yet Ben-Gurion, in his pre-withdrawal statement to the Knesset, failed to mention what the Foreign Ministry had accomplished. His sole reference to Golda—that she had done what she had been "instructed" to do—effectively rendered her a functionary.[31] His—possibly unintended—deprecation of Golda's role during this time was followed with another set of clumsy comments in a speech at kibbutz Givat Haim. After a diatribe against Sharett in which he charged him with having "failed" to ensure Israel's security, he addressed Golda's role during Sinai. Though in all likelihood Ben-Gurion did not think that his remarks were uncomplimentary and may have even considered them praise, she must have felt some sting: "Golda will not be angry and not dispute me, if I say that the comrade who preceded her all the years in the Foreign Ministry was far superior to her in his vast experience in Israeli and international politics, in his general and Jewish education, as well as other talents."[32] Then he acknowledged that she did have one "advantage" over Sharett. She lacked "any experience in the Foreign Ministry." This inexperience allowed Israel to ignore "protocol . . . rituals . . . [and] accepted channels" and engage in "unorthodox efforts [that] bore fruit." Since Golda was in charge of protocols, rituals, and accepted channels, Ben-Gurion was essentially saying she could be ignored. When he compared her to

Sharett, Ben-Gurion's assessment was correct. Sharett was far more experienced than she in international affairs. She hated diplomatic niceties and, much to the chagrin of people such as Sharett and Eban, but probably to Ben-Gurion's delight, she spoke her mind in the most undiplomatic fashion. And her efforts did bear fruit. But the comment must have stung somewhat, especially in light of what she endured from Sharett and his supporters.

But she, together with Mapai veterans, were now facing another set of Ben-Gurion–inspired challenges. After the Sinai War, a group of "youngsters," Shimon Peres, Moshe Dayan, Abba Eban, and a few others, had emerged with their reputations—and, even more important, Ben-Gurion's faith in them—greatly enhanced. Ben-Gurion wisely understood the need to ensure that the leadership of the state was infused with "new blood." He respected and had long worked with veterans like Golda, Eshkol, and Pinhas Sapir, all of whom had risen to power through party politics. But in his eyes, they increasingly represented the past. He contrasted them with these self-assured (one could legitimately use the word *cocky*) young men who had made their mark in both the military and civil service. They were, Ben-Gurion rightly discerned, Israel's future. Ben-Gurion sought ways to promote them and give them vital leadership experience, even if that entailed riding roughshod over the veterans.

Most directly troubling to Golda was the way they seemed to encroach on her bailiwick of foreign relations. Ben-Gurion had tried to make Eban his personal foreign policy person, a move that would have put two people—Golda and her subordinate Eban—in charge of policy. Peres thought it legitimate for the Ministry of Defense to engage in foreign policy matters, often without Golda's knowledge. He forged a particularly strong alliance with France, procuring for Israel arms and diplomatic support. (As a result, when the 1967 war came, Israel was better prepared than it otherwise would have been.) What

rankled Golda was not necessarily what Peres and his compatriots were doing, but that she often only learned of these activities ex post facto. When she complained to Ben-Gurion, he promised that nothing would be done behind her back. Each time she came to him, he would repeat that promise. The fact that he had to keep repeating it indicates the problem was not resolved.

This antipathy had a personal component. Golda and her fellow veterans dismissed this cadre of younger leaders as ambitious technocrats. She did not like or trust them. They reciprocated the sentiment. In 1958 Peres dismissed Golda and her contemporaries as "tiresome, grey and outdated." They considered Mozart's *Eine Kleine Nachtmusik* and the Russian *rubashkas* [blouses] as "the height of modern Israeli originality." In contrast to them, he and his colleagues showed an "energy for life, exhilaration, levity and even a little provocative irony." In his attack on the veterans, Dayan wondered why Israeli youth in general and in particular the emerging young leaders, many of whom had fought in two wars in less than fifteen years, were thought to "understand less the problems of the Jewish people than those who sat for the past twenty-five years on the fifth floor of the Histadrut?"[33] The veterans, Golda prominently among them, were no less critical. They repeatedly complained to Ben-Gurion. They kept their adversaries out of the government. They derided them for expecting they could achieve high-ranking positions without seniority. The youngsters, in turn, saw increasingly ossified leaders who seemed to believe that appointment to a high office was earned by longevity as much as by talent and new ideas. They made it clear that they wanted and believed they deserved to be running matters. Golda, who had leapfrogged over others early in her career, found the idea of them doing the same to her and her colleagues anathema.

Though Ben-Gurion tried to mediate, he understood that eventually the younger generation would lead the state. At first

they might do so in concert with the veterans, but in the long run they would be on their own. Ben-Gurion biographer Michael Bar-Zohar aptly notes that Ben-Gurion did more than "support the younger generation's assault on the leadership, he instigated it."[34] Ben-Gurion's recognition of the "youngsters" as representing the future did not preclude his sincere affection for Golda. During the Sinai War, when she took sick in New York, Ben-Gurion urged Eban to do everything in his power to ensure that she recovered, even if that meant curtailing her fundraising efforts. "Golda is more important to Israel than several million dollars." When she turned sixty his letter to her was addressed to "precious and beloved Golda," not his usual salutation. When the American Jewish Congress gave her a prestigious award, Ben-Gurion praised the "dignity and splendor" of her service to the nation and spoke of Israel's "love and esteem" for her. He did not merely praise her in the public arena. In his diary he voiced his awe of her abilities. After a memorial evening for a fellow Zionist pioneer, Ben-Gurion vented profound annoyance at having to endure the endless string of prosaic speeches. But when Golda rose to give the final talk, his attitude changed. "The whole evening was worthwhile just to hear her words. How does she know from her very first sentence to touch the hearts of her listeners straight into the depths of the heart and soul, and not to move from there until her final word?"[35] This was high praise—the highest—from a man who understood and valued the power of words.

In anticipation of the forthcoming elections, Ben-Gurion announced his plan to bring the younger leaders into the government. He correctly thought that if they were eventually going to lead, they needed the experience now. While Golda disliked the whole idea and was annoyed with the younger leaders' hubris, she was particularly irritated by Ben-Gurion's plan to appoint Eban to the amorphous job of being an "information minister who would present Israeli views abroad." This, of course,

was something that she did—and did well. Annoyed, she told Ben-Gurion that if this came to pass, she would leave the cabinet. Aware that this would be a political liability for him, he cajoled her to stay, sealing the deal by agreeing not to appoint Eban to a post that directly encroached on her job. She relented. Mapai proceeded to win a stunning victory. One might assume that, in the wake of that victory, harmony would be restored. It was not.

The Lavon affair, the bungled and ill-thought-out plan to harm Egypt's relations with America and Britain, now became part of this inter-generational fight. Information had surfaced indicating that some of the documents implicating Lavon had been forged. Lavon demanded that Ben-Gurion clear his name. When he refused, Lavon appeared before a Knesset committee and told a sordid story suggesting that Ben-Gurion, with the active assistance of Peres and Dayan, had connived to falsely pin the blame on him. A committee of cabinet ministers conducted a quasi-judicial investigation that cleared Lavon. Ben-Gurion, unhappy with the result, demanded additional investigations. Golda and her colleagues, fearful of dragging out the matter and further harming the party, opposed the idea. In an attempt to satisfy Ben-Gurion, they agreed that Lavon should be made to relinquish his powerful position as Histadrut's secretary-general. Ben-Gurion was not appeased. He kept insisting on additional investigations and threatened to resign if he did not get his wish. Golda ostensibly supported him, but her doubts about his ability to lead were growing.

The Lavon affair was still being debated when the Mossad reported that German scientists were in Egypt helping to develop missiles capable of reaching Israel. The Mossad feared that the missiles' warheads might be designed to be filled with radioactive material. Both Golda and Security Chief Isser Harel, the driving force behind the successful capture of Eichmann, demanded that Ben-Gurion ask Germany to recall these scientists. Ben-Gurion saw things differently. Reiterating his oft-stated po-

sition that Adenauer's Germany was "not the Germany of Hitler," he pointed out that Israel was then in the midst of negotiating a $500 million German loan on exceptionally beneficial terms. He insisted that if Israel vilified Germany, "we shall not receive arms."[36]

While the prime minister refused to publicly criticize Germany, he did allow Harel to undertake a campaign to deter the scientists from continuing their work. Harel seems to have taken this campaign to an extreme. His agents sent letter bombs, threatened scientists' family members, and may have had a hand in the disappearance of one scientist. His plan imploded when two of his agents who were trying to coerce one of the scientists' daughters to get him to stop his work were arrested in Switzerland.[37] After consulting with Golda, Harel asked Ben-Gurion, who was then vacationing in Tiberias, to pressure Germany to have the men released. Ben-Gurion refused. When the news subsequently broke that German scientists were in Egypt, all hell broke loose. The press—and much of the public—found it unfathomable that Germans were now engaging in creating weapons aimed at destroying a large remnant of surviving Jews.

The debate moved to the Knesset. Ben-Gurion, still on vacation, authorized Golda to deliver a joint statement from the cabinet criticizing Germany but reassuring the public that there was no threat. She did so, echoing Ben-Gurion's assertion that West Germany was not Nazi Germany. But then, going a bit off message, she gave voice to many of her fellow Israelis' angst and declared that history could well be on the cusp of repetition. Those who had already destroyed Jews "reappear today with actions designed to eradicate the state of Israel." Her criticisms, while cutting, paled in comparison to those of Ben-Gurion's archrival, Menahem Begin. He accused the prime minister of not just providing Germany with an alibi but of giving Israeli Uzis to Germany while it, in turn, provided Israel's enemies with microbes. Golda struck back at Begin's personal attacks on

Ben-Gurion. But when she did, she did not vigorously defend the prime minister's German policy.

Ben-Gurion, recognizing that his hands-off approach to this imbroglio was insufficient, now asked the IDF to investigate. They assured him that the panic was overwrought and the threat to Israel's security from these second-rate scientists was minimal. Harel, Golda's primary compatriot in this fight, was outraged and, convinced that the prime minister no longer trusted him, resigned. Matters grew worse when the German press reported that as a result of an agreement Peres had concluded, IDF soldiers were being trained in Germany on weapons systems. Furious that she had to learn of this from the press, Golda confronted the prime minister. The acrimonious meeting ended, according to Teddy Kollek, Ben-Gurion's aide, with a mutual distancing. Bar-Zohar describes it as "the last straw" for Ben-Gurion, who thought of the criticism he was receiving from Golda and other members of the cabinet as the equivalent of a palace revolt. He announced his intention to resign.

Medzini credits Golda with leading the campaign against Ben-Gurion. Even if she did this, she adhered to her previously established behavior and implored him to reconsider. However, this may have been a bit of a charade designed for public consumption. As Klagsbrun observes, she officially tried to get him to reconsider, but "she didn't try as hard as she might have."[38] She had lost faith in his ability to lead. His frequent threats to resign, refusal to let the Lavon matter rest, and overtures to Germany (which were strategically imperative but psychologically tone-deaf) bothered Golda, Eshkol, and other veterans. Ben-Gurion and Peres believed Israel's best allies were in Europe. Golda placed her hope in the United States. She eventually might have made peace—or agreed to disagree—with Ben-Gurion about most of these issues. But he had allowed and even encouraged Peres to behave, as one Mapai veteran described it, like a "wildcatter," creating his own de facto Foreign Ministry

and acting behind her back too many times. Yitzhak Navon, a cabinet minister, described their relationship as "love-agony. . . . He loved her, she admired him, and then it fell apart."[39] This time the resignation was not rescinded and, with Ben-Gurion's imprimatur, Eshkol became Israel's third prime minister. The succession was quick and relatively drama free. The question remains: why not Golda? She had been in government as long as Eshkol. She was far more experienced in foreign affairs. But Eshkol was much more popular than she. She had alienated many people in the party with what her critics considered obstinacy. Nor did she have the requisite stature within Israel to be considered for the position.

Though he was out of office, Ben-Gurion was livid that Eshkol, whom he had supported to become prime minister, refused to reopen the Lavon affair. He began to attack Eshkol in what became a vendetta of sorts. In an angry speech at the 1965 Mapai convention, Ben-Gurion declared that those who opposed him were enemies of "truth and justice" and demanded that the Lavon matter be reopened. Sharett, sick with cancer, in a wheelchair, but determined to settle scores, appeared and called for Ben-Gurion's ouster. Golda, who was well aware of Sharett's disdain for her professional and intellectual abilities, walked over to him and, in a blatant demonstration of where her loyalties lay, planted a kiss on his forehead. Then she delivered what many analysts described as one of the most vituperative speeches ever directed at Ben-Gurion. She described him as always surrounded by "yes-men" whom, when they were no long among his "favorites," he replaced with younger and more reliable acolytes. When he did not get his way, he attributed this to a "miscarriage of justice" rather than the fact that he was either wrong or outvoted. He supported majority rule when it went his way and decried it when it did not. He condemned those who opposed him as "trampling the truth." She refused to concede that some of these younger folks might have substantial

talents. Nor did she acknowledge that, until recently, she had been in the initial group of "yes-men." The speech was sharp in the extreme. She correctly asserted that Ben-Gurion's authoritarian tendencies had probably been imperative while building a state, but now that leadership style was beginning to wear thin, even among his acolytes. Rather than reply to Golda, as he was scheduled to do, Ben-Gurion left the meeting. He described her speech as the "ugliest thing at the conference" in his diary. He could not believe "she was capable of absorbing and spewing such venom."[40] The next morning, when he did speak, he responded to Sharett but ignored Golda.

With the loyal support of the "youngsters," Ben-Gurion formed Rafi, a new political party. It suffered a crushing political defeat in the next election. He would get a measure of revenge in 1969 when the Knesset voted to confirm Golda as prime minister. In addition to the expected "no" votes from some members of the opposition, there was one abstention: Ben-Gurion. He insisted he could not vote for her because during the Lavon affair, she "lent her hand to something immoral."

Though they fought bitterly, the bonds between them, however tattered, remained. After her bitter public attack on him at the Mapai 1965 conclave, a correspondent sent Ben-Gurion a letter sharply criticizing her. He responded that though he was disappointed in her speech, "I cannot forget all the good things she did and the good things that I believe she will do in the future." She clearly felt similarly. Shortly after she became prime minister, she described him as "the greatest person" of our generation. Notwithstanding their bitter fights, she recognized his unparalleled contribution to the state. "Even Ben-Gurion cannot spoil my Ben-Gurion." Eventually the enmity passed. At his eighty-fifth birthday celebration, Golda Meir, then prime minister, praised Ben-Gurion as a man of true courage, someone who made the tough decisions not because he was unafraid but despite being afraid. They made peace but, as Golda noted

rather wistfully in her memoir, "By then Ben-Gurion wasn't really Ben-Gurion anymore."[41]

During Eshkol's initial years in office, Golda served as a de facto co–prime minister. He consulted with her on virtually every major policy decision. He did so not just because he appreciated her political instincts but because he was loath to antagonize her. However, soon both of them suffered medical setbacks. He had a heart attack and she had a slight stroke and was diagnosed with lymphoma. Somehow, in what may have been one of the most significant coups of her career, she managed to keep her cancer out of the Israeli press and therefore a secret to the public even as she received regular treatments.

It was at that point, in late 1965, that she announced her intention to resign. Newspapers worldwide lauded her record. Eban, who had waited, often not very patiently, succeeded her. Despite her lack of real warmth toward Eban (which he reciprocated), this transition was radically different from her accession to the position. In January 1966, on his first day in office, she accompanied her successor, feted him with luncheons, and joined him for public appearances. Of course, unlike Sharett, she was not being ousted.

She told the domestic and international press, which hounded her for interviews and comments, that now that she was liberated from obligatory appointments and official receptions, she would be a full-time grandmother, taking her grandchildren to the playground and pushing the baby stroller. She would visit her ailing sister and travel by bus to Tel Aviv cultural events. (Many bus drivers would make an unofficial stop in front of her home so that she did not have to walk from the bus stop.)

And that is what she did. For one month. Actually, a bit less.

10

Prime Minister

BY THE TIME Eshkol's new government took office in January 1966, Mapai, though victorious in the election, had been rendered a fractured party. A sequence of events—the Lavon affair, public rupture with Ben-Gurion, the presence of German scientists in Egypt, and repeated elections—had left it weaker than ever. It was still the dominant party, but in a far more precarious position politically. Party leaders, desperate to find a new secretary-general with the clout to bind the different factions together, turned to Golda. Luckily for them, while she had publicly proclaimed her love of retirement, she must have found life just a bit too quiet. She happily accepted this unelected position. Baby strollers were left far behind as she rapidly entered the political fray. She would transform her new position into a locus of political power.

While her restive nature might have attracted her to the job, she was also undoubtedly worried about her party's future.

In her memoir, she adopts a familiar mantra, insisting that she accepted only out of obligation, not personal ambition. "The future of the party was at stake. And . . . I couldn't turn my back . . . on my principles or my colleagues. So, I said yes and went back to work."[1] With the exception of when Remez rescued her from diaper washing in Jerusalem, she always made it appear as if she did not want the job and considered herself unworthy of it. She publicly adhered to the Labor Zionist ethic that one did not push oneself ahead of one's colleagues. One waited to be called. And, when called, one served. At the end of her tenure as foreign minister, she claimed in an interview with Brecher that when her colleagues gave her the job a decade earlier, she wept and implored them "not to impose the Foreign Minister's post on me."[2] This, on some level, was a factor in her resentment of Dayan, Peres, and their contemporaries. They did not wait to be asked. They openly fought for advancement and warmly embraced it when offered.

In late 1966 the Soviets, who had been supplying both Syria and Egypt with arms, began to escalate tensions in the area with entirely false charges that Israel was preparing for a full-scale attack on Syria. Though it was clearly a nonsensical charge that even UN officials acknowledged was fanciful, the USSR kept repeating it. Then in May of the following year, Nasser, emboldened by the Soviets, from whom he had received massive military assistance, demanded that the UN withdraw the Emergency Forces that had been placed in Gaza and Sharm el-Sheikh as part of the post-Sinai campaign withdrawal agreement. Within three days they were gone. As the last soldiers were leaving, an alarmed Golda warned her colleagues that "war might be nearer than expected."[3]

The UN's easy acceptance of Nasser's demands enraged but certainly did not shock Golda. The UN-brokered agreement on whose terms Israel had evacuated Sinai in 1957 evaporated without consultation with Israel. UN secretary-general U Thant's

unilateralism reaffirmed for her—yet again—the inherent untrustworthiness of international guarantees. For the rest of her political career, she repeatedly denigrated and dismissed them, even when compelled to accept them. Concerning the UN, she and Ben-Gurion, now political enemies, shared an assessment. Playing on the UN's Hebrew name, Oom, he used a term that illustrated even to the non-Hebrew speaker his contempt for the international institution: "*Oom, shmum.*" She felt precisely the same.

A few days later, Nasser, to no one's surprise, declared a blockade of ships headed through the Straits of Tiran, even though free passage had been guaranteed by a score of nations, including the United States, Britain, Canada, and France. Golda correctly predicted that these governments would protest—but not act. Israel considered the blockade a casus belli. Suddenly, the possibility of a three-sided war, one that no one really wanted or had planned on, became very real. Eshkol, anxious to create a national unity government, turned to Golda to get her approval to bring Mapai's iconic enemy Menahem Begin into the government. Recognizing the necessity for a broad-based coalition government, she gave it.

As the situation grew more precarious, Israel knew that, in contrast to 1956, this time it needed American support. At the very least, it needed to know that the United States would not oppose its actions. Eshkol proposed that Golda, whom he considered to be the best person to impress upon President Johnson the seriousness of the situation, travel to Washington. Eban, incensed at what he rightfully saw as an attempt to undercut his authority as foreign minister—in the same way that Golda's authority had been undermined by Ben-Gurion—threatened to resign. Golda backed Eban. Eshkol, reluctant to engage in an internal political struggle while the nation was on edge and graves were secretly being dug in Tel Aviv, relented.[4] She stayed in Israel.

But the crises facing Eshkol were not only international in nature. Much of the Israeli public considered Eshkol weak, uninspiring, and indecisive. There was a growing public consensus that although he could remain prime minister, he must relinquish the defense portfolio. Hoping to inspire public confidence, he delivered a national radio address. Rather than engender support, it achieved the precise opposite. Exhausted from intense deliberations, Eshkol halted and stammered as he tried to read from a heavily edited text, one laden with barely legible notations and typed additions on separate pages. (Even I, a non-native Hebrew speaker, listened in alarm.) In its wake, his colleagues questioned his capabilities as minister of defense. Golda defended his shaky, if not disastrous, performance, contending that it was to his eternal credit that he was hesitant about sending his people to war. But public faith in him was eroding, and his reassurances that the IDF was fully capable of facing any challenge were increasingly ringing hollow. Golda remained steadfast, not simply out of loyalty to Eshkol but because she did not want Dayan, who enjoyed popular support as the "hero" of the 1956 campaign, to get the job. She did not trust him or his commitment to running a democracy. Golda thought the groundswell of support for Dayan resulted from a "plot hatched" by Ben-Gurion and the "youngsters." Recognizing that Eshkol had to respond in some fashion, she unsuccessfully pressed him to select Yigal Allon, his special assistant for defense matters and an acknowledged military hero. When her opposition to Dayan became public, the public turned on her in an unprecedented fashion. Newspaper editorials and respected columnists excoriated her for sabotaging the nation in pursuit of what they considered to be crass political motives. Women whose husbands and sons would go to war demonstrated at her office demanding the selection of Dayan. Golda, though highly suspicious about the supposed "spontaneous" nature of this opposition, soon recognized that the fight—whether organized by her opponents or

not—was lost. A few days before the war began, Eshkol made Dayan defense minister.

Then came Israel's lightning victory. Dayan, hailed by the domestic and international press as its "main architect," became the face of the Israeli fighting force. Incensed, Golda argued, rightly so, that the credit should go to Eshkol's preparations and IDF chief Yitzhak Rabin's execution, not Dayan's actions, which had done little to affect the war's outcome. During his four years as defense minister, Eshkol had overseen the buildup of the IDF infrastructure and, together with Rabin, acquired a range of expensive new weapons. Today most historical assessments of the war agree with Golda. Dayan contributed to the victory but was hardly its architect. Not only did Eshkol not get the credit she believed he deserved, he was left broken and diminished as a leader.

But Golda had been given another pressing assignment: gaining Israel international support. It was to that she now turned. The war had not yet ended when, after an emotional visit to the Western Wall, where she prayed for peace and embraced and wept with weary soldiers, she boarded a plane for New York. The trip, arranged prior to the war, now took on a decidedly different tone. American Jews, who had so worried about Israel's survival, were beset with a postwar euphoria. While they had generally warmly greeted any Israeli emissary, the welcome Golda received was on an entirely different scale. A ticket to her Madison Square Garden rally became a precious commodity. While moved by this overwhelming support, what really intrigued her were the thousands of young Jews—twenty-five hundred in New York alone—who, during May, desperately attempted to get to Israel. They had willingly dropped everything—including their final exams—to go to a war zone. Golda asked to meet with them. With less than twenty-four hours' notice, a thousand young people appeared. "Why," she asked, "did you want to come? Was it because of the way you were brought up?

Or because you thought it would be exciting? Or because you are Zionists?" She singled out one of the variety of responses she received, probably because it reflected her own Weltan-schauung. "My life will never be the same again. . . . The fact that Israel came so close to being destroyed—has changed everything for me: my feelings about myself, my family, even my neighbors." In his words Golda heard more than an expression of his identity as a Jew and his being part of a larger "family." Not surprisingly, she heard in his words an echo of her own determination that there would be no "second Holocaust."[5]

Golda was not alone among Israeli leaders and Jews everywhere in assessing May 1967 through the prism of the Holocaust. In the weeks leading up to the fighting, as Israel contemplated a three-front war, the ever-present nightmare of another Holocaust loomed large. One heard it mentioned—I did—in the streets, at markets, on buses. It was very real. But within a few years the political mood changed. There was a backlash, particularly among some of the younger generations, against succumbing to the *Holocaust syndrome*, that is, seeing the present through the looming history of this genocide. A few years later a group of senior IDF officers, annoyed by the depiction of Israel as having been on the brink of destruction, argued that it was an exaggeration. Israel, they posited, had not faced destruction in 1967. Golda, deeply angered by what she considered historical revisionism, dismissed the officers' comments as utter "nonsense." Rabin agreed, arguing that Israel had not fought "for freedom of navigation" in the Suez Canal but "for its existence."[6] Notwithstanding these attempts at revisionist history, for Golda the events of spring 1967 reconfirmed her conviction that when Jewish lives were on the line, it would always be us against them. In the lead-up to the war, as the situation deteriorated, the great powers dithered. Rather than aid Israel, they repeatedly warned it not to act first. In contrast, Jews worldwide, alarmed at what might happen, sent not just money but

their children. For Golda there was no stronger demonstration of the fact that in situations such as this, Israel's only truly reliable allies were other Jews.

In the aftermath of the war, with most of the different factions of the Labor Party tenuously united, an exhausted Golda retired. In her memoir she depicts the next nine months as a grandmother's time of peace and quiet, claiming that nothing or no one could persuade her to accept another job. At age seventy, she declared herself glad to be free from the daily grind of politics. It was time, she told journalists who came to interview her, to move aside for the next generation.

Then came Eshkol's sudden death. In her memoir Golda describes herself as utterly shocked. She had spoken with him the previous night. All seemed fine. The Israeli media, which immediately began to speculate about who would succeed him, quickly discerned that party leaders had chosen her. She denied that this plan was in the offing, becoming furious with reporters who appeared on her doorstep to tell her, "Everyone says there is only one solution. Golda must come back." When an editor of *Maariv* declared that only she possessed the "authority, experience and credit" for the job, she erupted, suggesting that this particular topic was the furthest thing from her mind at the moment. "Eshkol isn't even buried. . . . How can you talk to me of these things?" After the funeral, in the wake of much public cajoling and having received the imprimatur of her children and doctors, she agreed to take the job, albeit with a great show of reluctance. In her memoir she repeated her familiar mantra. Comparing herself to her milkman who, when called to go to war, took up his post as an officer because that was his responsibility, she wrote, "Neither of us had any particular relish for the job, but we both did it as well as we could."[7]

That is her version. The truth is a bit more complex. Her succession did not emerge organically upon Eshkol's death. There was no desperate search for a successor. All had been decided

months earlier with her approval. Eshkol's health was failing by early 1968. Senior Mapai leaders led by Finance Minister Pinhas Sapir, aware of the party's weakened political status and anxious to avoid a public contest, determined that succession plans had to be put in place. They settled on Golda, despite the fact that she had little overt support in the party and was resented by the public for attempting to prevent Dayan from becoming defense minister. They worried that unless they acted Dayan might be chosen. They shared Golda's distrust of him and knew that his objective was to oust them. Dayan's main challenger was Yigal Allon, a Palmach hero and former general. The veterans did not consider Allon a strong enough personality to be prime minister. Golda agreed with their assessment; she diagnosed him as suffering from "Dayan Syndrome": an overwhelming desire to out-Dayan Dayan. Compelled to prove himself stronger than Dayan, he would make serious mistakes, such as enabling the first group of settlers who came to Hebron in 1968 to obtain weapons. By doing so, he gave them a quasi-governmental imprimatur and inadvertently launched what would become the settler movement.[8] Fearful of these two options and with Eshkol weakening, the veterans turned to Golda. In late 1968 Sapir visited her at a health spa in Switzerland to inform her of the prime minister's condition and that she was the leadership's choice. When she did not object, they knew they had their candidate.

When Eshkol died the charade began. The cabinet ministers gathered at his residence to pay their respects. They then retired to a room to debate where he should be buried. He had left no instructions and his wife had deferred to them. Since he was the first prime minister to die in office, they had no guiding precedent. The kibbutzniks argued that it should be Degania, the iconic kibbutz he had helped found. Others insisted that he should be interred on Jerusalem's Mount Herzl, where Israel's other leaders were buried. Golda, who was not a member of the government, waited as the cabinet debated. As matters reached

an impasse, some of the ministers trickled out of the room. They gathered on the sofa around Golda and asked for her opinion. After polling their preferences, she ruminated momentarily, then declared: "Jerusalem." And with that the decision was made. A deputy minister who was watching her recalled realizing, "*This* is the next prime minister of Israel." A few days later, when the Mapai leaders met to officially choose a successor, that same deputy minister made a grievous mistake. Turning to Golda, he proposed that she be the candidate. "After all," he declared, "you want it with all your heart and soul." Yossi Sarid, one of the younger people at the gathering, described this moment as akin to "a hand grenade . . . [being] tossed into the middle of the room." Aghast at this overt violation of socialist mores—giving someone a job because they want it—Golda exploded: "I don't *want* anything." Anxious to defuse the situation, all those present gathered around to console her and insist that she was the best person for the job and must take it. If the gathering on Eshkol's sofa had been her "selection," this was, as one observer described it, her "coronation."[9] Even after Mapai voted to confirm her nomination, she maintained the charade, telling reporters, "My own candidate is Yigal [Allon]. I would be happier if there were a clear vote between Yigal and Dayan. Regrettably, my opinion was not accepted."[10] In March the Knesset overwhelmingly approved her new government. Prior to her selection, according to a poll, just 3 percent of the Israeli public supported her as Eshkol's successor. Within a few months of her taking office, that number was 80 percent. But the love affair would not last.

Many people—including the public, the media, the veterans who anointed her, and possibly even Golda herself—initially assumed that she was an interim prime minister and would resign after the October elections. But she enjoyed a miraculous rebirth. The job breathed new life into this "71-year old grandmother," as many news outlets described her. (Notably, one finds

few, if any, instances where a male officeholder's grandfather status is used as a reference point, much less even mentioned.) Aaron Remez, the Israeli ambassador to England and the son of Golda's mentor and former lover, visited her shortly before her nomination. Struck by her aura of "fatalism," he felt he was visiting a "dying" person. A few months later, a stunned Remez watched as she arrived in London and "jumped from a plane . . . like a young woman." When he showed her the light schedule he had arranged, she demanded that he add more meetings. At 11 p.m., after an intense day of consultations, Golda invited him for coffee. When he expressed his amazement at her miraculous recovery, she informed him that "the only medicine for her sickness and pains was being prime minister."[11]

Not only was her body soon strengthened, so was her control of both government affairs and the ministers who conducted them. Acting unlike someone who thought of herself as a caretaker or interim officeholder, she took charge. She was no longer obligated to defer to others. Others had to answer to her. In contrast to Eshkol, who presented himself as a man of compromise, she was domineering, particularly to those in her cabinet. She was described by *Time* magazine as running her cabinet "like a front-line officer." An aide agreed. "She listens to everyone, but she interrupts if they ramble. She has an open mind, but it's like arguing before a judge. When she decides, it's made."[12] Those around her, both colleagues and aides, became increasingly loath to challenge or confront her. For many people this was initially a welcome change from Eshkol, who often seemed unsure of what to do. But her certainties had a downside. People who worked for her and were loyal to her repeatedly described their "fear," particularly when they had to disagree with her. One told Klagsbrun that he "stood at attention" when she called. Klagsbrun noted that he said this "only half-jokingly." The party spokesman at the time recalls sitting with all the "ti-

tans of the generation," people who had helped build the state, and he was startled to see that in meetings with her "everyone is paralyzed, not daring to say a word. They are afraid of her glance. They don't open their mouths, not even Pinchas Sapir."[13]

Chaim Herzog, who during the Yom Kippur War was a major general and head of Israeli military intelligence, described her as having a "doctrinaire, inflexible approach to problems" and governing with "no checks and balances." Once she made up her mind, "no alternative evaluations" were to be voiced. (Herzog had his own run-ins with her.) Golda believed her position demanded that she act forcefully and definitively. Decisions had to be made. Long, drawn-out deliberations with everyone opining at great length were neither efficient nor efficacious. However, because her closest aides were increasingly reluctant to criticize or even question her decisions, she was sometimes deprived of alternative views. Some of her biggest mistakes would come because she did not have people around her who felt free to challenge her. The media depicted her as the quintessential Jewish mother—preparing snacks for her guests, making gefilte fish, and meeting with her top advisers in her kitchen (truly a kitchen cabinet). However, Herzog claimed that contrary to the idyllic image, this mother used an iron hand to rule the roost and "believed that only she was right about any subject under discussion."[14]

Julie Nixon Eisenhower, who interviewed Golda shortly after her retirement, saw remnants of that steely control. When she met Golda, Eisenhower expected to see "fire" in her eyes, but instead she found "gentle concern." For much of the interview, Golda was warm and forthcoming, asking Eisenhower about her mother's well-being, fondly recalling visits with her parents, and answering all her questions. But then, as the interview progressed Eisenhower discovered that when Golda resented a question or did not wish to answer it, her eyes grew "cold

and dark." Sometimes she simply did not respond. Her former spokesman described her as having a particular ability to be full of love, yet also to be exceptionally "cold and cruel."[15]

Golda's tenure began and ended with a war. Egypt's War of Attrition, which entailed attacks on Israeli positions on the east side of the canal, began almost simultaneously with her entry into office. Nasser believed that what had been taken from Egypt by force would be returned by force. The shelling was unrelenting. This conflict often fades from memory because it was followed by the far greater and more traumatic Yom Kippur War. However, it was, as Golda noted, a real war. Terrorist attacks on Israelis were taking place simultaneously in Israel and in places far from it. The loss of over fourteen hundred soldiers' lives during this war and the dramatic increase in Palestine Liberation Organization attacks took a physical and emotional toll on both the Israeli population and Golda. She insisted on being told each time a soldier was killed, even if it meant being awakened in the middle of the night. For years, she repeatedly lamented, it was impossible for her to finish a dream. The conflict became a little Vietnam, a never-ending encounter with continual losses and no change in the situation.

Throughout it all there was a steady stream of international negotiators who arrived in Jerusalem with a mind-spinning series of proposals, all intent on resolving the "situation." In the face of this intense pressure, Golda remained publicly wedded to certain convictions. First, Israel rejected the three "no"s the Arab nations had declared in the wake of the war: no peace, no recognition, no negotiations without a complete Israeli withdrawal and the resolution of the refugee problem. She resolutely insisted that negotiations might lead *to* withdrawal, but withdrawal could not be a prerequisite for negotiations. Second, before Israel would rely upon international guarantees, the Arabs had to accept Israel as a permanent fixture. As she told the Knesset in 1971 and repeated in a myriad of speeches and interviews,

"International guarantees are not a substitute" for free unconditional negotiations.[16] In virtually every speech she made regarding the situation, she repeated the same thing. Israel was willing to sit down and talk. As she put it on her first day in office: "We are prepared to discuss peace with our neighbors, any day and on all matters." However, she had two absolutes: no return to 1967 borders and no decisions about withdrawals without "agreement and negotiations with the relevant partners."[17]

Until those negotiations and final agreement, the territories were the key to Israel's security and could not, she stipulated, be returned. Though her governing style was decidedly different from Eshkol's, both of them believed that the solution was to be found in a territorial compromise that would entail Jordan keeping the majority of the Palestinian population within its borders. There were certain territories that, she believed, could not be returned. She reasoned that abandoning Jerusalem, the Golan, Gaza, and Sharm el-Sheikh would put Israel in a militarily "inferior position." She opposed any attempt to create an additional state between Israel and Jordan because, in the words of Simha Dinitz, director general of the prime minister's office during her tenure, such a state would not be stable, lacking "an adequate geographic or demographic base." Like Eshkol, she was firmly committed to preserving both the democratic and Jewish character of the state. The territories, she was convinced, could not be kept in their entirety if one wanted, as she did, "a Jewish state with a Jewish majority." From the outset, she disdained what she considered the fanaticism of those Israelis who supported keeping the territories on theological and historical grounds.[18]

She also held firm convictions about Palestinian Arabs, whose existence as a national or specific unit she only reluctantly acknowledged. In a June 1969 interview with the *Sunday Times* of London, she gave voice to her deep-seated sentiments about the Palestinian Arabs. In her familiar unequivocal style, she made

a statement that would be linked to her forever. "There is no such thing as Palestinians. . . . They did not exist." Widely excoriated for saying this, she repeatedly tried to walk it back or qualify it. She pointed to her Mandatory papers, which identified her as a Palestinian. A Palestinian could be an Arab. A Palestinian could be a Jew. She tried to add nuance to her statement by contending that what she meant was that there had never been a Palestinian *nation*. When the Zionists began to establish the Yishuv, they had not gained control of a Palestinian nation. But all her protestations were of little avail. Her critics—and even some of her friends—considered her statement a reflection of her uncompromising hostility toward the national aspirations of the Arabs living in areas under Israeli control. What she said may have been historically accurate—there never had been a Palestinian *nation*—but it also seemed to confirm her inability to see a quickly evolving reality.[19] Eventually she acquiesced, acknowledging that there might indeed be people who considered themselves Palestinian. However, even as she admitted the point, she seemed unable to feel their deep sense of humiliation and deprivation, particularly after 1967. She could have acknowledged that dislocation even without materially changing her policy. Some of her critics consider her inability to see nuances among the Arabs as her Achilles heel, causing her to miss crucial opportunities to reach out to Israel's neighbors.

But her public pronouncements aside, she was not a totally free agent. However great their bombast, Israeli prime ministers never are. In the wake of the 1967 war, Israel desperately needed arms, and with France no longer a supplier, America had to fill the void. Golda could not afford to alienate the Nixon administration. That relationship had started with a triumphant visit to the White House in September 1969, shortly before the Israeli elections. Forty-eight years after sailing from New York on a broken-down ship in a third-class cabin, she was greeted in Philadelphia by thousands of people and then feted on the

White House lawn with a twenty-one-gun salute. This was followed by a resplendent dinner, with entertainment provided by Leonard Bernstein and Isaac Stern. The visit included long and what she was sure were productive meetings with Nixon. Though most of their meetings took place in the presence of their advisers, Golda and Nixon had one short—fifteen minutes—private meeting. It took place on the White House Lawn out of earshot of any of their aides or recording devices. Historians agree that this is when she officially informed Nixon of the true purpose of the Dimona nuclear reactor, about which he in all likelihood already knew. Years earlier she had argued that it was to Israel's advantage to be honest with the Americans. Ben-Gurion, with the strong encouragement of Peres, who thought her naïve, disagreed. Now, as prime minister, she could do as she saw fit. She promised Nixon that Israel would never be the first to use nuclear weapons and he apparently agreed not to press, as previous administrations had done, for on-site visits. Israel's nuclear weapons became and remained for decades thereafter an unspoken subject between the two countries.[20] This is precisely what she thought would have happened had Kennedy been told about Dimona's true purpose.

After the successful visit and her repeated praise of Nixon, which riled many American Jews, Golda anticipated that Israel would soon receive the military "hardware" that she had told the president was so desperately needed. Instead, to Golda and Ambassador Rabin's great surprise, instead of "hardware" they received "software," that is, a peace plan from Secretary of State William Rogers. Ignoring much of what had been discussed with Nixon, it stipulated that all land must be returned, the refugee issue resolved, and Jerusalem jointly administered by Jordan and Israel. All of this was to happen without direct negotiations or diplomatic recognition. Golda considered it to directly contradict the assurances Nixon had given her. Angry about America's continued withholding of arms, she was also

quizzical about the fact that the agreement's guarantors included not only the United States, the United Kingdom, and France, but also the Soviet Union, which was already providing Egypt with both military advisers and the latest technology. The plan shocked Israelis in every aspect. Luckily for Golda, the Arabs and the Soviets also rejected Rogers's plan. But shelling continued and Golda adopted an "asymmetrical response" policy—hit them back harder than they hit us.

During this period, one of Golda's primary American interlocutors was Henry Kissinger, who would often berate her for her "intransigence." During some tense negotiations, Kissinger complained that in Egypt he was hugged but in Israel he was attacked mercilessly. She told him that if she were an Egyptian, she would also hug him. One analyst described how, using his identity as a Jew and a refugee, she was able to make him feel like a "wayward nephew." Probably unlike any other head of state with whom Kissinger interacted, she knew how to lay "guilt trips" on him when they had disagreements.[21]

The growing conviction among some left-leaning intellectuals and academics that Golda was uninterested in peace was reinforced in March 1970 by the Nahum Goldmann contretemps. Goldmann, president of both the World Zionist Organization and the World Jewish Congress, asserted that high-ranking Egyptian officials had sent him an "invitation" to visit Nasser. Goldmann, a cosmopolitan man, had, both his ardent fans and severe critics agree, exemplary public diplomacy skills and an outsized ego. He seemed happiest was sitting with important international personages negotiating Jewish issues. Having turned down a government position when Israel was established, he never settled in Israel and, in fact, maintained a problematic relationship with the Jewish state. He contended that Zionists outside of Israel, particularly people such as himself, should have a say in Israeli affairs. He would frequently meet with foreign leaders to discuss Israeli affairs. Often it was unclear who

gave him the authority to engage. Also unclear was whether he was discussing or negotiating. While he might insist it was the former, his interlocutors often assumed it was the latter. He fostered that ambiguity. He won no fans in Golda's Foreign Ministry when in the wake of such meetings, he would send what officials described as "some grain that he calls a report." After one such incident in which he "negotiated" with an influential American senator who had a justifiable reputation of not being a supporter of Israel, Israeli officials felt compelled to remind U.S. officials that Goldmann neither represented Israel nor spoke on its behalf. Israeli ambassador Yitzhak Rabin even proposed that Goldmann's Israeli diplomatic passport, which enhanced his image as an official spokesperson, be cancelled.

In truth, Israel owed Goldmann a great deal. Beginning in 1951, long before any Israeli official could or would meet with German officials, he laid the groundwork for German reparations and greatly facilitated them. But he also reveled in taking iconoclastic positions that caused great ire among Israeli leaders. When Eichmann was captured, he rejected Ben-Gurion's insistence that Israel—and Israel alone—sit in judgment. He publicly proposed the convening of an international judicial tribunal presided over by an Israeli judge. Ben-Gurion and Golda considered this a lack of faith in the Israeli judicial system and a suggestion that Israel did not have legal standing to act. During the tense weeks preceding the Six-Day War, Goldmann opposed a war. He did not come to Israel, even as thousands of other Jews fought to make their way there.

On the matter of Soviet Jewry, he also eventually came to loggerheads with not just Israel but many in the world Jewish community. During the 1950s and into the early 1960s, he, together with the leadership of the Jewish community and Israel, followed a policy of quiet diplomacy. In the late 1960s, as Soviet oppression increased, Jewish leaders in different countries and the Israeli government began to advocate a more activist

public protest program. As activism among Jewish students increased exponentially during the decade, the notion of public protest on behalf of Soviet Jews gained momentum. Goldmann hated it. He believed that, since most Soviet Jews would have to remain in the USSR, nothing should be done to alienate the Soviets. (He publicly—and, it must be noted, justifiably—criticized those who said that the Soviet treatment of Jews constituted a second Holocaust.) But he insisted on quiet diplomacy even as it became clear that this approach was producing few, if any, results. His opposition may well have been motivated, at least in part, by his hope that he would be recognized by the Kremlin as what historian Yaakov Roi has aptly described "the plenipotentiary of Western Jewry" and be invited to discuss the status of Soviet Jews. The activist policy of protest, which Golda strongly supported and worked to facilitate, soon began to show substantial results. Nonetheless, Goldmann refused to change his stance and continued to insist that "it would be a betrayal to take the view that Jews in the Soviet Union should be released to go to Israel."[22]

In March 1970 Goldmann visited Golda to inform her of the Egyptian invitation. According to him, the Egyptians had said that he must bring concrete Israeli peace proposals, have the imprimatur of the Israeli government, and keep the visit secret until they chose to publicize it. She told him that she had to confer with the cabinet. Though they both agreed to keep the matter a secret for ten days, these two seasoned politicians knew that the invitation, however real it was, was now dead. The cabinet, including Golda's fellow Laborites, was not going to allow it to proceed. Though Eban strongly supported it, Dayan and Peres, among others, did not. In the interim Goldmann met with a broad array of government ministers and officials— something he would not have done, some analysts argue, if he thought either the invitation or Golda's consideration of it was serious. Moreover, he did not meet with Menahem Begin, who as

a member of the unity government and the leader of the center-right coalition would need to approve such a visit. Predictably, the cabinet turned it down flat. Once the idea became public, Egypt denied that any invitation had ever been forthcoming.

Most of the international press echoed the *New York Times*, which declared it "sad" that Israel, which insisted it was waiting for a call from the Arabs, declined, "when Dr. Goldmann's phone rang . . . to let him answer."[23] The Israeli reaction varied. *Haaretz* believed the rejection of the invitation was a "mistake that needs rectifying." Two polls—one by *Haaretz* and one by the government—came up with diametrically opposed results. Predictably, *Haaretz*'s poll showed a majority supporting the proposal, while the government's showed the opposite. However, both demonstrated that, at the very least, over a third of the Israeli population thought Goldmann should have been given the green light. Goldmann had his Israeli critics. After Egypt denied issuing an invitation, critics such as the popular poet and journalist Haim Gouri deprecated Goldmann for behaving like "an irresponsible publicity-hungry adventurer who involved Israel in a stupid delusion and blackened her name in front of the entire world." He dismissed the whole effort as a fabrication designed by Goldmann to return his name to the headlines. After attending the Knesset session where Golda and Eban had to defend the government's response, Gouri acknowledged that the Zionist leader's plan had succeeded. "Goldmann. Goldmann. Goldmann. It's all about Goldmann."[24]

The critics' conviction that the whole thing was a ploy was strengthened the day after the cabinet's rejection of the plan when Goldmann published a series of well-prepared articles in the Israeli and foreign press strongly criticizing Israel's failure to achieve peace. Some people began to speculate that he had orchestrated this "invitation," knowing it would be rejected, so that his articles would capture far more attention. Others contended that he assumed Golda would reject the idea and thus

was ready with the articles. That anger against Goldmann increased when the prestigious journal *Foreign Affairs* published his piece "The Future of Israel." The article, which clearly had been written and accepted long before this imbroglio, did not just criticize Israel's peace policy; it questioned the purpose of the state itself. In the opening paragraph Goldmann declared, "I am beginning to have doubts as to whether the establishment of the state of Israel as it is today, a state like all other states in structure and form, was the fullest accomplishment of the Zionist idea." He then proceeded to propose that, rather than be a state like any other, Israel should become a demilitarized neutral state or a protectorate, its security guaranteed by the Four Powers and the Arab nations. Then and only then could it embody "the special nature of the Jewish people and Jewish history" and fulfill its mission to be a source of "Jewish inspiration" and the "the spiritual center of the Jewish people."[25] Even some who supported Goldmann thought he had gone too far in suggesting that the Arab nations guarantee Israel's well-being. An incensed Golda declared that he was no longer a Zionist.

Goldmann's behavior—telling many people about the plan, not meeting with those who had the power to negate it, having his articles ready for publication, and proposing a new vision for Israel with its security guaranteed by its then sworn enemies— suggests that the "invitation" might have been more of a ploy to provoke an Israeli debate about foreign policy than a plan for an actual visit. If this was his objective, he succeeded remarkably. Israelis on the left, including leading intellectuals, academics, and cultural icons, were increasingly convinced that Israel in general and Golda in particular should be more flexible. More and more they saw Golda as a "naysayer" who piously promised to pursue every avenue for peace but failed to do so. The rejection of the Goldmann visit served as their proof positive.

Golda's standing with the intellectuals on the left was plummeting even before the Goldmann affair. In mid-April, when

the whole country was debating Goldmann's "invitation," a play opened in Tel Aviv's prestigious Cameri theater. Hanoch Levin's *Queen of the Bathtub* was an unequivocal satirical attack on the country's veteran leaders, chief among them Golda. One song paraphrased Churchill's famous speech to the British people during World War II. Levin's mythical leaders promised Israelis "blood and tears," which they would soon have "very bad." They could be sure this would happen because, the leader sang, "my word is my word."[26] The play closed not long after opening due to an irate public reaction.

Shortly thereafter, a letter signed by fifty-six Israeli high school students from one of Jerusalem's most selective schools further convulsed the nation. The students, all of whom were about to join the IDF, accused Golda and her government of "missing chances for peace" by rejecting Goldmann's mission. How, they asked, could they be expected to put their lives on the line if the government did not do everything possible to advance the cause of peace? Goldmann's supposed invitation suggested, the students contended, that Golda was wrong to insist on policies she defended on the grounds that "there is no other choice." The letter closed with a plea that paraphrased the anti–Vietnam War chant "Give peace a chance," then being heard worldwide. Their call—"Give Goldmann a chance"—won broad attention. Golda took their protest seriously enough to ask Deputy Prime Minister Allon to meet with them. But the growing groundswell of criticism from the Israeli left only grew more vociferous.

Years later Golda told a journalist whom she liked and, more important, trusted, that she made a mistake by refusing Goldmann's permission. If the meeting had happened, it would have demonstrated that there could be conversations between Arab leaders and Jewish leaders with close connections to Israel.[27] If, as was more likely, Nasser had pulled out before the visit took place because such a meeting violated the inviolate "no"s, her

position would have been reinforced. She knew this in 1970. She also knew that letting Goldmann accept could blunt the perception that she was intransigent. Why, then, did she ensure that the plan would be rejected?

First, she believed that she did not need Goldmann to convey a message to Arab nations. The many foreign dignitaries who wended their way through Jerusalem could and were already doing that. But there were additional factors that were probably more significant in forging her response. Goldmann's rather iconoclastic position on Soviet Jewry displeased Golda. More important, to rely on Goldmann may well have struck her as an echo of the past, a past she so adamantly rejected and one that was, she fully believed, antithetical to what the Jewish state represented. She was the prime minister of an independent Jewish state with a democratically elected government. To even contemplate ceding her authority to someone whom she considered an unelected, self-appointed Jewish bigwig who decided for himself what was best for his fellow Jews was an anathema. In centuries past, when Jews were disenfranchised without political power, they depended on the *Shtadlan*, a powerful and wealthy Jew, to intercede on their behalf. However, regardless of the extent of his power or financial prowess, the *Shtadlan* always came as a supplicant. At the 1938 Evian conference, where she sat on the sidelines while her people's fate was debated, she had been incensed that she had to passively observe and then beg for succor in fourteen-minute meetings. For Golda, Israel's existence meant that Jews, at least those who lived there, could speak for themselves. She may have believed these justifications, but ultimately they were immaterial. The invitation imbroglio made her look increasingly inflexible.

This perception of inflexibility was enhanced by her rejection of multiple other proposals. Gunnar Jarring had been appointed by the UN secretary-general as a special Middle East mediator. After a number of false starts, in late 1970 he sent

Egypt and Israel a proposal that they enter into a peace agreement. It stipulated that Israel withdraw to the 1967 Egypt-Israel border. Much to many people's surprise, Egypt seemed to agree but added a number of caveats, including total withdrawal, the division of Jerusalem, and resolution of the refugee crisis within the context of UN resolutions. This was the first time an Egyptian government publicly announced its willingness to sign a peace treaty. Israel, impressed by this, responded but refused to agree to a return to pre–June 1967 lines as a condition for entering into negotiations. Ultimately Jarring's efforts died.

Then in early 1971 came yet another proposal, this one from Egypt's new president, Anwar Sadat. He extended a cease-fire and then suggested that Egypt might consider some sort of peace agreement. While the particulars of what such an "agreement" would look like were murky at best, Sadat's demands were quite specific. Israel was to give a prior commitment to withdrawing from all newly acquired territories, dividing Jerusalem, resolving the refugee problem on the basis of UN resolutions, and terminating all acts of belligerency. Golda, finding the preconditions unacceptable, said no and dismissed the proposal as containing nothing new. Her critics, particularly in Israel, argued that it should not have been summarily rejected. Though she was convinced that she could not accept Sadat's preconditions, which did not even guarantee an actual peace agreement even if all the conditions were met, she might have used the overture to initiate a conversation. It might have been a ploy, or it might have opened the door to genuine negotiations. It is unclear whether a different approach would have prevented the October 1973 Yom Kippur War, but at least Golda would have appeared to have tried. Her Israeli critics, both in the public square and the academy, many of whom fought in the Yom Kippur War, never forgave her for not doing so, especially in light of the high cost of the war and the fact that Egypt and Israel eventually came to this agreement regarding the Sinai in 1979. One

cannot, of course, ignore the fact that Golda believed the stalemate situation that now reigned was in Israel's interest. It gave Israel time to win Nixon's approval for a new military aid package and at the same time gave a certain permanence to Israel's hold on the territories. According to Kissinger, she "considered Israel militarily impregnable; there was [therefore] . . . no need for any change." She was generally "willing to enter talks, though not to commit herself to an outcome."[28]

Golda had another impetus for preferring the status quo. An election was looming and the Alignment, the ruling coalition, differed markedly on what policy to pursue. At one end of the spectrum, Dayan supported expanding the Israeli presence in the West Bank. At the other, Abba Eban and Pinhas Sapir believed that keeping the territories would harm Israel's Jewish and democratic identity. Stalemate, they contended, was likely to push the Arabs to see military confrontation as their only option. In light of these and other differences of opinion within her own government, doing nothing seemed to be a viable and politically astute option.

During these years, most of her energies and emotions were focused on foreign matters. She largely left domestic affairs to her cabinet ministers. However, she was not unaware of the poverty afflicting a sizeable portion of the Mizrahim, Jews from the Middle East and North Africa. They endured poor schools, substandard housing, neighborhoods that could legitimately be classified as slums, and a lack of good jobs. The immigrant generation of Mizrahim, those whom Golda had helped to come in the immediate aftermath of independence, had tolerated the substandard conditions. Their children, however, were less inclined to do so, particularly as the Israeli economy expanded in the wake of the 1967 war. They contended, with good reason, that the Ashkenazim, the power players, did not believe them to be as smart, capable, hardworking, and serious as Ashkenazim. Golda and those around her in the government and Histadrut

could not comprehend that this might be a problem rooted in ethnic discrimination. They saw it as a social and economic problem. If these Mizrahi Jews, their thinking went, had modernized and were less resistant to change, the situation would have long ago been resolved. Then Soviet Jews began to arrive and Golda, thrilled with this unexpected development, made sure they received new apartments, jobs, and a host of other benefits. The younger Mizrahim, convinced that the new arrivals were receiving preferential treatment because they were Ashkenazim, protested. Golda deflected this criticism by arguing that if the Soviet immigrants complained about the conditions they found in Israel, Jews still in the USSR would not want to come. In addition, such complaints would give Soviet authorities a useful propaganda tool. Her explanations did not assuage the young Mizrahim, whose protests became more vocal.

Golda took this issue quite personally. She was immensely proud of having facilitated, in her capacity as labor minister, the immigration of over two hundred thousand North African Jews. She knew that immigrants from the Middle East and North Africa had faced particularly difficult conditions when they arrived, including challenges to their integration into Israeli Ashkenazi-dominated society. She, rather unfairly, attributed their difficulties to their lack of skills and unfamiliarity with "work." She had less sympathy for people of younger generations, many of whom had been born in Israel. They had dropped out of school, gotten into trouble with the police, and not held steady work.

Her failure to grasp some of the challenges they faced was painfully evident when she met with a group of young Mizrahim from Musrara, a dilapidated Jerusalem neighborhood that until 1967 was on the Israel/Jordanian border and overnight became prime property. Inspired by protest movements happening worldwide, these young people, who were "social dropouts" and members of a street gang, began to organize to demand

better conditions for their communities. In a stroke of media savvy and with the input of a far-left anti-Zionist Israeli group, they chose "Black Panthers" as their name. This was happening at precisely the time when the Black-Jewish alliance in America was crumbling. The more moderate and conciliatory modus operandi of the Reverend Dr. Martin Luther King was being overshadowed by a militancy that many observers believed condoned violence. The American Black Panthers presented themselves as a revolutionary party that advocated Black nationalism, socialism, and armed insurrection. Their public statements were often laced with antisemitism. The Musrara group's choice of this name was bound to be provocative. Golda was perplexed, if not annoyed, by their choice. It certainly colored her attitude toward them.

In March 1971 the Israeli Black Panthers applied for a permit to stage a protest. Their request, which should have been a pro forma matter, went up the chain of command to the prime minister's office. When the police learned that the group's far-left advisers had recommended bringing black flags and spikes with nails to use against the police, their request was denied. They held a protest anyway. Then, shortly before Passover, they organized a fast at the Western Wall. The international media was transfixed.

Golda, recognizing that this could not be ignored and possibly thinking she could reason with them, invited the leaders to meet her in her office. They came armed with statistics that detailed the economic discrimination their communities faced and made sweeping demands for change. They demanded free schooling from kindergarten through university, free housing for the needy, subsidies for large families, and proportional representation of Mizrahim in all state institutions. They claimed that they believed that once Golda, the leader of a workers' party and lifelong socialist, heard what they had to say and learned of the reality of their situation, she would resolve their problems.

They claimed that they expected not just empathy but immediate action.

The meeting was, in the words of one of Golda's aides, a "catastrophe." She began the exchange by going around the table and asking each participant if they worked and if their parents worked. Many of them did not or held menial jobs. They were insulted by her question and argued that they had not come to speak about themselves, but about all Mizrahim. Golda protested that she would initiate a conversation with any group of young people who came to her office by asking them what they did. Given that Israel was then facing a labor shortage, for Golda, who had once washed diapers in her children's nursery, the fact that they did not work was incomprehensible. When they presented her with their demands, Golda, whose cabinet had in the wake of the first demonstration allocated 80 million Israeli pounds for special programs, brushed them off with "Don't talk to me about statistics." When they insisted that Mizrahim faced discrimination and that was why they lived in such poverty, she informed them they were wrong. Yes, there was poverty, she acknowledged, but no, there was not discrimination. In response, one of them said to her, "You're a liar."[29] Dismissing their proposals for ameliorating the situation, she offered them a simple solution: "Start working."[30]

The Mizrahim left the meeting far more aggrieved than when they had arrived. A month later they organized a massive protest in Jerusalem. Some of those present threw Molotov cocktails at police officers and started fires. The next day an enraged Golda gave a previously scheduled talk before an organization of Moroccan Jews. She expressed her deep concern about ethnic bifurcations in Israeli society and acknowledged that more needed to be done to improve the disparities in society. Then, turning to the protest, she reprised the question she had asked forty years earlier when Mapai youth had attacked Revisionists in Haifa. "How could Jewish hands throw Molotov cock-

tails at other Jews?" When the head of the organization that had convened the gathering described the bomb throwers as "nice boys," Golda responded with words that would haunt her: "They were once nice boys and I hope they will once again be nice boys, but there are some who will remain the same." Fifty years after she said this, many commentators, including scholars who revel in painting her in a bad light, assert that she was speaking of all Mizrahim, thereby condemning half of Israel's population. But in truth she was speaking only of the bomb throwers, responding to what had been said about them.[31]

Nor was she unresponsive to their situation. Her next budget allocated more funds for housing, education, and welfare than any previous Israeli budget. She set up a special commission to investigate the economic and social disparities extant in Israel. In contrast to her usual modus operandi, she attended the commission's extended meetings. Then, when its report was issued, she did something her staff described as "highly unusual."[32] She held a press conference in which she insisted she would personally see that the facts the commission uncovered would not be buried in Israel's famed bureaucratic maze. She established a "Youth Authority" in the prime minister's office to ensure that the problem was addressed.

All these were affirmative—and in many cases, unprecedented—actions. But after the catastrophic meeting with the Mizrahim youth, her difficulty in accepting that prejudice existed, and her disastrous—though taken out of context—"not nice" comment, her budgetary responses were almost irrelevant. History has certainly forgotten many of these concrete responses. Her critics proceeded to use this moment to transform Golda Meir, who considered herself the emblematic socialist, into a symbol of racist elitism. She, who had marched her entire life to the beat of the Labor Zionist drummer with its promise of a better life for Jews, one free of discrimination and persecution, and had not financially bettered herself in a lifetime of so

doing, could not fathom how she was being accused of racism and discrimination. She was angry with those who made that assertion.

Her critics on the left used this exchange to argue that their prime minister was out of touch not just on foreign matters but also on what was happening at home. This impression of being out of touch was further exacerbated by her altercation with Israeli feminists, Shulamit Aloni in particular. Aloni, a Mapai MK, was brash, outspoken, an early critic of Israel's policies toward the Palestinians, and a fierce fighter on behalf of civil rights in general and women's rights in particular. Aloni was far more liberal than Golda. But their differences were not just rooted in politics; the two women disliked each other intensely. Aloni, not entirely incorrectly, believed Meir to be a controlling person who brooked no dissent. Aloni, whom Golda considered, again not entirely incorrectly, a person willing to say anything outrageous to get attention, became increasingly public in her criticism of Golda. At one point, she even suggested Golda be named president. This suggestion, which may have sounded like an honor, would have served to remove Golda from the political fray. Golda returned the antipathy measure for measure. But she had a weapon in her quiver that Aloni did not: power. In the next election, Aloni was given such a low place on the Mapai list that it guaranteed she would lose her seat in the Knesset.

Golda's complicated relationship with feminism extended beyond Aloni. As we have seen, already in the 1930s she had fervently defended working mothers who continually feel torn between home and career in a way that men do not. At the same time, in another article, she attacked women extremists. Making the hyperbolic accusation that they were engaged in a "war against the male gender," she wrongly contended that they considered men the "enemy."[33] Forty years later she again vastly exaggerated when she dismissed the women's movement as "crazy women who burn their bras and go around all disheveled and

hate men." The bra-burning women against whom she railed were a figment of her imagination or a creation by critics to demean and denigrate feminists. She was so eager to distance herself from feminists that she told the Italian journalist Oriana Fallaci that she had never been part of a women's organization when, in fact, she had headed two of them early in her career. She may have wrongly conceived of herself as having served as the Histadrut or Mapai's emissary *to* these organizations rather than being part *of* them.

She also shaded the truth when she told Fallaci that she had never faced any obstacles as a woman. She had fought with her parents about her education. She had not been included on the Nachshon board of directors, despite knowing more about the topic than anyone else. She was not included in the provisional government. When named foreign minister, she was frequently asked what it felt like to be one of the few "women foreign ministers." (She responded that she had never been a male foreign minister so she had no grounds for comparison.) It is possible that she elided her work for women's organizations in an effort to differentiate herself from Aloni and other Israeli feminists. But she may also have been responding in a fashion not unfamiliar in people who have reached the pinnacle of their career. When they look back on what they have achieved, the obstacles they faced seem petty and unimportant. Why complain about your parents stopping you from getting an education when you are the first woman in the world to become the head of a country on your own accord?

Some of those who write about Golda describe her as "antifeminist." But her record belies such a simple moniker. She was more complicated than that. On a number of occasions, with the use of a quick quip, she quashed cabinet proposals that were decidedly sexist (a word she probably did not know at the time, and if she had would probably not have used to describe actions). Shortly after the establishment of the state, when dis-

cussion arose as to what members of the Knesset should be called—by their first name, last name, or both—a cabinet member suggested that the Knesset follow the method used in the synagogue: the member's first name followed by the father's name. Golda suggested that the mother's name be used instead. The proposal was tabled.[34] When there were a rash of rapes in Israel, one cabinet minister suggested a curfew for women. Golda observed that since it was the men doing the raping, the curfew should be for them. This proposal was also tabled. In 1949, after returning from Moscow, where she had sat in the women's section in the synagogue, a rabbi invited her to attend synagogue in Tel Aviv. When it was clear that she would have to sit in the women's section, she declined the invitation, explaining, "In Moscow I went to be with Jews, so I agreed to sit even in the segregated women's section upstairs, but here in Tel Aviv I am prepared to go tomorrow . . . if you arrange a seat for me downstairs in the sanctuary among the men."[35] She hated the statement attributed to Ben-Gurion that she was the only man in his cabinet and correctly wondered if a man would be pleased to be called the "only woman in his cabinet." Telling a woman she was valuable because she acted like a man did not constitute a compliment in her eyes—or, if she had checked, in the eyes of most feminists. She was given and very much appreciated a poster then quite popular in the United States. Over a picture of her with her proverbial purse on her lap were the words: "But can she type?"

She knew there was sexism. She had encountered it. Yet she was also convinced that since she had succeeded without a special boost, others could certainly do the same. She wanted to be seen as a *leader*, not a *woman leader*. She wanted her dedication to the job to be what characterized her, not her gender. Women who worked for her in the 1950s and 1960s in the Foreign Ministry felt she did not fully understand or commiserate with the challenges they faced. One woman, a former Foreign Ministry

official, observed that while she may not have hated women, "she certainly wasn't a friend to us."[36] Had Golda heard this statement, she might have wondered why the women expected her to be a "friend" to them any more than to the men on the staff. She helped some women advance, but more often than not, she positioned herself as "neutral" on the matter. The question, of course, remains: is there a "neutral" position in the face of discrimination?

Her critics wove together the letter from the high school students, the encounter with the Black Panthers, altercations with Aloni, the rejection of the Goldmann invitation, and the dismissal of the Sadat "proposal" as indicative of a failed leader, one who was mightily out of touch. Then came the Yom Kippur War, which they would wed to this litany of "shortcomings." Here too they may have overstated the case.

11

The Yom Kippur War:
An Ignominious End to a Storied Career

MUCH HAS BEEN WRITTEN about the 1973 Yom Kippur War. To this day, many Israelis villainize Golda, holding her responsible for the death of twenty-six hundred Israelis. They consider her culpable because of both the disastrous beginning of the war and the missed opportunities that preceded it. In the months and even days before the start of the war, as what some people saw as warning signs proliferated, the highest-ranking military and intelligence officers repeatedly reassured Golda that no attack was coming. The Arabs would not attack, they kept telling her, because they feared the IDF. And if any attack did come, it would be easily repulsed. There might be a small skirmish, but nothing more. Despite receiving a serious warning on Rosh Hashanah from King Hussein about a coming attack, Golda ignored it. She did so in great measure because the idea of an attack was rejected by virtually all of the former *bithonistim*, security men in the cabinet, including former Palmach commander

Allon, former director general of the Defense Ministry Peres, and former IDF chiefs Haim Bar-Lev and Dayan.

When Golda asked what factors caused the Arabs to fear Israel, the IDF leaders offered what should have been recognized as a tautological response. "The Arabs are always apprehensive." When she asked if the Egyptians might engage in some small actions to "keep us busy" while Syrian president Hafez al-Assad attacked the Golan, the rather self-assured security representatives responded in the same fashion. "Assad knows his limitation, because they are aware of Israel's strategic superiority." She repeatedly asked about an early warning on the Egyptian front. How much time would Israel have? Again and again, IDF leaders and the chief of military intelligence reassured her that Egypt would not risk a crossing of the canal, but if it did, Israel would have a warning. Her follow-up question, which at first sounds a bit convoluted, was actually quite simple: How will we know when we know? In other words, just when would we get that warning? Given that Israeli and Arab forces were not far apart—separated by a few meters in the north and the canal in the south—she was suggesting that by the time "we know" it would be too late. The enemy forces would be here. And that was precisely what happened.

In retrospect it is easy to say that Golda was too easily assuaged by these assurances and that as prime minister she should have pushed far harder. Eban believed her deference to the military establishment was one of her greatest shortcomings as prime minister. She believed, Eban recalled, that concerning security matters, her only choice was to "blindly accept the military view."[1] Political scientist Uri Bar-Joseph believes that while she was clearly unhappy with the answers she was being given, she failed to ask crucial questions. Could the IDF stop a possible attack and would a call-up of the reserves, even a limited one, be efficacious? One can only speculate whether, if she had served in the IDF and was personally familiar with security matters,

she would have been less willing to accept the assurances of the military men. She might have given more weight to her doubts. Chaim Herzog, despite contending that her "stubborn blindness" about the looming threat of the war "was nearly disastrous," acknowledged that during the war itself she showed "great strength of character and enormous composure and . . . common sense." Much of that common sense was evident, Herzog believes, in her opposition to many of the choices made by "lifelong military men . . . [her] choices were usually correct."[2]

By Friday morning, which was also Yom Kippur eve, the doubts of virtually everyone in the higher ranks of the government about an impending war had faded. They knew a war was coming. At that point, Golda had the option of ordering a first strike. However, the Nixon administration had repeatedly warned her not to do so. Kissinger had told Rabin that under no circumstances should Israel strike first. During the first few days of the war, when matters looked bleak, she berated herself for heeding these instructions. After the war, during the investigation by the commission she established, she stood by her original decision. If Israel had launched the first strike, some of the fallen soldiers would be alive but, she wondered, how many might have subsequently fallen due to a lack of equipment? It was Hobson's choice: no choice at all.

During the early days of the war, not only did Israel suffer losses of territory and lives, its arms' supply grew worryingly low. Increasingly desperate, Golda considered flying to Washington to impress upon Nixon the severity of the situation. Kissinger dissuaded her from doing so and agreed to an immediate shipment of arms. Then Defense Secretary James Schlesinger slowed the transfer down. Finally Kissinger broke the logjam and a massive supply of arms began to arrive.

During the war, Golda worried not only about the setbacks on the ground but what the perception of Israel would be *after* the war. "We want to survive in the future," she told the IDF

leaders.[3] She understood from a strategic perspective that if Israel appeared weak and vulnerable, the world powers might try to force it to accept greatly reduced borders. Military analysts credit her with thinking strategically. Such calculations also fit precisely into her worldview. Simply put: no one is more vulnerable than the weak Jew—or in this case, a Jewish state that is perceived to be weak. When some members of the cabinet, Dayan in particular, urged that Israel accept a cease-fire agreement with Egypt, one that would leave it some distance from the canal, Golda shot it down: "That is not a cease-fire, it is surrender." When a proposal that Israel push into Syria toward Damascus was under consideration, and cabinet members worried about the cost, she told them: "Since the beginning of the campaign I have lived with the feeling that we cannot come out of this in a situation where the world will say: 'That's it; whatever we thought about Israel and the IDF—that's it.' . . . Because any nation can win or lose, but if we, heaven forbid, do not win—then all is lost."[4]

She cared about the loss of life. However, convinced that unless Israel emerged with a decisive victory America might not think the Jewish state worth defending, she told her colleagues, "Jews in general are not loved, weak Jews are loved even less. We will be thrown to the dogs."[5] As the military situation improved, she took an aggressive stance and strongly supported IDF forces moving toward Damascus in the north and crossing the canal in the south. She knew full well that her decisions would result in additional losses. Critics would fault her for being willing to sacrifice soldiers' lives. However, she was determined that Israel capture as much land as possible—even if every inch would be returned—prior to being compelled to accept a cease-fire. Ending the war with the status quo ante— back in the same position as when it began—would constitute a loss.

Even those who are severely critical of her prewar intransi-

gence increasingly credit Golda with ensuring the eventual Is-
raeli victory. From a military perspective, the war ended well for
Israel. Israeli forces were on both banks of the canal and Da-
mascus was within easy reach. Nonetheless, Golda considered
the war a spectacular failure. Though the commission of inquiry
absolved her of responsibility, no one was surprised by her sub-
sequent decision to step down from office. Her leadership days
were over. Years later, shortly before her death, Golda acknowl-
edged that since that war, "I am not the same person."

She retired to her relatively modest home and spent much
of her time defending her wartime record and her efforts at
peacemaking. She agreed to write a memoir, in part because of
her concerns about finances. It became a best seller. She was
named a number of times as the most admired woman in the
world. Journalists hounded her for interviews. In Israel she re-
mained out of the spotlight, with a couple of stark exceptions.
One came during the visit of Prime Minister Sadat to Israel.
In his day and a half on Israeli soil, she met him twice. She was
on the tarmac to greet him as he descended from his plane. He
was clearly delighted to see her. At the second meeting she
spoke movingly—and extemporaneously—of his great courage
in being willing to reject one of the "no"s: face-to-face negotia-
tions. But it was her final words to him, delivered as she sat next
to him in a Knesset conference room, that are most remem-
bered. "Let us, at least, conclude one thing: the beginning that
you have made, with such courage and with such hope for peace
. . . that it must go on, face-face between us and between you,
so that even an old lady like I am will live to see the day . . . of
peace between you and us . . . and all our neighbors." When she
described herself as "an old lady," Sadat broke into a wide grin
and then erupted in genuine laughter. When Golda interjected,
"Yes, you always called me an old lady," the Egyptian presi-
dent, whose amusement, perhaps delight, was palpable, turned to
Shimon Peres, who was seated on his other side and said, "Yes,

yes, that's what I called her." Then, to cement the wonder of the moment, Golda handed Sadat a small gift-wrapped box containing a present for his newborn granddaughter saying, here is a gift from "a grandmother to a grandfather." When she finished, those present erupted in laughter and cheers. Sadat, shaking his head from side to side, repeatedly declared: "Marvelous. Marvelous."

Others were negotiating. She had no part in any of that. Both Begin and Sadat were playing to the crowds and the hordes of media during the visit. But with this exchange, Golda stole the show.

Epilogue

I BEGAN BY ASKING, who is the real Golda Meir? An amalgam of many things, she was an immigrant a number of times over, having moved from Russia to America, from America to the Yishuv, from the kibbutz to the loneliness and despair of a Jerusalem existence, and then to the embrace of her fellow Labor Zionists, with whom she devotedly and eagerly built a state.

To this multifaceted amalgam, she brought strong personality traits. She was predisposed to act when the times demanded it. We have seen repeated examples of how she shaped her own future without the support of those around her. At age fourteen she fled from her parents in order to get an education. She gave street corner harangues despite her father's objections. She insisted on joining a kibbutz, even though any discerning person could have assessed that this was not the place for her husband. She told the man she loved that she hoped he would come *with* her. The fact that this was her—not his—decision was evident

in the recollections she shared with members of her daughter's kibbutz in the early 1970s. "I decided to settle in Palestine. I knew that I would go to a cooperative settlement. I choose Merhavia." Tellingly, after speaking in the first-person singular about making the choice, she switched to the plural. "We arrived in July; we were told that no applications would be considered until in the middle of summer. We would have to wait."[1] *She* wanted to go. *They* went. She raised critically needed funds in remarkable amounts from American Jews, including those who thought this nationalist enterprise might be a mistake. She insisted on creating a social security system when Israel's coffers were empty and food was being rationed. She brought immigrants to Israel, even when there was no place to house them. She believed that Soviet Jews could be redeemed when others thought the notion ludicrous and possibly even dangerous. She forged much of the world's early perceptions of Israel, particularly among Jews. Often her actions were motivated by a need to solve a problem and sometimes they were prompted by fear, a fear born in her early years in Russia that stayed with her throughout her career. It framed her life, policies, and worldview.

She knew how to take charge when the times demanded it. During the Yom Kippur War, when Moshe Dayan, the perceived hero of two major wars, suggested it was time to contemplate the nuclear option, she responded with a clear-cut command: "Forget it." And it was forgotten. She authorized an IDF crossing of the Suez Canal when others, including security specialists, doubted it was worthwhile. She knew there would be a human cost. But she also firmly believed that the cost of not doing it would be even greater.

She had no compunctions about speaking truth to power, regardless of whether it was to her father, a British official, or a UN secretary-general. She treated them as her equals, even when they considered her anything but. She hated duplicity, especially

when it emanated from those who thought themselves her betters. She excoriated the British for claiming not to have enough ships to rescue Jewish children—but somehow having them in abundance when it came to removing Jews from Palestine. She observed, not without bitter irony, that the British forced the passengers on the SS *Exodus* to go back to Europe but allowed the bodies of those who had died on board to remain in Palestine, a sad example of the aphorism "People are more sympathetic to dead Jews than to live Jews." When the chief secretary of the Mandate, John Shaw, told her that German POWs would be used to build British bases in Palestine, she pointed out that there were Jews looking for such work. He insisted he would not hire Jewish workers because "things they build tend to blow up." She replied, without camouflaging her sarcasm, "[And] Nazis are more reliable?"[2]

When she became prime minister at age seventy and was asked about her age, she brushed off the question with one of her quips. "Being seventy is not a sin." It isn't. People can change their views, even at that age. (I know.) But Golda Meir reached the pinnacle of leadership at a time when the entire world seemed to be in upheaval. Young people were rising up and demanding change. Social, cultural, racial, political, and sexual mores were being challenged, often violently. Long-standing norms were being upended. She was appalled by much of what she saw and seemed to forget, as is not uncommon even among aging revolutionaries, how fifty years earlier she had rebelled against the mores of her own time. All the passions in her life—Zionism, socialism, kibbutz life, and the political act of creating a state— were revolutionary in their time.

Though she claimed not to worry about being popular, she bristled and often lashed out when she was criticized. Once she had made up her mind, the topic was generally closed for discussion, even if it involved an entire group—Palestinian Arabs,

Israeli Black Panthers, or feminists. She hated the notion "It's coming to me, it's my due," regardless of where it emanated from. She had received no special privileges and believed she had struggled for all she achieved. Others, she reasoned, could and should do the same. She was often not just dismissive of those who saw matters differently but denigrated them personally. Subordinates—people on her own team—strategized about how best to tell her something that ran counter to what she had concluded. Some reported that before having to bring her bad news, they practiced what they would say in front of a mirror. Though depicted as the warm Jewish mother, she could be cold and cruel to her subordinates.

Her critics fault her for not being an intellectual or conceptual thinker. That may be true. But her contribution was not in the realm of intellectual discourse. She was a doer. She excelled in her ability to move people and institutions, a talent that some—most—intellectual giants don't possess. (That was one of David Ben-Gurion unique qualities: he was both an intellectual giant and a mover of people.) She did have a vision of what the Jewish homeland should be like. Her work to realize it was more practical than theoretical, more activist than intellectual, more substantive than nuanced. But ignoring or deprecating that nuance often came with a cost.

As I read a myriad of assessments of Golda, I returned to another question I raised at the outset. Might some of the criticism leveled against her have been mitigated if she had been a man? Might what has been depicted as "stubbornness" have been considered "strong-willed"? Might the critique that she "could not think conceptually" have been transmuted into "pragmatism that got things done"? Might the complaint that she saw things as "black or white," with no shades of gray or nuance, have been translated into praise for her decisiveness? Conversely, might some of the adulation she prompted have been more muted

had she been a man? Would American Jews have been as enthralled with her if her first name was David? Was she often judged—for better or for worse—more on her gender than her record? While much may have been based on her gender, had she not had the skill and determination to make things happen and the ability to speak to people's hearts, she never would have reached the pinnacle she did.

Golda built her career on a synthesis of a variety of impulses: the fears she internalized in Russia, the unique life lessons she encountered in America, her profound sense of Jewish impotence during the Holocaust, her deep-seated conviction that Arabs want to deny Israel the right to exist, and her sense of betrayal by foreigners, whom she perceived as being ready to generously tell Israel what to do while being unwilling to help it at critical moments. Ultimately, all these strains were wound around a central fiber: her total devotion to the Zionist dream realized in a socialist context. For Golda, Zionism, socialism, and the equality that she fervently believed was embedded therein remained the foundations of her life. They were her lodestones. So central were they to her essence that she had trouble acknowledging their shortcomings. At the end of her life she, who had broken so many molds and built so many things ex nihilo, found it hard to accept that the structures she created might have inherent flaws. Women did face discrimination. Mizrahim did confront racism. Palestinian Arabs were a people with a distinct identity and could not be dismissed as nonexistent simply because she had once been labeled a "Palestinian" on her British-era passport.

Golda was not blind to the state's failures. She knew that it had not lived up to some of its self-proclaimed ideals, but she considered those failures not as inherently structural but as temporary obstacles that needed to be overcome. She was infused with love and devotion for an ideal, a vision, and an impossible

dream, a dream that scores of people dismissed as unattainable but to whose realization she devoted her life. In a life marked with great, almost unparalleled, accomplishments, this deep-seated, unwavering, uncritical, and blinding love may have been at the root of both Golda Meir's greatest successes and her most significant failures.

<hr />

Introduction

1. Golda Meir, née Mabovitch, was also known for a good portion of her professional career as Meyerson. When she became Israel's second foreign minister, she Hebraicized her name to Meir. In the interests of uniformity, I refer to her as Golda, because this is how virtually all Israelis and many non-Israelis think of her.

2. Golda Meir (as told to Judith Krantz), "At Home in Jerusalem," *Good Housekeeping*, July 1957, 68–69.

3. Congressional Record, vol. 154, no. 130, August 1, 2008, E1652–E1654, https://www.govinfo.gov/content/pkg/CREC-2008-08-01/html/CREC-2008-08-01-pt1-PgE1652-4.htm.

4. Shani Rozanes, Udi Nir, and Sagi Bornstein, dirs., *Golda* (Tel Aviv: Film Platform, 2019), 5:38.

5. *New York Times*, January 2, 1975.

Chapter 1. Laying the Foundation

1. Oriana Fallaci, "Golda Meir," in *Interviews with History and Conversations with Power* (New York: Rizzoli, 2011), 70–71; Marie Syrkin, *Golda Meir: Woman with a Cause* (New York: G. P. Putnam's Sons, 1963), 19.

2. Golda Meir, *My Life* (New York: G. P. Putnam's Sons, 1975), 408. While this exchange was taking place between the two heads of state, a far lighter conversation was occurring between their aides. The Israeli observed how remarkable it was that the daughter of a carpenter was being received by the head of the Holy See. The papal official reminded him, in a wry observation that would have been worthy of Meir herself, that the Vatican had very kindly feelings toward carpenters.

3. Fallaci, 71; Meir, *My Life*, 13.

4. Meir, *My Life*, 16.

5. Meir, *My Life*, 29.

6. Meir, *My Life*, 35–36.

7. Marie Syrkin, *Way of Valor: A Biography of Golda Meyerson* (New York: Sharon Books, 1953), 31.

8. Ralph G. Martin, *Golda Meir: The Romantic Years* (New York: Charles Scribner's, 1988), 55.

9. Syrkin, *Way of Valor*, 32.

10. Syrkin, *Way of Valor*, 27.

11. Meir, *My Life*, 18.

12. Meir, *My Life*, 32

13. Meir, *My Life*, 21.

14. Meron Medzini, *Golda Meir: A Political Biography* (Oldenburg: De Gruyter, 2008), 6.

15. Meir, *My Life*, 26; Golda Meir, A *Land of Our Own: An Oral Autobiography* (New York: G. P. Putnam's Sons, 1973), 22.

16. Shani Rozanes, Udi Nir, and Sagi Bornstein, dirs., *Golda* (Tel Aviv: Film Platform, 2019), 14:00.

17. Francine Klagsbrun, *Lioness: Golda Meir and the Nation of Israel* (New York: Schocken, 2017), 38; Meir, *My Life*, 37.

18. Meir, *My Life*, 40.

19. Meir, *My Life*, 37; Medzini, 15.

20. Syrkin, *Way of Valor*, 35.

21. Medzini, 12, 16; Syrkin, *Way of Valor*, 35, 41.

22. Menahem Meir, *My Mother Golda Meir: A Son's Evocation of Life with Golda Meir* (New York: Arbor House, 1983), 12.

23. Martin, 63.

24. Meir, *My Life*, 59; Medzini, 16; Martin, 71.

25. Meir, *A Land*, 30.

26. Meir, *My Life*, 62–63.

27. Meir, *My Life*, 59, 64; Syrkin *Way of Valor*, 42.

28. Meir, *My Life*, 65–68; Syrkin, *Way of Valor*, 48.

29. Louis J. Swichkow, "Memoirs of a Milwaukee Labor Zionist," in *Michael: On the History of the Jews in the Diaspora* (Tel Aviv: Tel Aviv University, 1975), 140, http://www.jstor.org/stable /23493797.

30. Medzini, 20; Meir, *My Life*, 68; Klagsbrun, 65; Syrkin, *Way of Valor*, 45; Carole S. Kessner, *Marie Syrkin: An Exemplary Life* (Waltham, MA: Brandeis University Press, 2008), 229.

31. Menahem Meir, 14–15.

32. Meir, *My Life*, 69; Syrkin, *Way of Valor*, 13.

33. Meir, *My Life*, 6.

34. Michael Brown, "The American Element in the Rise of Golda Meir, 1906–1922," *Jewish History* 6, nos. 1–2 (1992): 35–50.

35. See, for example, *How to Become a Citizen of the United States* (Washington, DC: Smithsonian Institution/Foreign Language Information Service, 1926), https://americanhistory.si.edu /collections/search/object/nmah_1122012.

36. Meir, *My Life*, 70; Fallaci, 72.

Chapter 2. The Kibbutz Years

1. Golda Meir, *My Life* (New York: G. P. Putnam's Sons, 1975), 52–55; Marie Syrkin, *Way of Valor: A Biography of Golda Meyerson* (New York: Sharon Books, 1953), 17–18; Meron Medzini, *Golda Meir: A Political Biography* (Oldenburg: De Gruyter, 2008), 22–23.

2. Syrkin, *Way of Valor*, 21; Meir, *My Life*, 73.

3. Golda Meyerson to Shamai Korngold, August 24, 1921 [in

Hebrew] in *Golda Meir: HaReviet b'Roshei HaMemshala: Mivchar Teudot u'Mavot m'Perkei Haya (1898–1978)* [Golda Meir: The fourth prime minister: Selected documents from the chapters of her life (1898–1978)], ed. Hagai Tsoref (Jerusalem: Israel State Archives, 2016), no. 10, p. 26.

4. Ralph G. Martin, *Golda Meir: The Romantic Years* (New York: Charles Scribner's, 1988), 114.

5. Menahem Meir, *My Mother Golda Meir: A Son's Evocation of Life with Golda Meir* (New York: Arbor House, 1983), 15; Meir, *My Life*, 79, 81, 82.

6. Meir, *My Life*, 79.

7. Sheyna Korngold, *Zikhroynes* [Memories] (Tel Aviv: Farlag Idpres, 1968), 158–59.

8. Golda Meir, interview with Rinna Samuel, May 29, 1973, Lavon Institute for Labour Research, Tel Aviv, as quoted in Martin, 123.

9. Esther Becker, "The Founding of Merhavyah," in *The Plough Woman*, ed. Mark A. Raider and Miriam B. Raider-Roth (Hanover, NH: University Press of America, 2002), 25.

10. These recollections can be found in Raider and Raider-Roth, *Plough Woman*: Rivka Danit, "With Kvuzah of Shepherds," 39; Yehudit Edelman, "From Judea to Samaria," 41; Rahel Yanait (Ben-Zvi), "Stages," 109.

11. Golda Meir, "How I Made It in My Kibbutz," in *Golda Meir Speaks Out*, ed. Marie Syrkin (London: Weidenfeld and Nicolson, 1973), 38–42.

12. Syrkin, *Way of Valor*, 55–57.

13. Meir, *My Life*, 90.

14. Meir, *My Life*, 89–93.

15. Syrkin, *Way of Valor*, 62.

16. Dafna N. Izraeli, "The Zionist Women's Movement in Palestine," *Signs: Journal of Women in Culture and Society* 7, no. 1 (Autumn 1981): 93–94.

17. Rachel Rojanski, *Yiddish in Israel: A History* (Bloomington: Indiana University Press, 2020), 30–31, https://doi.org/10.2307/j.ctvs32tq1.

18. Menahem Meir, 14.

19. Meir, "How I Made It in My Kibbutz," 38–42.

20. Golda Meir, interview with Kenneth Harris, *Washington Post*, January 17, 1971.

21. Meyerson to Korngold, August 24, 1921.

22. Meir, *My Life*, 99.

23. Menahem Meir, 9.

Chapter 3. Emissary to America

1. Golda Meir, *My Life* (New York: G. P. Putnam's Sons, 1975), 119, 126.

2. Menahem Meir, *My Mother Golda Meir: A Son's Evocation of Life with Golda Meir* (New York: Arbor House, 1983), 31.

3. Tom Segev, *Ben-Gurion: A State at Any Cost* (New York: Farrar, Straus and Giroux, 2019), 250.

4. Ralph G. Martin, *Golda Meir: The Romantic Years* (New York: Charles Scribner's, 1988), 90.

5. *Morgan Journal*, December 31, 1928, January 1, 1929, as cited in Michael Brown, "The American Element in the Rise of Golda Meir, 1906–1922," *Jewish History* 6, nos. 1–2 (1992): 44.

6. Brown, 39.

7. *Igrot Ben-Gurion* [Ben-Gurion's correspondence], ed. Yehuda Erez (Tel Aviv: Am Oved and Tel Aviv University, 1971), 3:96.

8. Erez, *Igrot Ben-Gurion*, 3:122.

9. Golda Meir, interview with Rinna Samuel, June 18, 1973, Lavon Institute for Labour Research, Tel Aviv, as quoted in Martin, 170; Hapoel Hatzair, August 15, 1930, as cited in Francine Klagsbrun, *Lioness: Golda Meir and the Nation of Israel* (New York: Schocken, 2017), 136.

10. Secretariat of the Va'ad Hapoel, September 1, 1930, 268, 275, as cited in Meron Medzini, *Golda Meir: A Political Biography* (Oldenburg: De Gruyter, 2008), 61.

11. For contemporaneous descriptions of the relationship between Shazar and Meir, see Martin, 180–82; Klagsbrun, 122–24, passim.

12. Pnina Lahav, "A Great Episode in the History of Jewish Womanhood: Golda Meir, the Women's Workers' Council, Pioneer Women and the Struggle for Gender Equality," *Israel Studies* 23, no. 1 (2018): 4, https://doi.org/10.2979/israelstudies.23.1.01.

13. Rebecca Kohut, "Jewish Women's Organizations in the United States," *American Jewish Yearbook 5692* 33 (1932): 187–88.

14. Mark A. Raider, *The Emergence of American Zionism* (New York: New York University Press, 1998), 57.

15. Meir, *My Life*, 138.

16. Marie Syrkin, *Way of Valor: A Biography of Golda Meyerson* (New York: Sharon Books, 1953), 72; Meir, *My Life*, 130.

17. Syrkin, *Way of Valor*, 74; Menahem Meir, 43.

18. Golda Meir, "Borrowed Mothers," in *The Plough Woman*, ed. Mark A. Raider and Miriam B. Raider-Roth (Hanover, NH: University Press of America, 2002), 164–65.

19. Golda Meir, "Asher Eynai Rahu" [What my eyes have seen], *Davar*, May 25, 1932.

20. Zvi Triger, "Golda Meir's Reluctant Feminism," *Israel Studies* 19, no. 3 (Fall 2014): 125.

21. Meir, *My Life*, 140.

22. Klagsbrun, 149–52.

23. Joseph Sprinzak, *Igrot* [Letters] (Tel Aviv: Tarbut vehinukh, 1969), 2:257–58, 274–75, as quoted in Medzini, 64.

Chapter 4. Tel Aviv, 1934–39

1. For analysis of Jabotinsky's views on Zionism, see Hillel Halkin, *Jabotinsky: A Life* (New Haven: Yale University Press, 2014).

2. Madeline Tress, "Fascist Components in the Political Thought of Vladimir Jabotinsky," *Arab Studies Quarterly* 6, no. 4 (1984): 304, http://www.jstor.org/stable/41857736.

3. Yfaat Weiss, "The Transfer Agreement and the Boycott Movement," *Yad Vashem Studies* 26 (1998): 129–72, https://www.yadvashem.org/odot_pdf/Microsoft%20Word%20-%203231.pdf.

4. Mapai Central Committee minutes, October 21, 1934, as quoted in Francine Klagsbrun, *Lioness: Golda Meir and the Nation*

of Israel (New York: Schocken, 2017), 156; Golda Meir, *My Life* (New York: G. P. Putnam's Sons, 1975), 145.

5. Menahem Meir, *My Mother Golda Meir: A Son's Evocation of Life with Golda Meir* (New York: Arbor House, 1983), 28.

6. Menahem Meir, 55; Sarah Meyerson Rehabi, interview with Martin, n.d., in Ralph G. Martin, *Golda Meir: The Romantic Years* (New York: Charles Scribner's, 1988), 187.

7. Meir, *My Life*, 148.

8. Oriana Fallaci, "Golda Meir," in *Interviews with History and Conversations with Power* (New York: Rizzoli, 2011), 74.

9. Michael Bar-Zohar, *Ben-Gurion: A Biography* (New York: Delacorte, 1978), 9.

10. Klagsbrun, 170; Meron Medzini, *Golda Meir: A Political Biography* (Oldenburg: De Gruyter, 2008), 76.

11. Meir, *My Life*, 157.

12. Anita Shapira, *Berl Katznelson* (Tel Aviv: Am Oved, 1980), 2:705–6.

13. *New York Times*, March 16, 18, 1938.

14. Secretary of State (Hull) to the Ambassador in the United Kingdom (Kennedy), Washington, DC, March 23, 1938, in *Foreign Relations of the United States*, 1938 (Washington, DC: Government Printing Office, 1955), 1:740–41.

15. Menahem Meir, 53; Meir, *My Life*, 158–59.

16. Interview with Arieh Tartakower, April 12, 1971, Abraham Hartman Institute for Contemporary Jewry, Department of Oral Documentation, Hebrew University of Jerusalem, 11ff., https://www.nli.org.il/he/audio/NNL_ALEPH004419120/NLI.

17. *Haaretz*, July 18, 1938; Meir, *My Life*, 159; Julie Eisenhower, *Special People* (New York: Simon and Schuster, 1977), 22.

18. Golda Meyerson to Sarah and Menachem Meyerson, November 16, 1938 [in Hebrew], in *Golda Meir: HaReviet b'Roshei HaMemshala: Mivchar Teudot u'Mavot m'Perkei Haya (1898–1978)* [Golda Meir: The fourth prime minister: Selected documents from the chapters of her life (1898–1978)], ed. Hagai Tsoref (Jerusalem: Israel State Archives, 2016), no. 10, p. 27.

19. Wolf Zeev Rabinowitsch, ed., *Pinsk* (Tel Aviv: Irgun yots'e Pinsḳ-Ḳarlin bi-Medinat Yiśra'el, 1966–77), vol. 1, part 2, pp. 474ff., New York Public Library Digital Collections, 1966–77, https://digitalcollections.nypl.org/items/86d947c0-fd1a-0134 -3d2a-691d72f134de.

Chapter 5. The Apocalypse, 1939–45

1. Menahem Meir, *My Mother Golda Meir: A Son's Evocation of Life with Golda Meir* (New York: Arbor House, 1983), 55–57.

2. Golda Meyerson, "This Is Our Strength, *D'var Ha'Poelet*, May 3, 1939," in *This Is Our Strength: Selected Papers of Golda Meir*, ed. Henry Christman (New York: Macmillan, 1962), 1–7; Golda Meir, *My Life* (New York: G. P. Putnam's Sons, 1975), 168.

3. Martin Gilbert, *Exile and Return* (New York: J. B. Lippincott, 1978), 243–44.

4. Menahem Meir, 55–57.

5. In anticipation of the White Paper, Ben-Gurion, who was in London, laid out his strategy for illegal immigration, relations with the British, and other aspects of what he anticipated would need to be the Yishuv's policy during a forthcoming war. Ben-Gurion to the Zionist Executive, March 22, 1939, Ben Gurion Archives, https://bengurionarchive.bgu.ac.il/en/node/13562.

6. "War Fears Curtail Zionist Congress 3 Days; Weizmann Lashes Britain but Pledges 'Clean Fight,'" *Jewish Telegraphic Agency*, Geneva, August 17, 1939, https://www.jta.org/1939/08/17/archive /war-fears-curtail-zionist-congress-3-days-weizmann-lashes-britain -but-pledges-clean-fight; Michael Bar-Zohar, *Ben-Gurion: A Biography* (New York: Delacorte, 1978), 100.

7. Marie Syrkin, *Way of Valor: A Biography of Golda Meyerson* (New York: Sharon Books, 1953), 101–2, 104.

8. Syrkin, *Way of Valor*, 102.

9. Meron Medzini, *Golda Meir: A Political Biography* (Oldenburg: De Gruyter, 2008), 84.

10. Golda Meyerson, "Mutual Aid within the Workers' Community: Address before the Executive Council of the Mapai Party, Tel Aviv, December 16, 1939," in Christman, 9–10.

11. Syrkin, *Way of Valor*, 94–95.

12. Meyerson, "Mutual Aid," 14–15.

13. Meir, *My Life*, 144; Francine Klagsbrun, *Lioness: Golda Meir and the Nation of Israel* (New York: Schocken, 2017), 195.

14. Klagsbrun, 200.

15. Meir, *My Life*, 164.

16. Golda Meyerson, "To Our Friends and Comrades in the British Labour Government: Address to Histadrut, September 12, 1946," in Christman, 26–27; Ralph G. Martin, *Golda Meir: The Romantic Years* (New York: Charles Scribner's, 1988), 277.

17. Jehuda Reinharz and Yaacov Shavit, *The Road to September 1939* (Waltham, MA: Brandeis, 2018), 260.

18. Nicholas Bethell, *The Palestine Triangle: The Struggle for the Holy Land, 1935–48* (New York: G. P. Putnam's Sons, 1979), 146.

19. Richard Crossman, *Palestine Mission: A Personal Record* (New York: Harper, 1947), 123.

20. Bethell, 121–23.

21. Martin, 233.

22. Meir, *My Life*, 184–89.

23. Meir, *My Life*, 185.

24. Meir, *My Life*, 168; Yoav Gelber, "Zionist Policy and the Fate of European Jewry, 1943–44," *Studies in Zionism* 4, no. 1 (1983): 146.

25. Syrkin, *Way of Valor*, 116.

26. Dina Porat, *Hanhagah B'Milkud* [Trapped Leadership] (Tel Aviv: Am Oved, 1986), 164.

27. Bernard Wasserstein, *Britain and the Jews of Europe, 1939–1945* (Oxford: Institute of Jewish Affairs, Clarendon, 1979), 293.

28. Porat, *Hanhagah*, 263.

29. Secretariat of the Va'ad Hapoel, February 23, 1944, as quoted in Medzini, 100.

30. Shabtai Teveth, *Ben-Gurion and the Holocaust* (New York: Harcourt, Brace, 1996), 34.

31. Golda Meyerson, "Address," *Divrei Ha-Knesset*, January 8, 1952, in *The Reparations Controversy: The Jewish State and German Money in the Shadow of the Holocaust, 1951–1952*, ed. Yaakov Sharett

(Berlin: De Gruyter, 2011), 224–25, http://www.jstor.org/stable/j
.ctvbkjzj1.24.

32. Secretariat of the Va'ad Hapoel, April 29, 1943, as quoted in
Tom Segev, *The Seventh Million* (New York: Henry Holt, 1991), 103.

Chapter 6. "Imagine, We Have a State"

1. Golda Meyerson, "To Our Friends and Comrades in the
British Labour Government: Address to Histadrut, September 12,
1946," in *This Is Our Strength: Selected Papers of Golda Meir*, ed.
Henry Christman (New York: Macmillan, 1962), 24.

2. Ben-Gurion diary, May 7–8, 1945, as quoted in Anita Sha-
pira, *Ben-Gurion: Father of Modern Israel* (New Haven: Yale Uni-
versity Press, 2014), 134.

3. Harry S. Truman to Clement Attlee, August 31, 1945,
https://www.presidency.ucsb.edu/documents/letter-prime-minister
-attlee-concerning-the-need-for-resettlement-jewish-refugees.

4. "Weizmann Breaks Silence; Hits British Government's
New Policy on Palestine," *Jewish Telegraphic Agency*, November
20, 1945, https://www.jta.org/archive/weizmann-breaks-silence-hits
-british-governments-mew-policy-on-palestine.

5. The British Minister (Makins) to the Director of the Of-
fice of European Affairs (Matthews), October 6, 1945, document
no. 552, 1194–95; The British Embassy to the Department of State:
Aide-Memoire, October 9, 1945, document no. 553, 1195–96;
The British Embassy to the Department of State: Aide-Memoire,
December 29, 1945, document no. 573, 1221, in *Foreign Relations
of the United States, 1945*, vol. 2 (Washington, DC: United States
Government Printing Office, 1967).

6. Golda Meir, *My Life* (New York: G. P. Putnam's Sons,
1975), 201.

7. Meir, *My Life*, 199.

8. Golda Meyerson, "The Jewish Labor Movement in Pales-
tine: Testimony before the Anglo-American Committee of Inquiry,
March 25, 1946," in Christman, 21ff.; Marie Syrkin, *Way of Valor:
A Biography of Golda Meyerson* (New York: Sharon Books, 1953),
151–52.

9. *Palestine Post,* March 26, 1946.

10. Meir, *My Life,* 194.

11. Meir, *My Life,* 194; Menahem Meir, *My Mother Golda Meir: A Son's Evocation of Life with Golda Meir* (New York: Arbor House, 1983), 75.

12. *New York Times,* June 13, 1946.

13. Meir, *My Life,* 194.

14. Marie Syrkin, interview with Martin, n.d., in Ralph G. Martin, *Golda Meir: The Romantic Years* (New York: Charles Scribner's, 1988), 267.

15. Meir, *My Life,* 203.

16. Meir, *My Life,* 200; Natan Alterman, "Nehum Teshuvah l'Rav Hovelim Italki" [A response to an Italian captain], *Davar,* January 15, 1946, http://www.palyam.org/English/Hahapala/ujv ItalianCapitanHeb.php.

17. Martin, 278.

18. Golda Meyerson, "The Immigrant Ship *Exodus:* Address before the Va'ad Leumi," Jerusalem, August 26, 1947, in Christman, 34.

19. *New York Times,* January 27, 1948. For full text of her comments, see Golda Meyerson, "The Present Struggle in Palestine," in Christman, 37–47.

20. Henry Montor, "History of the United Jewish Appeal," interview with Menachem Kaufman, October 14, 1975, Abraham Hartman Institute for Contemporary Jewry, Department of Oral Documentation, Hebrew University of Jerusalem, https://www.nli .org.il/he/audio/NNL_ALEPH004415032/NLI; Francine Klagsbrun, *Lioness: Golda Meir and the Nation of Israel* (New York: Schocken, 2017), 303.

21. Golda Meir, A *Land of Our Own: An Oral Autobiography* (New York: G. P. Putnam's Sons, 1973), 73ff. A full text of her speech can also be found at Golda Meir, "In the Midst of Battle," Speaking While Female, https://speakingwhilefemale.co/war-meir/.

22. Meron Medzini, *Golda Meir: A Political Biography* (Oldenburg: De Gruyter, 2008), 152; Klagsbrun, 305; Montor.

23. Golda Meyerson to David Ben-Gurion, February 9, 1948

[in Hebrew], in *Golda Meir: HaReviet b'Roshei HaMemshala: Mivchar Teudot u'Mavot m'Perkei Haya (1898–1978)* [Golda Meir: The fourth prime minister: Selected documents from the chapters of her life (1898–1978)], ed. Hagai Tsoref (Jerusalem: Israel State Archives, 2016), no. 20, p. 60.

24. Menahem Meir, 116.

25. Meir, *My Life,* 212–14.

26. Meir, *My Life,* 235.

27. Martin, 316–17.

28. Meir, *My Life,* 218ff.

29. Medzini, 168.

30. Syrkin, *Way of Valor,* 231; Meir, *My Life,* 228.

Chapter 7. A Return to Russia

1. Moshe Sharett, *The Diary of Moshe Sharett, 1953–56* (Bloomington: Indiana University Press, 2019), June 16, 1956, 3:1459.

2. Mark Azbel, *Autobiography of a Jew,* 60–61, as cited in Yaakov Roi, *The Struggle for Soviet Jewish Emigration, 1948–1967* (New York: Cambridge University Press, 1991), 28.

3. Mordechai Namir, *Mission to Moscow: Honeymoon and Years of Wrath* [in Hebrew] (Tel Aviv: Am Oved, 1971), 50.

4. *Documents on Israeli-Soviet Relations, 1941–1953,* part 1 (London: Frank Cass, 2000). For the complete text of the Ehrenburg article, see G. M. Malenkov to I. V. Stalin, Moscow, September 18, 1948, in *Documents,* no. 168. For reports on Meir's time in the USSR, see *Documents,* nos. 148, 164, 167, 180, 202, 213, 221, 219, 239, 240.

5. *Palestine Post,* November 9, 1949.

6. *Jerusalem Post,* January 16, 1966.

7. G. Meyerson (Moscow) to W. Eytan (Tel Aviv), October 6, 1948, in *Documents,* no. 180; Golda Meir, *My Life* (New York: G. P. Putnam's Sons, 1975), 251.

8. Meir, *My Life,* 248; Meeting: A.Ia. Vyshinskii-G. Meyerson (Moscow), January 20, 1949, in *Documents,* no. 213; G. Meyerson to M. Sharett (Tel Aviv), February 9, 1949, in *Documents,* no. 221.

9. Meir, *My Life*, 253–54.

10. Roi, 49–50.

11. Meir, *My Life*, 256.

12. Roi, 354n103.

13. *Documents*, nos. 148, 164, 167, 202, 213, 219.

14. *Maariv*, February 13, 1953; Francine Klagsbrun, *Lioness: Golda Meir and the Nation of Israel* (New York: Schocken, 2017), 378.

15. Klagsbrun, 378; "Editorial Note: Israel's Participation in the Meeting of the Political Committee of the UN General Assembly, April 13–16, 1953," in *Documents on Israeli Foreign Policy*, ed. Yemimah Rosenthal (Jerusalem: Israel State Archives, 1995), no. 165, p. 149; Golda Meyerson, *Proceedings of the United Nations*, GAOR, 7th session, 1st committee, 597th meeting, UN Doc A/C.1/SR597 (April 13, 1953), 1:599–601, https://digitallibrary.un.org/record/13027559?in=zh_CN.

Chapter 8. Minister of Labor

1. Golda Meyerson, "Two Nations in Israel: Address before a Workers' Delegation upon Its Return from a Tour of the United States, Tel Aviv, July 25, 1950," in *This Is Our Strength: Selected Papers of Golda Meir*, ed. Henry Christman (New York: Macmillan, 1962), 52.

2. Hezy Lufbann, *Ish Yotze et Ehav* [A man against his brother] (Tel Aviv: Am Oved, 1969), 94; Zionist Executive, June 19, 1949, August 19, 1949, as quoted in Tom Segev, *1949: The First Israelis* (New York: Free Press, 1986), 117.

3. *Divrei Ha-Knesset*, August 8, 1949, 2:1275, June 1, 1949, 1:633–34, as quoted in Segev, *1949*, 133.

4. Golda Meyerson, "Israel's Unemployment Problem: Address before the Executive Council of Mapai, March 11, 1953," in Christman, 61.

5. Meron Medzini, *Golda Meir: A Political Biography* (Oldenburg: De Gruyter, 2008), 224.

6. Golda Meyerson, "Address to the Knesset," February 5, 1952 [in Hebrew], in *Golda Meir: HaReviet b'Roshei HaMemshala:*

Mivchar Teudot u'Mavot m'Perkei Haya (1898–1978) [Golda Meir: The fourth prime minister: Selected documents from the chapters of her life (1898–1978)], ed. Hagai Tsoref (Jerusalem: Israel State Archives, 2016), no. 31, p. 98.

7. Marie Syrkin, *Way of Valor: A Biography of Golda Meyerson* (New York: Sharon Books, 1953), 287–88.

8. Golda Meir, *My Life* (New York: G. P. Putnam's Sons, 1975), 270.

9. *Divrei Ha-Knesset*, July 23, 1953, https://main.knesset.gov .il/Activity/Legislation/Laws/Pages/LawBill.aspx?t=lawsuggestions search&lawitemid=148579.

10. Raul Hilberg, *The Destruction of European Jews* (Chicago: Quadrangle, 1961), 119; Norbert Frei, *Adenauer's Germany and the Nazi Past* (New York: Columbia University Press, 2003), 55.

11. Golda Meyerson, "Address," *Divrei Ha-Knesset*, January 8, 1952, in *The Reparations Controversy: The Jewish State and German Money in the Shadow of the Holocaust, 1951–1952*, ed. Yaakov Sharett (Berlin: De Gruyter, 2011), 224–25, http://www.jstor.org/stable/j .ctvbkjzj1.24.

12. Cabinet Meeting, October 28, 1951, in *The Reparations Controversy*, 93–97, http://www.jstor.org/stable/j.ctvbkjzj1.16.

13. Moshe Sharett, *The Diary of Moshe Sharett, 1953–56* (Bloomington: Indiana University Press, 2019), October 25, 1953, 1:67.

14. Sharett, *Diary*, October 29, 1953, 1:91.

Chapter 9. Madam Foreign Minister

1. Moshe Sharett, *The Diary of Moshe Sharett, 1953–56* (Bloomington: Indiana University Press, 2019), May 29, 1956, 3:1412. The matter dragged on through much of the spring with Sharett refusing to resign. Tellingly, Sharett entitled the chapter regarding this whole matter "Resignation or Dismissal?" See entries for May 30, 1956, 3:1419; June 1–8, 1956, 3:1421–32; June 16, 1956, 3:1459.

2. Sharett, *Diary*, June 16, 1956, 3:1459; June 19, 1956, 3:1487.

3. Menahem Meir, *My Mother Golda Meir: A Son's Evocation of Life with Golda Meir* (New York: Arbor House, 1983), 157; Sharett,

Dairy, June 21, 1956, 3:1496; July 18, 1956, 3:1568; August 14, 1956, 3:1620; Golda Meir, *My Life* (New York: G. P. Putnam's Sons, 1975), 292.

4. Sharett, *Diary*, July 2, 1956, 3:1531; July 2, 1956, 3:1531; June 29, 1956, 3:1526; September 11, 1956, 3:1654.

5. Meron Medzini, *Golda Meir: A Political Biography* (Oldenburg: De Gruyter, 2008), 292ff.; Neil Caplan, "Why Was Moshe Sharett Sacked? Examining the Premature End of a Political Career, 1956," *Middle East Journal* 70, no. 2 (2016): 297, http://www.jstor.org/stable/26427402; Avi Shlaim, *Iron Walls* (New York: Norton, 2014), 197; Michael Brecher, *The Foreign Policy System of Israel: Settings, Images, Process* (New Haven: Yale University Press, 1972), 285.

6. Abba Eban, *An Autobiography* (New York: Random House, 1977), 203.

7. Aaron Demsky, "The Hebraization of Names in Modern Israel," *Brown Journal of World Affairs* 25 (2018): 7.

8. Michael Brecher, *Decisions in Israel's Foreign Policy* (New Haven: Yale University Press, 1975), 233–34; Medzini, 276.

9. "Mrs. Meir, Middle East: The War and the Woman," *Time*, September 19, 1969.

10. Abba Eban, *Personal Witness: Israel through My Eyes* (New York: G. P. Putnam's Sons, 1992), 476–77.

11. Terence Robertson, *Crisis: The Inside Story of the Suez Conspiracy* (New York: Athenaeum, 1964), 298, 325.

12. Abba Eban, *Personal Witness*, 267, 336; Brecher, *System*, 266, 304–6.

13. Selwyn Lloyd, *Suez 1956: A Personal Account* (London: Jonathan Cape, 1978), 218.

14. Gideon Rafael, *Destination Peace: Three Decades of Israeli Foreign Policy* (New York: Stein and Day, 1981), 67–68; Brecher, *Decisions*, 301n2.

15. *Jerusalem Post*, May 5, 1969. See, for example, the speech she gave "on the spur of the moment and without any preparation or text," to the General Assembly on Israel's tenth anniversary: Meir, *My Life*, 308–9.

16. "Mrs. Meir," *Time*, September 19, 1969.

17. Solel Boneh, the Histadrut's construction arm, built the large terminal in Entebbe, Ethiopia, where Palestinian terrorists held Israeli hostages in 1976. While planning the rescue operation Israeli officials were able to inspect the building's plans, which were still on file in the Solel Boneh offices.

18. Golda Meir, *Divrei Ha-Knesset*, October 24, 1960, as cited in Brecher, *System*, 308.

19. Golda Meir, "The New Nations—Their Goals and Their Problems: Address before the General Assembly of the United Nations, New York, October 10, 1960," in *This Is Our Strength: Selected Papers of Golda Meir*, ed. Henry Christman (New York: Macmillan, 1962), 143–46.

20. Meir, *My Life*, 323, 327, 336; Gideon Shimoni, *Community and Conscience: The Jews in South Africa"* (Hanover, NH: University Press of New England, 2003), 53.

21. Golda Meir, A *Land of Our Own: An Oral Autobiography* (New York: G. P. Putnam's Sons, 1973), 127, 132, 134; Sidney Liskofsky, "The Eichmann Trial," *American Jewish Year Book*, vol. 62 (New York: American Jewish Committee, 1961), 202, http://www.jstor.org/stable/23603238.

22. Meir, *A Land*, 133; Meir, *My Life*, 177–80.

23. Medzini, 326.

24. "'Dear Hannah Arendt . . . ': Correspondence between Leni Yahil and Hannah Arendt, 1961–1971," *Eurozine*, September 24, 2010, https://www.eurozine.com/dear-hannah-arendt/. For some of Arendt's comments regarding Meir, see her correspondence with Gershom Scholem. At his request, when the correspondence was published, she did not refer to Meir by name. Hannah Arendt and Gershom Scholem, *The Correspondence of Hannah Arendt and Gershom Scholem* (Chicago: University of Chicago Press, 2017).

25. Hannah Arendt, "To Save the Jewish Homeland: There Is Still Time," *Commentary*, May 5, 1948, 400, https://www.commentary.org/articles/mortbarrgmailcom/to-save-the-jewish-homelandthere-is-still-time/.

26. "'Dear Hannah Arendt . . .'"

27. Hannah Arendt to Heinrich Blücher, April 15, 1961, as quoted in Walter Laqueur, "The Arendt Cult," *Journal of Contemporary History* 33, no. 4 (1998): 493; Hannah Arendt to Karl Jaspers, April 13, 1961, in *Hannah Arendt/Karl Jaspers: Correspondence, 1926–69* (New York: Harcourt Brace, 1992), 434.

28. Myer (Mike) Feldman, interview with John F. Stewart, August 20, 1966, Kennedy Oral History Program, 412, 416, 421–22, 425, https://docs.google.com/viewerng/viewer?url=https://www.jfklibrary.org/sites/default/files/archives/JFKOH/Feldman,+Myer/JFKOH-MF-09/JFKOH-MF-09-TR.pdf.

29. "Memorandum of Conversation with Israel Foreign Minister Meir," Palm Beach, Florida, December 27, 1962, 10 a.m., in *Foreign Relations of the United States, 1961–1963*, vol. 27, Near East, document no. 121 (Washington, DC: Government Printing Office, 1994). For Meir's relation of the meeting, see Meir, *My Life*, 311–13.

30. Avner Cohen, *Israel and the Bomb* (New York: Columbia University Press, 1998), 165; Avner Cohen, *The Worst-Kept Secret: Israel's Bargain with the Bomb* (New York: Columbia University Press, 2021).

31. Statement to the Knesset by Prime Minister Ben-Gurion, March 5, 1957, in *Historical Documents* (Jerusalem: Israel Ministry of Foreign Affairs), vols. 1–2, 1947–1974, https://www.mfa.gov.il/MFA/ForeignPolicy/MFADocuments/Yearbook1/Pages/29%20Statement%20to%20the%20Knesset%20by%20Prime%20Minister%20Ben-.aspx.

32. Sharett, *Diary*, January 18, 1957, 3:1963–67.

33. Medzini, 363.

34. Michael Bar-Zohar, *Ben-Gurion: A Biography* (New York: Delacorte, 1978), 284.

35. Ben-Gurion, *Diary*, February 10, 1959, as quoted in Francine Klagsbrun, *Lioness: Golda Meir and the Nation of Israel* (New York: Schocken, 2017), 429.

36. David Ben-Gurion, "Address," *Knesset*, July 1, 1959 (Jerusalem: State of Israel Government Press Office, 1959), 14, as quoted in Brecher, *Decisions*, 104.

37. Klagsbrun, 466–67; Medzini, 374.

38. Bar-Zohar, 306; Medzini, 377; Klagsbrun, 468.

39. Yitzhak Navon, interview with Klagsbrun, May 19, 2005, in Klagsbrun, 471; Brecher, *System*, 405–6.

40. Bar-Zohar, 308–9; Medzini, 382–83; Eran Eldar, "David Ben-Gurion and Golda Meir: From Partnership to Enmity," *Israel Affairs* 26, no. 2 (2020): 178–80, doi:10.1080/13537121.2020.1720111.

41. Eldar, 180; Meir, *My Life*, 291.

Chapter 10. Prime Minister

1. Golda Meir, *My Life* (New York: G. P. Putnam's Sons, 1975), 352.

2. Michael Brecher, *The Foreign Policy System of Israel: Settings, Images, Process* (New Haven: Yale University Press, 1972), 392.

3. Michael Brecher, *Decisions in Israel's Foreign Policy* (New Haven: Yale University Press, 1975), 367.

4. On the eve of the war, the head of the Mossad encountered welfare minister Yosef Burg in a Tel Aviv hotel. Burg told him that members of the cabinet had been instructed to stay in Tel Aviv to facilitate meetings and that graves were secretly being dug in Tel Aviv. Anshel Peffer, "Interview with Efraim Halevy," *Jewish Chronicle*, June 6, 2017, https://www.thejc.com/news/features/efraim-halevy-they-were-digging-graves-in-parks-but-i-was-not-so-gloomy-1.439584.

5. Meir, *My Life*, 361

6. Meir, *My Life*, 361; Brecher, *Decisions*, 334–35.

7. Meir, *My Life*, 376–79.

8. Meron Medzini, *Golda Meir: A Political Biography* (Oldenburg: De Gruyter, 2008), 445.

9. Amnon Barzilai, "Prime Time, by Default," *Haaretz*, October 10, 2003, https://www.haaretz.com/1.4717289.

10. *Jerusalem Post*, March 4, 1969, 1; Medzini, 443ff.

11. Yechiam Weitz, "Golda Meir, Israel's Fourth Prime Minister (1969–74)," *Middle Eastern Studies* 47, no. 1 (January 2011):

47; Meir, *My Life*, 66–68; Marie Syrkin, *Way of Valor: A Biography of Golda Meyerson* (New York: Sharon Books, 1953), 44, 47.

12. *Time*, September 16, 1969, 32.

13. Francine Klagsbrun, *Lioness: Golda Meir and the Nation of Israel* (New York: Schocken, 2017), 541; Barzilai.

14. Chaim Herzog, *The War of Atonement, October 1973* (Boston: Little, Brown, 1975), 281–82; Chaim Herzog, *Living History: A Memoir* (New York: Pantheon, 1996), 173.

15. Julie Eisenhower, *Special People* (New York: Simon and Schuster, 1977), 16; Shani Rozanes, Udi Nir, and Sagi Bornstein, dirs., *Golda* (Tel Aviv: Film Platform, 2019), 6:45.

16. *Maariv*, March 14, 1971.

17. Medzini, 419.

18. Meir, *My Life*, 382–83; Medzini, 424; Simha Dinitz, interview with Avi Shlaim, n.d., in Avi Shlaim, *Iron Walls* (New York: Norton, 2014), 315–16; *New York Times*, August 27, 1972.

19. *London Sunday Times*, June 15, 1969; *New York Times*, August 27, 1972.

20. Avner Cohen and George Perkovich, "The Obama-Netanyahu Meeting: Nuclear Issues," *Proliferation Analysis*, May 14, 2009, Carnegie Endowment for International Peace, https://carnegie endowment.org/2009/05/14/obama-netanyahu-meeting-nuclear -issues-pub-23124.

21. Martin Indyk, *Haaretz Podcast*, October 25, 2021, 27:00, https://www.haaretz.com/israel-news/podcasts/PODCAST-listen -what-the-mossad-ring-busted-in-turkey-was-doing-there-1 .10324476.

22. *New York Times*, June 11, 1965, June 15, 1965, December 20, 1971; Suzanne D. Rutland, "Leadership of Accommodation or Protest? Nahum Goldmann and the Struggle for Soviet Jewry," in *Nahum Goldmann: Statesman without a State*, ed. Mark A. Raider (Albany: State University of New York Press, 2009), 273–92; Yaakov Roi, *The Struggle for Soviet Jewish Emigration, 1948–1967* (New York: Cambridge University Press, 1991), 197.

23. *New York Times*, April 10, 1970. For additional details on

this invitation and the response to it, see Meir Chazan, "Goldmann's Initiative to Meet with Nasser in 1970," in Raider, *Nahum Goldmann*, 270–324.

24. Haggai (Haim Gouri), "Hakoz vehakfafah" [The thorn and the glove], *Lamerhav*, April 8, 1970, https://www.nli.org.il/en/newspapers/lmrv/1970/04/08/01/article/22/?e=———-en-20-1—img-txIN%7ctxTI——————1; Chazan, 309–10.

25. Nahum Goldmann, "The Future of Israel," *Foreign Affairs*, April 1970.

26. Hanoch Levin, "Havtakha" [Promise], in *Malkat Ha'ambatyah* [Queen of the bathtub], https://www.hanochlevin.com/texts/1657.

27. Klagsbrun, 529.

28. Henry Kissinger, *Years of Upheaval* (London: Weidenfeld and Nicolson, 1982), 220–21; Shlaim, 320.

29. He apparently apologized after saying it. But he said it, and it could not have helped her disposition toward them.

30. Rozanes, Nir, and Bornstein, 31:00.

31. Sarah Schmidt, "Hagiography in the Diaspora: Golda Meir and Her Biographers," *American Jewish History* 92, no. 2 (June 2004): 157.

32. Medzini, 539.

33. Golda Meir, "Asher Eynai Rahu" [What my eyes have seen], *Davar*, May 25, 1932.

34. *Palestine Post*, September 15, 1949, 4.

35. *Maariv*, May 4, 1949, 1.

36. Elinor Burkett, *Golda* (New York: Harper Collins, 2008), 199.

Chapter 11. The Yom Kippur War

1. Abba Eban, interview with Avi Shlaim, n.d., in Avi Shlaim, *Iron Walls* (New York: Norton, 2014), 290.

2. Uri Bar-Joseph, *The Watchman Fell Asleep: The Surprise of Yom Kippur and Its Sources* (Albany: State University of New York Press, 2005), 163; Chaim Herzog, *Living History: A Memoir* (New York: Pantheon, 1996), 188.

3. "Conversation between the Prime Minister and the IDF

Deputy Commander," *Diary of the PMO* (Prime Minister's Office), October 19, 1973, 4:40 p.m. [in Hebrew], in *Golda Meir: HaReviet b'Roshei HaMemshala: Mivchar Teudot u'Mavot m'Perkei Haya (1898–1978)* [Golda Meir: The fourth prime minister: Selected documents from the chapters of her life (1898–1978)], ed. Hagai Tsoref (Jerusalem: Israel State Archives, 2016), no. 32, p. 551.

4. Golda Meir, "Comments at Political Security Consultation," October 10, 1973 [in Hebrew], in Tsoref, no. 152, p. 538; Bar-Joseph, 231–34.

5. "*Diary of the PMO*," October 7, 1973 [in Hebrew], in Tsoref, no. 146, p. 524.

Epilogue

1. Golda Meir, A *Land of Our Own: An Oral Autobiography* (New York: G. P. Putnam's Sons, 1973), 38.

2. Meron Medzini, *Golda Meir: A Political Biography* (Oldenburg: De Gruyter, 2008), 108. I have taken the liberty of adding "And" to the beginning of her statement and inserting a question mark at the end. After listening to a myriad of interviews with her and speeches by her, there is no doubt in my mind that both were there. Any Yiddish or Yinglish speaker would attest to that.

ACKNOWLEDGMENTS

I AM DEEPLY GRATEFUL to Professors Anita Shapira and Steve Zipperstein, the editors of the Jewish Lives series, for encouraging me to take on this project. Their advice and patience throughout the process of creating this work helped me in a myriad of ways and enhanced the book's quality. The responsibility for any mistakes or shortcomings that nonetheless crept in is mine.

I greatly appreciate having been invited by the Jack, Joseph and Morton Mandel Center for Advanced Holocaust Studies of the United States Holocaust Memorial Museum to serve as the Ina Levine Invitational Scholar. My time at the center allowed me to delve deeply into the many Holocaust-related issues that shaped Golda Meir's Weltanschauung and career.

Numerous scholars and authors have analyzed aspects of Golda's career. I have perused many of their works and am grateful for their insights and research. I wish to offer particular thanks to Meron Medzini, who served for a period as Golda's chief of staff, and Francine Klagsbrun, whose research on Golda spans decades.

They amassed an extensive array of sources about Golda, her associates, and the history of the founding of the State of Israel. They interviewed many of the principals, something that was no longer possible when I began my work. Even when I disagreed with their conclusions, I was and remain beholden to them for the work they have done.

For the past thirty years, Emory University has been unwavering in its support of my work. The then dean of Emory College, Michael Elliott, was a stalwart champion of my research. I am also grateful to Emory University's Department of Religion and Tam Institute for Jewish Studies for the generous support they offered me in so many ways. Many colleagues served as sounding boards during the writing process. I am grateful to all of them. Joyce Burkhalter Flueckiger was an enthusiastic supporter from the outset. Her questions and comments about women in leadership were indispensable to making this a better book. Grace Cohen Grossman's close read of this manuscript saved me from many errors.

I have far too many friends to name them all. They all urged me on. But my compatriot and future coauthor, Erica Brown, was relentless in prompting me to finish this book. Even when I had many other legitimate distractions—see the next paragraph—she rightfully said, "Finish it now or you never will." I heard her loud and clear. And I did.

I was in the midst of writing this book when President Biden nominated me to serve as the United States Special Envoy to Monitor and Combat Antisemitism with the rank of ambassador. The long and often arduous Senate confirmation process paralleled the completion of this book. Throughout that period many people stood by my side offering encouragement and advice. It is impossible to name them all. Some, however, extended themselves beyond my wildest expectations. Dubbed by me as "Team Deborah," they buoyed my sprits when the process dragged on and rejoiced with me when it ended.

With my entry into this new role, I have embarked on a different path, moving temporarily from the world of scholarship to the world of diplomacy. It was fortuitous that my final work before

this move concerned a strong-willed woman who meshed action with diplomacy and who, above all, was committed to making a difference. She was not without her flaws—who is?—but she did exactly that: she made a difference.

I can only hope that in some far smaller fashion, I can do the same.

Deborah E. Lipstadt
Washington, D.C.
May 1, 2022

JEWISH LIVES is a prizewinning series of interpretative biography designed to explore the many facets of Jewish identity. Individual volumes illuminate the imprint of Jewish figures upon literature, religion, philosophy, politics, cultural and economic life, and the arts and sciences. Subjects are paired with authors to elicit lively, deeply informed books that explore the range and depth of the Jewish experience from antiquity to the present.

Jewish Lives is a partnership of Yale University Press and the Leon D. Black Foundation. Ileene Smith is editorial director. Anita Shapira and Steven J. Zipperstein are series editors.